✓ T5-CVH-282

AP® ART HISTORY
CRASH COURSE®

By Gayle Asch, M.A., M.S.

and

Matt Curless, M.A.

Research & Education Association

Visit our website at: www.rea.com

Research & Education Association
61 Ethel Road West
Piscataway, New Jersey 08854
E-mail: info@rea.com

AP® ART HISTORY CRASH COURSE®, 2nd Edition

Printed in the United States of America

Library of Congress Control Number 2015942762

ISBN-13: 978-0-7386-1200-3
ISBN-10: 0-7386-1200-6

AP ART HISTORY CRASH COURSE TABLE OF CONTENTS

PART I INTRODUCTION

PART II CONTENT REVIEW

PART III

TEST-TAKING TIPS

ABOUT OUR AUTHORS

Gayle Asch has been teaching Art in the New York City public schools since 1993. She currently teaches at the elite Bronx High School of Science. Many of her students have won awards for their artwork and have continued their study of Art History in college. Ms. Asch received her B.F.A. from the School of Visual Arts in New York City, an M.A. from the College of New Rochelle and her M.S. from Mercy College.

Matt Curless received both his Bachelor of Fine Arts in Graphic Design and Master of Arts in Education from the College of Mount St. Joseph in Cincinnati. Since 1995, Mr. Curless has taught a wide range of art courses, including Art Foundations, Drawing & Painting, Photography, Computer Graphics, Web Design, Yearbook, and his favorite, AP Art History. He has been a Fine Arts faculty member with the Kentucky Governor's Scholars Program for the past 14 years. In April 2008, Mr. Curless received a "Teacher of the Week" award from the Warm98 radio station in Cincinnati, and was honored as Great American Insurance Company's Teacher of the Year in May 2008. He has been an Art and Technology teacher at Glen Este High School in Cincinnati, Ohio, since 1999.

ABOUT OUR EDITORS

Lauren Schoellhorn is a social studies teacher in the Rockwood School district in suburban St. Louis, Missouri. She received her Bachelor's degree in Social Science Education from the University of Missouri-St. Louis in 2005 and her Master's in Social Science Education from Webster University in 2012. During her teaching career, Mrs. Schoellhorn has taught AP Art History, AP World History, U.S. history, and psychology. She is also an adjunct professor at Webster University in St. Louis. In addition, Mrs. Schoellhorn volunteers as a Master Guide at Bellefontaine Cemetery where she enjoys incorporating her love of art and architecture into the rich history of the St. Louis region.

Alexis Culotta, Ph.D., is a professor of Art History at Chicago's American Academy of Art, as well as an adjunct lecturer at the Art Institute of Chicago. In addition, she also works as an arts writer and editor for a variety of print and online publishers.

ABOUT THE AP ART HISTORY IMAGES

- To access the AP Art History images referred to in this book go to *www.collegeboard.org/ap*.

- Select AP Art History from the **AP Course Homepages** drop-down menu.

- At the AP Art History Course Homepage, click the link to the *AP Art History Course and Exam Description*. Download the PDF file to your desktop for easy access to the complete image set.

ABOUT THIS BOOK

REA's *AP Art History Crash Course* is the first book of its kind for the last-minute studier or any AP student who wants a quick refresher on the course. The *Crash Course* is based upon a careful analysis of the new 2016 AP Art History Course Description outline and available AP test questions.

Written by two AP Art History experts with years of experience teaching AP Art History, our easy-to-read format gives students a crash course in the major facts, terms, and concepts needed for success on the Art History exam. The targeted review chapters prepare students by focusing only on the material tested on the new 2016 exam.

Unlike other test preps, REA's *AP Art History Crash Course* gives you a review specifically focused on what you really need to know to ace the exam. Part I discusses how to prepare for the exam and includes a glossary of must-know AP Art History terms. Part II is the content review section. These concise chapters cover all the important historical, religious, political, and cultural influences that affected the creation of art from prehistory through the present. Also included is information about all 250 works of art the College Board requires students be familiar with for the new AP Art History exam. Each image is explained in context, so you'll be prepared on test day!

Finally, the *Crash Course* concludes with test-taking strategies for the multiple-choice and free-response sections of the exam.

No matter how or when you prepare for the AP Art History exam, REA's *Crash Course* will show you how to study efficiently and strategically, so you can boost your score!

To check your test readiness for the AP Art History exam, take **REA's FREE online practice exam** either before or after studying this *Crash Course*. To access your practice exam, visit *www.rea.com/studycenter* and follow the on-screen instructions. This true-to-format test features automatic scoring, detailed explanations of all answers, and diagnostic score reporting that will help you identify your strengths and weaknesses so you'll be ready on exam day!

Good luck on your AP Art History exam!

ABOUT REA

Founded in 1959, Research & Education Association (REA) is dedicated to publishing the finest and most effective educational materials—including study guides and test preps—for students in middle school, high school, college, graduate school, and beyond.

Today, REA's wide-ranging catalog is a leading resource for students, teachers, and other professionals. Visit *www.rea.com* to see a complete listing of all our titles.

ACKNOWLEDGMENTS

In addition to our authors, we would like to thank Larry B. Kling, Vice President, Editorial, for his overall guidance, which brought this publication to completion; Pam Weston, Publisher, for setting the quality standards for production integrity and managing the publication to completion; Diane Goldschmidt, Senior Editor, for project management; Eve Grinnell, Graphic Artist, for design and file management; and Fred N. Grayson of American BookWorks Corporation for overseeing manuscript development and typesetting.

PART I

INTRODUCTION

KEYS FOR SUCCESS ON THE AP ART HISTORY EXAM

Taking any Advanced Placement exam can be a daunting experience. The AP Art History exam is no exception. After all, the exam is based on a two-semester college-level introductory Art History course, and you're still in high school! Don't panic...relax. This *Crash Course* is going to guide you to success on the exam.

The AP Art History course and exam require you to develop your critical-thinking skills while helping you develop an in-depth understanding of the historical and cultural concepts of architecture, sculpture, painting, and other media.

Our *Crash* Course was designed to help you be more pragmatic in your approach to studying for the AP Art History exam *by using a straightforward outline format.*

1. **Understand the Structure of the Exam**

 The AP Art History exam consists of both multiple-choice questions as well as free-response questions. The sections of the exam are as follows:

 A. Section I consists of 80 multiple-choice questions.

 i. This section will test your knowledge of the 250 selected works of art (the image set).

 ii. It is important to understand the context of each work in relation to the learning objectives (see Chapter 3). You will be expected to explain/discuss how the time period in which the work was created impacted the form, content, and function of the piece.

 iii. Some of the questions will be based on images and may be posed as single questions or as sets of questions. Some of the questions will not have accompanying images.

 iv. This section is timed and students will have 60 minutes to complete all of the questions.

 v. The grade for this section counts as 50% of your total grade for the exam.

B. Section II consists of 6 free-response questions (essays).

 i. This section will test the application of art historical skills, based primarily on the image set, contextual understanding of the artworks, as well as in-depth knowledge of artworks.

 ii. You may be asked to compare or contrast artworks from different time periods and/or cultures.

 iii. Images beyond the image set may be included to test students' ability to recognize and/or attribute styles.

 iv. For some questions, images will be used, while for others students will need to choose an appropriate image or images to refer to in order to answer the question. These images may be from the image set or beyond.

 v. The total time allowed for the section is two hours.

 vi. The two longer free-response questions will be timed, and students will have 30 minutes to complete each one.

 vii. The four shorter free-response questions must be completed in 60 minutes. It is recommended that students spend 15 minutes on each question.

 viii. The grade for Section II will count as 50% of the total exam grade.

2. Understand the AP Art History Topical Outline

Many students believe that members of the AP Art History exam development committee have the freedom to write any question they wish. This widespread belief is not true. AP Art History test writers use a detailed topical outline that tells them what they can and cannot ask.

Every question on the AP Art History exam can be linked to a specific point in the topical outline. Familiarize yourself with this outline before studying for the exam. The content areas found on the exam are as follows:

Content Area	Percentage of Exam	Number of Images
Global Prehistory 30,000–500 BCE	4	11
Ancient Mediterranean 3500 BCE–300 CE	15	36
Early Europe and Colonial Americas 200–1750 CE	20	51
Later Europe and Americas 1750–1980 CE	22	54
Indigenous Americas 1000 BCE–1980 CE	6	14
Africa 1100–1980 CE	6	14
West and Central Asia 500 BCE–1980 CE	4	11
South, East, and Southeast Asia 300 BCE–1980 CE	8	21
The Pacific 700–1980 CE	4	11
Global Contemporary 1980 CE to present	11	27

3. Understand How the Exam Is Scored

The College Board reports your combined multiple-choice score and your total free-response score on a five-point scale:

5	Extremely well-qualified
4	Well-qualified
3	Qualified
2	Possibly qualified
1	No recommendation

Many colleges give course credit for a score of 3 or better; other colleges take nothing below a 4, while still others give college credit only for the top score, a 5. Find out the AP policies of the colleges where you are seeking admission. Also, be aware that colleges and universities can change their AP acceptance policies whenever they want.

Be aware that in many instances, colleges that focus on art, such as the Rhode Island School of Design, Pratt Institute, School of Visual Arts, or School of the Art Institute of Chicago, may not award you any credit for your AP Art History Exam, regardless of your score. Nonetheless, many other colleges and universities will award extra credit or placement, so be sure to ask.

4. Understand the Overlap Between the Multiple-Choice Questions and the Free-Response Questions

Both the multiple-choice questions and the free-response question are taken from the topical outline in the AP Art History Course Description Booklet. As a result, studying for the multiple-choice questions is tantamount to studying for the free-response questions. Many students fail to grasp the significance of this point. Since the multiple-choice questions are highly predictable, so are the free-response questions. The two types of questions are, in fact, highly related, since they both come from the same topical outline.

5. Know Some Basic Test-Taking Strategies

Keep in mind that one of the best ways to prepare for this exam is to take the AP Art History Practice Exam available online with the purchase of this book. This practice exam will help you become familiar with the format of the test and the types of questions you will be asked. Our answer section, complete with detailed explanations, will provide feedback that will help you to pinpoint which questions give you the most difficulty. Then you can go back to the text of this book, reread the appropriate sections of your textbook, or ask your teacher for help.

When it comes time to take the actual test, remember to read all the questions carefully, and be alert for words like "always," "never,"

"not," and "except." On the multiple-choice section, review all the answer choices before selecting your answer.

On the free-response section, make sure you write legibly. This sounds like a very simple thing, but if those who are scoring your exam cannot read your answer, you will not get credit. We suggest that you cross out errors—using a single line through any mistakes—rather than erase them.

At this stage of your school career, it is probably too obvious to remind you of some basic preparations right before test day, but we will anyway: get a good night's sleep the night before the exam, eat a good breakfast, and don't forget a bunch of those famous No. 2 pencils and several blue or black ink pens.

6. Use Supplementary Materials

This *Crash Course* focuses on what you need to know to score well on the AP Art History exam. You should, however, supplement it with materials provided by the College Board, especially the *AP Art History Course and Exam Description*. Also be sure to review your class notes and textbook as well.

7. Using the AP Art History Image Set and This Book

The AP Art History required course content is represented within a specific image set of 250 works of art categorized by geographic and chronological designations, beginning with works from global prehistory and ending with global contemporary works.

The images referred to in this *Crash Course* can be viewed in the *AP Art History Course and Exam Description* PDF located at *www.collegeboard.org/ap*. See page vi of this book for downloading instructions.

Every image in the AP Art History image set is referred to in this book. Although the information may not be in the same order as found in the College Board image set, the reference number used in this book and in the AP Art History image set are the same. For example, *Peplos Kore from the Acropolis* is cited as Image 28 in this book as well as in the AP Art History image set.

KEY TERMS

Art historians use a large number of terms to describe works of art. The glossaries of most art history texts contain between 700 and 800 terms. Fortunately, your AP Art History exam will not cover all of these terms. This chapter provides you with a list of the most important terms that you must know. You do not have to memorize the definitions. Instead, read over the list and familiarize yourself with each term. Remember: familiarize, don't memorize.

1. **AMBULATORY**

 The passageway around the apse and choir of a church. The ambulatory was originally a feature of Romanesque churches that developed in connection with their use as pilgrimage centers.

2. **ANTHROPOMORPHIC**

 Ascribing human characteristics or forms to nonhuman things.

3. **APSE**

 In a church, a semicircular termination or recess that is usually vaulted.

4. **ARCHITRAVE**

 The lintel or beam that rests on top of the capitals of columns.

5. **ASSEMBLAGE**

 An artwork constructed from already existing objects.

6. AVANT-GARDE

Late 19th- and 20th-century artists whose work emphasized innovation and challenged established conventions.

7. BARREL VAULT

A vault is a roof or ceiling. A barrel vault is, in effect, a deep arch or an uninterrupted series of arches. Roman architects developed barrel vaults, and they are one of the characteristic features of Romanesque churches.

8. BIOMORPHIC

An adjective used to describe forms that resemble or suggest shapes found in nature. Biomorphs are therefore not abstract shapes.

9. BUTTRESS

Large stone pier that holds the roof vaults in place. A buttress may be visible or it may be hidden among other architectural elements.

10. CANTILEVER

A beam or structure that is anchored at one end and projects horizontally beyond its vertical support into space.

11. CARYATID

A column carved to represent a woman.

12. CHIAROSCURO

In drawing or painting, the treatment and use of light and dark, especially by gradations of light that produce the effect of modeling.

13. CHOIR

The part of a church beyond the transept. It may be a step or two above the level of the nave.

14. CLERESTORY

A row of windows in the uppermost part of a wall.

15. CONTRAPPOSTO

The relaxed natural pose or "weight-shift" first introduced in the Classical Greek sculpture Kritios Boy, created in 480 BCE. Contrapposto separates Classical Greek statuary from the preceding Archaic movement.

16. CORBELED VAULT

A vault formed by the piling of stone blocks in horizontal courses, cantilevered inward until the two walls meet in an arch.

17. CORNICE

A horizontal decorative molding that is located in the upper portion of an architectural structure. A cornice can be located at the top of a building below the roof, over a door, above a window, along the top of an interior wall, etc.

18. CRYPT

A vaulted space in a church usually located under the apse. Since a crypt is wholly or partly underground, it is not found in the nave elevation of a church.

19. DIPTYCH

A two-paneled painting or altarpiece.

20. ENCAUSTIC

A painting technique in which pigment is mixed with wax and applied to the surface while the mixture is hot.

21. ENTABLATURE

In Classical architecture, the part of a building above the columns and below the roof. The entablature of a Classical temple includes the architrave, frieze, and cornice.

22. FLYING BUTTRESS

A support built against an exterior wall to reinforce it and to allow for higher roofs and larger interior spaces.

23. FRESCO

A painting done on a wall using a mixture of plaster and paint.

24. FRIEZE

In Classical architecture, a frieze is a continuous horizontal band of sculptural decoration.

25. GROIN VAULT

A groin vault is formed at the point at which two barrel vaults intersect at right angles. Groin vaults are one of the characteristic features of Gothic cathedrals.

26. HIERARCHICAL SCALE

The representation of more important figures as larger than less important figures.

27. HYPOSTYLE

A hall with a roof supported by rows of columns.

28. ICONOCLASM

The practice of banning and destroying images. The destroyers of images were known as iconoclasts.

29. IMPASTO

The application of thick layers of oil paint.

30. INTAGLIO

A graphic technique in which the design is incised, or scratched, onto a metal plate, either manually (ENGRAVING) or chemically

(ETCHING). The incised lines of the design take the ink, making this the reverse of the woodcut technique.

31. JAPONISME

The French fascination with all things Japanese. Japonisme emerged in the second half of the 19th century. The Impressionists and Post-Impressionists were particularly enthralled with the use of bold contour lines, flat areas of color and cropped edges in Japanese woodblock prints.

32. KORE

An Archaic Greek statue of a standing draped female.

33. KOUROS

An Archaic Greek statue of a standing nude male.

34. MIHRAB

A semicircular niche set into the qibla wall of a mosque.

35. MUDRA

In Buddhist and Hindu iconography, a stylized and symbolic hand gesture.

36. MOSAIC

Image composed of small pieces of colored glass or stone.

37. NARTHEX

An entrance hall located at the opposite end (usually the western side) of the main altar of a church. Located outside of the main doorway to the church, it is not considered to be part of the church proper. It is usually used as a gathering place before and after services take place.

38. PAGODA

A multistoried Chinese structure, usually associated with a Buddhist temple, having a multiplicity of projecting eaves.

39. PEDIMENT

In Classical architecture, the triangular section above a temple's entablature often decorated with sculpture.

40. PENDENTIVE

The concave triangular section of a vault that forms the transition between a square or polygonal space and the circular base of a dome.

41. PHOTOMONTAGE

A composition made by pasting together pictures or parts of pictures, especially photographs. Also called a PHOTOCOLLAGE.

42. PREDELLA

The painted or sculpted lower portion of an altarpiece that relates to the subjects of the upper portion.

43. PYLON

A pair of truncated, pyramidal towers flanking the entrance to an Egyptian temple.

44. QIBLA WALL

The wall of a mosque that the congregation faces during prayer. The wall is the one most closely aligned with the direction of the Kaaba in Mecca.

45. READYMADE

An ordinary object that, when an artist gives it a new context and title, is transformed into an art object. Readymades were important features of the Dada and Surrealist movements of the early 20th century.

46. REGISTER

One of a series of rows in a pictorial narrative.

47. REPOUSSÉ

A technique in which a relief is formed on the front by hammering a metal plate from the back.

48. STELE

An upright stone slab or pillar.

49. STUPA

A large, mound-shaped Buddhist shrine.

50. TRIPTYCH

A three-paneled painting or altarpiece.

51. TYMPANUM

The lunette-shaped space above the portals of Romanesque and Gothic churches.

52. UKIYO-E

Japanese "pictures of the floating world." A style of Japanese art that influenced 19th-century Western art.

53. VELLUM

Calfskin prepared as a surface for writing or painting.

54. VERISTIC

Artwork that is very realistic.

55. ZOOMORPHIC

Anything that is perceived or created to have animal forms or characteristics.

WHAT YOU NEED TO UNDERSTAND ABOUT THE ARTWORKS

I. The Relationship Between Materials and Ideas

A work of art can be understood in terms of how the artist used the elements and principles of art (form), why the work was created (function), the subject matter of the work (content), and the relationship of the work to the originating time period and culture (context). Each of these is a distinct component of a work of art, yet these components are also interrelated.

The materials and techniques used to make the artwork should be understood in terms of how the chosen material and/or technique affected the form, function and/or content of the work. The original context of the artwork must be understood in order to appreciate the artist's intent. Contextual information may include time period, culture, intended audience, and/or the desires of the patron/sponsor of the work.

II. Tradition and Change in Art

Artworks either employ tradition or embody a departure. How and why an artwork, or group of artworks, employs an established tradition or a significant departure from tradition is essential to understanding the work of art. Contextual information such as function, materials and techniques, artistic movements and organizations, intended audience, patrons/sponsors, culture, cultural diffusion, religious ideas, politics, and economics is an essential component of this understanding.

Artworks that adopt or reject an established tradition have influence on other works of art and/or methods of artistic production. It is important to understand why and how artworks influence each other.

III. Proper Identification and Interpretation

Proper identification of a work of art must include: the name of the artist(s) and/or culture of origin, the title or designation, the date of creation, and the medium with which the work was created.

Artists use the elements and principles of art in order to elicit a response from the viewer. The intended response may be interpreted in terms of perception, intellectual concept, tactile qualities, and/or emotional content. The interpretation of a work of art is related to the context in which it is viewed. Variables may include time, place, culture, method of display and/or audience.

Stylistic tendencies are components of identification. Images beyond the image set may be included on the exam. Students should be able to attribute these to a particular artist, culture, time period, and/or art movement based on the observation of stylistic tendencies. In addition, students may be asked to compare two works of art from similar or different time periods and/or cultures. Discussion of similarities and differences may include how the elements and principles of art are used as well as the function, subject matter and/or context of the works of art.

PART II
CONTENT REVIEW

GLOBAL PREHISTORY 30,000–500 BCE

Note: The image set for this chapter can be found on pages 30–33 of the College Board's *AP Art History Course and Exam Description*.

I. PERIODS OF PREHISTORY

A. The Paleolithic Age

 i. Also called the Old Stone Age, this period lasted for more than 90% of human history.

 ii. It began approximately 2.5 million years ago and ended around 20,000 BCE, although some scholars place the end of the period at 10,000 BCE.

 iii. Technologically, it is characterized by the first use of stone tools to scrape, cut, carve, and kill prey.

 iv. Culturally, it is characterized by the formation (later in the period) of burial customs and other symbolic or ritualistic behaviors as well as the creation of paintings in caves and on rocks.

 v. Small sculptures that were easily transported by nomadic peoples were probably prevalent during this period, although only a few survive.

 vi. Cave and rock paintings of this period mostly depict animals.

B. The Mesolithic Age

 i. Also called the Middle Stone Age, this is the transitional period from 20,000 BCE to approximately 8,000 BCE, although some scholars place it between 10,000 and 8,000 BCE.

 ii. This period saw the beginning of settled agrarian communities and inventions like the bow and arrow, pottery, and the limited domestication of animals (mostly for hunting assistance).

 iii. Though small portable sculptures were not created as frequently, cave and rock painting continued well into this period.

 iv. The paintings of this period often depict stylized humans engaged in activities such as hunting and ceremonial rituals. Some scholars believe these images are the primitive start of writing, similar to hieroglyphs.

C. The Neolithic Age

 i. Also called the New Stone Age, this period lasted from approximately 8,000 to 3,000 BCE, although some artworks that are grouped with this time period are from a later date.

 ii. During this period the climate stabilized into reliable seasons, and people mostly gave up hunting and gathering in favor of farming and domestication of animals to obtain food.

 iii. Sophisticated weaving, architecture, and increasingly stylized pictographs (that later evolved into writing) appear during this period.

 iv. People continued to paint and create pottery, and small portable sculptures were produced again.

 v. Art made during this period was often designed to be both durable and large scale as agricultural settlements became more permanent.

 vi. Earliest forms of architecture used post-and-lintel methods.

Test Tip

If the word "BOTH" appears in a multiple-choice question, be sure to eliminate any answers that apply to only one of the artworks being compared.

II. OVERVIEW

The period known as prehistory generally ends with people learning to smelt and use iron and bronze on a large scale. By the second millennium BCE iron was being used to make tools, weapons, etc., in a large area from Sub-Saharan Africa to China. However, there is evidence that iron was used as far back as the fourth millennium BCE and that gold, copper, and silver have been in use since the sixth millennium BCE. It should be noted that there are cultures, found in parts of the Americas, Africa, Australia, Asia, and Oceania, in which prehistoric styles of art continued well into the 20th century.

The artwork made during this time period was influenced by the changing environment and ancient people's daily struggle for survival. It is believed that people all over the world made art. Some of these art objects were used for practical purposes, while other pieces were created for ritualistic use or symbolic purpose.

Some of the major technological advances of this period occurred in the latter part of prehistory. These include refined methods of agriculture, turning clay into ceramics, the creation of symbolic/ritualistic architecture, and the use of stylized pictographs to represent ideas.

As people migrated all over the world, they took their artistic styles with them. As a result, similar styles of artwork, such as the "Venus" figures of the Neolithic period, have been found across a vast land area.

Due to a lack of written records from this time period, all information, other than carbon dating, is conjectural and subject to revision based on new information that may emerge. The art and artifacts of this period serve as the basis of understanding this period of history.

Test Tip

For the entire image set, consider how the time period in which the artwork was created impacts how the artwork looks, what it was used for, and what it is made of.

 III. ARTWORKS FROM THE IMAGE SET

Image 1. Apollo 11 Stones. Namibia. 25,500–25,300 BCE. (Paleolithic) Charcoal, ocher and white on stone.

i. This artwork was carried into a cave and is one of the oldest known rock paintings. Its location supports the theory that human existence began in Africa.

ii. This is one of the earliest examples of an approach to form that emphasizes representation, although the animal depicted is unknown.

iii. The style of the work is known as conceptual realism or twisted perspective. It combines a frontal and side view rather than a true optical view. It is believed that this was considered to be a more realistic representation of the animal depicted. This style of representation is also found in much later periods in Mesopotamia and Egypt.

Image 2. Great Hall of the Bulls. Part of a painted cave complex in Lascaux, France. 15,000–13,000 BCE. (Paleolithic or Mesolithic) Mineral pigment with incised areas on rock walls.

i. Thirty-six different animals are represented in the paintings of this cave complex.

ii. Most of the images are depictions of common prey of the time, but some represent hunting competitors such as lions, bears, and wolves.

iii. It is believed by some scholars that the paintings may indicate a concept of time represented by animal habits during different times of the year. Others interpret the work as a prehistoric understanding of the importance of the animals to human survival. Still others theorize that the work is a form of shamanistic magic made to influence or predict a successful hunt.

iv. In total, there are more than 2,000 painted figures in the cave complex. While most consist of depictions of animals, some are abstract designs, hand prints, and a few stylized humans that are very small compared to the animal images.

v. The paintings were completed by many different artists over a period of approximately 2,000 years.

vi. The paint was made from local minerals and was mostly sprayed on through tubes made of bone or plant materials. Some areas seem to have been swabbed on using fur, hair, or plant material. No evidence of the use of actual paint brushes has ever been found at the site.

vii. The painters would have been in very awkward positions while working on these paintings, and they would have had to work in very low light. Holes in the walls are considered to be evidence of the use of scaffolds to aid in the creation of these works.

viii. The exceptional realism, the use of the contours of the walls to enhance three-dimensional qualities, and the expanded color palette represent a massive artistic leap forward from works such as the Apollo 11 stones.

ix. The paintings were done using a style known as twisted perspective or conceptual realism. Scholars believe that the caves were probably used only for rituals of some kind since the lack of lighting would have made them unsuitable to live in.

Image 3. Camelid sacrum in the shape of a canine. Tequixquiac, central Mexico. 14,000–7,000 BCE. (Paleolithic or Mesolithic) Carved bone.

i. This is one of the oldest artifacts from Mesoamerica and one of the oldest artworks made of animal bone.

ii. The artist used the natural contours of the bone and carved out areas such as the mouth using stone implements.

iii. The medium (bone) of early works such as this one was influenced by available resources.

iv. While animals are a common theme of the time period, this piece may reflect the early use of canines as domesticated hunting or traveling partners, in rituals, or as a food source.

v. Later artwork and literature of Mesoamerica, particularly that of the Mayan culture, includes dogs associated with burial and sacrificial rituals. Dogs also play a large part in the Mayan creation myth.

Image 4. Running horned woman. Tassili n'Ajjer, Algeria. 6000–4000 BCE. (Neolithic) Mineral pigment on rock wall.

i. The paintings and engravings in the caves of this area number approximately 15,000 and are spread over a 72,000 square-kilometer area.

ii. The paintings contain depictions of rituals, daily life, animal migrations, and climatic changes.

iii. Images include domestic animals, humans, geometric designs, ancient script, and mythical creatures.

iv. The paintings were made over a long period of time. The later paintings indicate an Egyptian influence.

v. These caves are very different from those of previous periods because, while some of these painted caves may have been used for rituals, the majority of them seem to have been caves where people lived. The paintings may have served as decoration of domestic spaces.

vi. This particular painting makes use of naturalistic realism rather than the twisted perspective used in earlier cave paintings.

Image 5. Beaker with ibex motifs. Susa, Iran. 4200–3500 BCE. (Neolithic) Painted terra cotta.

i. This large hand-thrown and painted vase was a funerary object from the prosperous city of Susa, one of the first agricultural communities of the region.

ii. The style is typical of the period and culture.

iii. Around the top is a frieze of aquatic birds. Stylized running dogs, possibly used for hunting, are depicted underneath the birds.

iv. Most of the vase features panels divided by what are known as meander patterns, with the center depicting a stylized goat.

v. The somewhat abstract depiction may have served to identify the clan or region from which the patron of the work originated.

vi. It is not known if painted ceramics were in common use at the time or if they were used only for burial customs.

vii. This work reflects the switch to a more agrarian society. The form of this work reflects the period in which it was created, when baskets were believed to be commonly used for farming practices and storage.

Image 6. Anthropomorphic stele. Arabian Peninsula. Fourth millennium BCE. (Neolithic) Sandstone.

i. This artwork is one of the oldest from an area known for ancient trade routes that lead through the area to Mesopotamia and Greece. It is one of many found across a large region of the Arabian Peninsula.

ii. The geometric stylization depicts a man with a double strap across his chest and a belt with a split blade dagger attached to it.

iii. The exact purpose of this work is unknown, but other similar steles containing the name of a person written in Aramaic may have been used for burial customs.

iv. This work also reflects an early religious practice of assigning human characteristics to objects, known as anthropomorphism.

Image 7. Jade *cong*. Liangzhu, China. 3300–2200 BCE. (Neolithic) Carved jade.

i. This is one of the earliest examples of this form. Cong were in continuous production until about 256 BCE.

ii. The cong, which was always paired with a disk-shaped piece known as a bi, was used as a burial object. Jade, precious and difficult to carve, was reserved for burial objects for people of high rank.

iii. Some tombs contained several bi and cong.

iv. The corners of most cong are decorated with stylized monster faces. The original meaning and use of cong and bi are unknown. There are theories based on later symbolism that state that the cong represented the earth as well as the elements of water, fire, wood, and metal, while the bi represented the heavens.

iv. The use of the circle inside of a square is a recurring motif found in later Chinese and other East Asian artworks.

Image 8 (two images). Stonehenge. Wiltshire, United Kingdom. c. 2500–1600 BCE. (Neolithic). Stone structure.

i. The site of Stonehenge is currently being studied. It is believed that the site was considered to be sacred to native peoples of the region for approximately 10,000 years, possibly due to an abundance of prey for hunting in the area. Speculations about the use of the site include fertility rites, celestial rituals, religious functions, etc.

ii. Most scholars agree that the site was used for rituals, possibly tied to celestial events.

iii. Considered to be an environmental/architectural monument, the remains of the site consist of large stones called sarsens (each of which weighs about 25 tons), which are believed to have come from about 20 miles away.

iv. Some of these stones are still connected by a lintel, and it is believed that at one time each pair had a lintel connecting them.

v. Smaller stones called bluestones (each of which weighs about 4 tons) originating from 140 miles away in modern-day Wales are also part of the structure.

vi. Some scholars believe that the bluestones arrived in the vicinity by way of a glacier deposit, while others believe that they were carried there from modern-day Wales.

vii. The most recent studies indicate that the visible structure was part of a large, complex group of structures.

viii. Evidence of widespread prehistoric hunting and numerous burial mounds dating back to approximately 7500 BCE have been found in and around the site.

ix. It is believed that the site originally contained a wooden building, several shrines, and at least two additional monuments.

x. Construction at the site seems to have ended about 4,000 years ago.

Image 9. The Ambum Stone. Ambum Valley, Enga Province, Papua New Guinea. c. 1500 BCE. Greywacke.

i. This is one of the oldest artworks from Oceania.

ii. This zoomorphic form, which resembles an anteater, is one of a group of about 100 sculptures that are stylistically

similar. While this is one of many intricately carved pestles used for grinding food or herbs, others are mortars carved in the form of birds, humans, geometric designs, and animals.

iii. It is not known if these sculptures were made for daily use or if they were made purely for ritual purposes. It is possible that they represent totemic, or "spirit," beings or ancestors.

Image 10. Tlatilco female figurine. Central Mexico, site of Tlatilco. 1200–900 BCE. Painted ceramic.

i. This is one of many female figurines found in graves amidst the remains of what was once a thriving early Mesoamerican community. Other funerary objects found there include ceramic vessels, masks, and musical instruments.

ii. All of the female figurines have detailed depictions of hairstyles, clothing, and body ornaments that may be based on real or idealized lifestyles.

iii. It is not known if these figurines depict real people or deities.

Image 11. Terra cotta fragment. Lapita, Solomon Islands, Reef Islands. 1000 BCE. Incised terra cotta.

i. This is one of many objects found that feature intricate, repetitive geometric designs, some of which feature anthropomorphic faces or figures. Similar patterns can be found in modern Polynesian tattoos and barkcloth designs.

ii. The designs were incised into the clay before firing, using a stamp-like tool.

iii. The Lapita people were an ancient Pacific culture and are the ancestors of the inhabitants of modern-day Polynesia, Micronesia, and parts of Melanesia.

iv. They were seafaring people who were excellent at navigation and who found and colonized islands separated by hundreds of square miles of ocean.

v. The ceramic objects may have been used for cooling, serving, or storing food.

vi. The meaning of the stamped designs is not known. Examples of this distinctive style of Lapita plain-ware pottery have been found in parts of New Guinea, Samoa, and Tonga.

Artworks from the prehistoric period exhibit major similarities regardless of where they were made. These objects reflect the ways that early humans made sense of their environment, time, and the cycle of life and death. Since there are no written documents from this period, all ideas about the artworks are conjectural.

ANCIENT MEDITERRANEAN– MESOPOTAMIA, EGYPT, GREECE, PERSIA, ETRURIA, AND ROME 3500 BCE–300 CE

> *Note:* The image set for this chapter can be found on pages 37–53 of the College Board's *AP Art History Course and Exam Description.*

I. MESOPOTAMIA, PERSIA AND EGYPT – COMMONALITIES

A. Much of the surviving artwork represents royal figures or divinities using formal stylistic conventions. Funerary objects and palatial architecture are also important to all three cultures.

B. There was an active exchange of ideas and artistic styles among Mesopotamia, Persia, Egypt, and beyond.

C. Written records serve as a foundation for understanding ancient art. Mesopotamia, Persia, and Egypt had a great influence on the Classical world of Greece and Rome.

D. All three cultures used formal stylistic conventions that included the use of twisted perspective or combined views (first seen in prehistoric art), as well as hierarchical scale.

E. Horizontal registers and sections were used in Mesopotamia and Egypt to tell historical narratives.

 MESOPOTAMIA OVERVIEW

A. Also called the ancient Near East, ancient Mesopotamia comprised the area of modern-day Iraq, Syria, Iran, Turkey, Lebanon, Israel, Jordan and Cyprus from 3500 to 330 BCE.

B. Many groups, including the Sumerians, Akkadians, Neo-Sumerians, Babylonians, Assyrians, Neo-Babylonians, and Persians, fought for and gained control of the area. Those groups that existed simultaneously created artworks that shared many stylistic conventions.

C. Mesopotamia had few borders for protection, which meant their lands were frequently invaded. As power changed hands, often artistic styles changed also.

 MESOPOTAMIAN ARTWORKS FROM THE IMAGE SET

A. Sumerians (3000–2371 BCE)

The Sumerians ruled Southeast Babylonia. The major contributions of this culture include the world's earliest known writing system (called cuneiform), the invention of the wheel, and the first developed urban communities.

Image 12 (two images). White Temple and its ziggurat. Uruk (modern Warka, Iraq). Sumerian. c. 3500–3000 BCE. Mud brick.

 i. Ziggurats and the temple complexes that stood atop them dominated the cities of Mesopotamia.

 ii. Their central placement and size made them visible from most of the city. This monumental architecture reflects the importance of religion to the culture.

 iii. Uruk was a thriving city of about 40,000. It is believed that the White Temple was dedicated to Anu, god of the sky and patron god of the city.

 iv. The four corners of the temple are oriented to the four cardinal directions.

 v. Scholars believe that only priests were allowed to enter the temple, creating social stratification. The basis for this

theory is the small size of the temple, which could not have accommodated large groups of worshippers.

Image 14. Statues of votive figures, from the Square Temple of Eshnunna (modern Tell Asmar, Iraq). Sumerian. c. 2700 BCE. Gypsum inlaid with shell and black limestone.

i. Since most members of the community could not enter the temple, the elite commissioned images of themselves to be carried into the temple.

ii. Many examples of these votive figures exist, all of which were found buried in groups under the temple floors, built into altars, or scattered in pieces in various rooms of the temple complexes of Mesopotamia. The exact way these figures were used is not known.

iii. Although of varying size, they share stylistic conventions. Men wear fringe or tufted fleece skirts, and women wear fringed or tufted fleece dresses that are draped over one shoulder.

iv. Most of the figures have large shell-inlaid eyes and painted hair.

v. The hands are usually clasped, right over left, at chest or waist level with some holding cups or vegetation.

vi. Most of the standing figures are depicted with the left foot forward.

vii. Women are depicted with a variety of hairstyles, while men are mostly bald and bearded, some with sidelocks.

viii. Some of the figures are more naturalistic while others are more abstract; this is possibly a reflection of either the style of the originating workshop or the time period of production.

ix. Some of the figures have a cuneiform inscription on them stating the name of the god for which they were intended along with the name of the donor.

Image 16 (two images). Standard of Ur. From the Royal Tombs at Ur (modern Tell el-Muqayyar, Iraq). Sumerian. c. 2600–2400 BCE. Wood inlaid with shell, lapis lazuli, and red limestone.

i. Hierarchical scale was used to make the ruler stand out from the rest of the people depicted.

 ii. Registers were employed to separate the narrative into parts. The story is read from bottom to top.

 iii. The war side depicts the defeat of an enemy, while the peace side depicts the bounty of the land being carried to a royal banquet complete with accompanying musicians.

 iv. The two narratives embody the two major roles of the Mesopotamian ruler, seen as a protective warrior as well as provider of food and water.

 v. Due to the small size of the object, it is believed to have been the sound box of a musical instrument.

Test Tip

Narrative artworks are important historical documents that helped to spread and solidify ideas about important events and people. Do not forget that the stories depicted were written by the victors and therefore may not be complete.

B. Babylonians (1792–1198 BCE)

Like the Sumerians, the Babylonians lived in large cities surrounded by villages and farms.

Hammurabi, who ruled from 1792–1750 BCE, led the "golden age" of Babylon. He is credited with creating one of the first codes of law, which was meant to unite the vast area and diverse peoples of his empire.

Image 19. The Code of Hammurabi. Babylon (modern Iran). Susian. c. 1792–1750 BCE. Basalt.

 i. The top portion of the eight-foot tall stele contains a low relief depicting Hammurabi receiving the right to rule from Shamash. The god of justice, Shamash was also the patron god of Sippar, where the stele was likely erected.

 ii. This stele represents the early establishment of divine right, which is the religious justification of the right to rule and create laws.

 iii. Below the top portion, carved in cuneiform script, are all of the 282 laws of the kingdom, including scaled punishments for infractions as well as laws relating to labor, contracts, and household and family relationships.

 iv. The stele was later taken as plunder to Susa during the 12th century BCE.

C. Assyrians and Neo-Assyrians (1198–612 BCE)

By 824 BCE the Assyrians ruled all of Mesopotamia. They added the territories of modern-day Syria, Armenia, Israel, and Palestine.

Assyrians were a warrior-based culture having adopted chariots and bronze weapons from the Hittites.

Image 25. Lamassu from the citadel of Sargon II,
Dur Sharrukin (modern Khorsabad, Iraq).
Neo-Assyrian. c. 720–705 BCE. Alabaster.

 i. The Neo-Assyrians built monumental palaces to show their superiority. They were one of the first cultures to create palace citadels.

 ii. The lamassu were incorporated into walls of the palace. They served as guardian figures styled as mythical winged, human-headed bulls or lions.

 iii. The stylistic convention of these lamassu includes the incorporation of five legs so that the guardian figures look complete from both the front and side views. From the front they appear to be standing firmly while from the side they appear to be walking forward.

 iv. Lamassu were used both for protection against enemies and to intimidate visitors.

D. Persians (550–330 BCE)

 i. The Achaemenid Persian empire under Cyrus II ("Cyrus the Great") added the territories of Egypt and Babylon to their existing territory. Later Darius I ("Darius the Great") added northwest India, creating the largest empire of the ancient world.

 ii. Under Darius I the empire was stabilized, roads were built, and a system of governors was put into place. He initiated two major building projects including the construction of the new center of the empire, called Persepolis.

 iii. The Persians and the Greeks had a long-standing rivalry. When Alexander III of Macedon ("Alexander the Great") defeated Darius III, who was killed by one of his own generals, Persepolis was razed and its treasures were taken.

 iv. Most of the existing evidence of Persian history and art comes from Greek writings of the time of Darius III, which portray the Persian Empire in a less-than-flattering way.

 v. Many Persian artistic styles were incorporated into Greek art, transforming it into what is known as the Hellenistic style.

Image 30 (two images). Audience Hall (apadana) of Darius and Xerxes. Persepolis, Iran. Persian. c. 520–465 BCE. Limestone.

 i. Persepolis was built over a period of 100 years on a terrace that was half artificial and half natural. It was one of the premiere dynastic cities of the ancient world, although most of it was destroyed in 330 BCE.

 ii. As in Mesopotamia, the primary building material used was sun-dried brick. Ashlar masonry was used for supporting elements like bases and capitals of columns, doorjambs, and lintels.

 iii. The walls were covered by sculpted friezes with monumental gateways featuring the winged bulls of Mesopotamian origin. It is believed that brightly painted designs once covered most surfaces of the palace complex.

 iv. A lighter-than-usual roof and wooden lintels allowed the architects to use an unusually small number of slender columns topped with elaborate capitals.

 v. Built to be a spectacular center for receptions and festivals, it contained audience halls (called apadana), reception rooms, formal halls, and private apartments all linked by staggered corridors in the Mesopotamian style.

 vi. Only a small contingent of the public was allowed access to the Audience Hall, the Throne Hall, and the Gate of Xerxes; the rest of the complex was private.

 vii. The bas-relief sculptures on the outside served as propaganda for visitors, and as a reminder to pay tribute to the king in this capital city of the Persian Empire.

 IV. **EGYPT – OVERVIEW AND ARTWORKS FROM THE IMAGE SET**

A. Ancient Egypt comprised the modern-day territories of Egypt and Sudan from 3000–330 BCE.

B. Due to their well-organized society and strong military, the Egyptians were a major world power with an almost unbroken artistic tradition for approximately 3,000 years.

C. Egypt's artistic traditions survived rule by foreign invaders, including first Persia and then Greece, but became heavily influenced under Greek Ptolemaic rule, beginning around 300 BCE, by the Greco-Roman style. This artistic impact was seen especially in the area of painting. The Greco-Roman influence persisted until finally Egyptian artistic traditions came to an end, around 30 BCE.

D. The reliable flooding of the Nile was necessary for Egyptian survival. Art and the Pharaoh were meant to be unchanging like the Nile.

E. Egyptian art was made to last for eternity. The belief in the cycle of rebirth led them to develop stylistic conventions that addressed concepts of the afterlife. These include ka sculptures, funerary objects, and decorations of tombs and sarcophagi meant to bring comfort to the deceased in the afterlife.

F. Although they were polytheistic, the sun god Re or Ra was the most important god of the pantheon.

G. The Pharaoh was considered to be the living embodiment of a god and descended directly from the sun god.

H. Monumental stone architecture, along with other artworks, embodies the belief in the absolute power of the Pharaoh.

I. The stylistic conventions adhered to include the use of twisted perspective when portraying humans. Eyes and torsos were depicted from a frontal view while heads, legs, and arms were shown in profile.

J. Depictions of royal figures were idealized, while lesser people were depicted in a more realistic style.

Image 13 (two images). Palette of King Narmer. Predynastic Egypt. c. 3000–2920 BCE. Greywacke.

i. One of the world's first historical works of art, the Palette of King Narmer commemorates the unification of Upper and Lower Egypt.

ii. The palette is an elaborate and much larger version of a common utilitarian object used to prepare the dark eyeliner that was an essential aspect of life in the sun-drenched empire. It was found buried among a group of sacred implements in an early temple of the falcon god Horus.

iii. On one side of the palette, the artist used hierarchical scale to depict the ruler Narmer. On the other side, a bull and intertwining feline necks represent Narmer and the unification of Egypt.

iv. The two crowns of Egypt worn by Narmer on the palette represent the unification of Upper and Lower Egypt. The presence of Horus on the right is a sign of divine approval of the unification.

v. This artwork marks the traditional start of ancient Egyptian history.

Image 15. Seated scribe. Saqqara, Egypt. Old Kingdom, Fourth Dynasty (or possibly Sixth Dynasty). 2620–2500 BCE. Painted limestone with inlaid details.

i. Scribes were important members of the court, and the art of writing was revered, as evidenced by the fact that, unlike most Egyptian citizens, this scribe had a ka sculpture.

ii. Like all funerary sculptures depicting the deceased, this is a ka sculpture and was meant to be a resting place for the soul.

iii. Like all non-royal ka sculptures, this work depicts the deceased in a more realistic manner and with less expensive materials compared to royal figures.

iv. His body is not idealized, and he is portrayed sitting on the floor at work, with a papyrus roll across his lap and right hand clenched to hold what must have been a brush (now missing).

v. Negative space is evident in this work due to the materials used. Royal ka sculptures were more blocky and did not contain negative space.

Image 17 (two images). Great Pyramids (Menkaura, Khafre, Khufu) and Great Sphinx. Giza, Egypt. Old Kingdom, Fourth Dynasty. c. 2550–2490 BCE. Cut limestone.

i. These pyramids are part of the royal necropolis of Memphis, the capital of the Egyptian empire throughout most of its history.

ii. The pyramid built for Khufu is the oldest and largest of the three. Its sides are oriented toward the cardinal directions of east and west to correspond to the rising and setting sun.

iii. Khufu's pyramid was the tallest structure on earth until the 20th century.

iv. All three originally contained grave goods and treasures yet were plundered in ancient, medieval, and modern times. Even the exterior white limestone façades of the pyramids have been mostly stripped.

v. Pyramids such as these were primarily made during the Old Kingdom. The practice of creating large structures to mark royal graves was abandoned after the realization that the pyramids were difficult to protect from grave robbers.

vi. The complex also included mortuary temples and smaller pyramids used to entomb lesser members of the royal family.

vii. The Great Sphinx was brightly painted and is part of Khafre's pyramid complex. It was carved of limestone and features the face of Khafre with the body of a lion, representing Ra.

viii. Although more than 100 stone pyramids were built between the Old Kingdom and the Middle Kingdom, these three are the largest.

ix. These monumental architectural achievements are a testament to the ancient Egyptian belief in the concept of eternity and illustrate the importance of burial customs.

Image 18. King Menkaura and queen. Old Kingdom, Fourth Dynasty. c. 2490–2472 BCE. Greywacke.

i. This double portrait is of Khafre's son and his favorite queen/wife, who may be Khamerernebty II.

ii. It was found in the valley temple of the pyramid of Menkaura.

iii. The queen is depicted in a more naturalistic pose with the triangle of her pubic area carefully delineated. This was a stylistic convention found on other statues of high-ranking women as well as fertility figurines.

iv. Standing sculptures like this one always portray the left leg slightly forward and the hips unnaturally even. They exhibit a system of proportions and idealized properties that were always featured in royal sculptures.

v. His larger step forward symbolized his masculinity, as opposed to her smaller step. Their united position may represent the unity of Egypt.

vi. The lack of negative space and blocky appearance is due both to stylistic convention and to the medium used. This solidity ensured that no pieces would break off, which, they believed, would anger the deceased.

vii. The sculpture was originally brightly painted and would have included details such as accessories.

viii. The sculpture is unfinished, evident in the legs and feet of the queen and the missing inscriptions.

Image 20 (three images). Temple of Amun-Re and Hypostyle Hall. Karnak, near Luxor, Egypt. New Kingdom, Eighteenth and Nineteenth Dynasties. Temple: c. 1550 BCE; Hall c. 1250 BCE. Cut sandstone and mud brick.

i. The Great Hypostyle hall is the large area behind the second pylon in the Temple of Amun-Re.

ii. The hall contains 134 colossal columns. All are crowned by huge capitals and carved to look like papyrus plants. It is believed that the 12 central (tallest) ones were part of the original structure and the others were added later.

iii. The invention of the clerestory, a row of small window-like openings along the base of the roof, is a unique and

monumental addition to architecture. This feature would later become an important part of Christian churches.

iv. Originally, throngs of statues of gods and kings stood among the columns.

v. The coronation ritual is depicted on the walls. Later wall decorations include great battles and rituals depicted in the familiar style that employs registers and hierarchical scale.

Image 21 (two images). Mortuary temple of Hatshepsut. Near Luxor, Egypt. New Kingdom, Eighteenth Dynasty. c. 1473–1458 BCE. Sandstone, partially carved into a rock cliff, with red granite. Kneeling statue of Hatshepsut. c. 1479–1458 BCE. Granite.

i. Hatshepsut was the world's first great female leader, ruling from 1479–1458 BCE. She was the daughter of Thutmose I and both the wife and half-sister of Thutmose II. When her husband died she took the throne for herself from Thutmose III, who was a small child at the time.

ii. When Thutmose III regained the throne he tried to wipe out her legacy and affect the comfort of her afterlife. All depictions of her were destroyed, and her name was struck from all historical records. Her temple was altered, and her mummified corpse was moved from its original location.

iii. Hatshepsut's mortuary temple was constructed at the foot of a mountain and placed against the rock wall.

iv. This location was chosen deliberately for its aesthetic elements, which are mirrored by the horizon and cliffs. She was not buried there because during the New Kingdom bodies were buried in secret to prevent grave robberies.

v. The kneeling statue depicts her with a mixture of female attributes (breasts) and traditionally male royal emblems, including the false beard and nemes headdress. Many scholars attribute this to the importance of consistency in the Egyptian culture, which trumped who she was as an individual.

vi. She is depicted giving symbols of order and justice to Amun-Re.

Image 22. A house altar showing Akhenaten, Nefertiti and three daughters. New Kingdom (Amarna period), Eighteenth Dynasty. c. 1353–1335 BCE. Limestone.

i. During the Amarna period (1353–1336 BCE) the pharaoh Akhenaten moved the capital of the empire from Thebes to Amarna and decreed that both old polytheistic religion and artistic traditions be replaced with a new set of beliefs. The result was what is believed to be the first monotheistic religion and one of the first attempts at a more naturalistic approach to art. This relief image embodies the break with the traditional Egyptian style.

ii. Although hierarchical scale is used, the ruler and his queen are depicted in motion, and there is a sense of equality between them. These were marked breaks from symbolic and artistic tradition.

iii. Both are interacting with their children; Akhenaten is kissing a daughter, and Nefertiti is holding one daughter while another plays with her earrings.

iv. The sun disk and rays, representing Aten, an aspect of the god Ra, are depicted between them to symbolize their devotion to the new monotheistic ideas.

Image 23. Tutankhamun's tomb, innermost coffin. New Kingdom, Eighteenth Dynasty. c. 1323 BCE. Gold with inlay of enamel and semiprecious stones.

i. The tomb of King Tutankhamun was discovered mostly intact. The last of his dynasty (he was the son of Akhenaton), he was responsible for restoring Egyptian religion and traditions, officially ending the Amarna period.

ii. He changed his name from Tutenkhaten to Tutenkhamun in deference to the old ways.

iii. The amount and quality of the burial objects found in his tomb allow us to imagine what may have been found in the other pyramids and tombs had they not been plundered.

iv. The anthropoidal coffin is the innermost of three coffins. It originally had two heavy faience necklaces above the neck's falcon collar. These necklaces would have been

similar to those awarded to military commanders and high officials by the ruler.

v. The king's arms are crossed on his chest, a pose that is linked to Osiris, god of the afterlife and father of Horus.

vi. In his hands are the crook (royal scepter) and flail, both symbols of royalty.

Image 24. Last judgment of Hu-Nefer, from his tomb (page from the *Book of the Dead*). New Kingdom, Nineteenth Dynasty. c. 1275 BCE. Painted papyrus scroll.

i. This is one of the best illustrations of what Egyptians believed happened to everyone after death.

ii. This continuous narrative shows Hu-Nefer on the left being walked by Anubis, the jackal-headed god, to the scales, where his heart is weighed against a feather. The painting shows his heart to be lighter than the feather, a sign that he lived according to Egyptian laws.

iii. He is shown again (this is called continuous narrative) being presented by Horus to Osiris, who is flanked by Isis and Hathor. Above, Hu-Nefer is depicted giving offerings to the sitting gods.

iv. *The Book of the Dead* was a collection of texts and illustrations used to assist a dead person's journey to the afterlife.

v. The collection of texts and illustrations was often created specifically for the deceased and placed in the coffin or burial chamber; sometimes it was painted directly onto the coffin. This was to prevent secrets of the afterlife from being available to common people.

vi. The alligator is depicted as a threat because alligators and hippos were regarded as the evil demons of the Nile.

V. GREECE AND ROME – COMMONALITIES

A. Greek and Roman art share a foundation in civic pride and polytheism.

B. The art of these cultures is usually studied in chronological order. Roman art, the last culture of the classical world, was

an appropriation of the earlier conquered cultures of Greece (which had appropriated Persian aesthetics) and Etruria, with a few minor technical innovations.

C. Both were influenced by earlier Mediterranean cultures and ended up having an influence on several later European artistic styles.

D. Both cultures shared a rich tradition of epic storytelling that focused on the trials and tribulations of heroes, gods, and goddesses. Records from the time show a great interest in poetry and public oratory.

VI. ANCIENT GREECE OVERVIEW AND ARTWORKS FROM THE IMAGE SET

A. The empire of Ancient Greece was comprised of present-day Greece, Turkey, southern Italy, Sicily, North Africa, and the coasts of both Southern France and Spain between 800 and 146 BCE.

B. The periods of Ancient Greek art, Archaic, Classical, and Hellenistic, are defined according to artistic style. This is different from Egyptian art—which is classified by dynasty—and from Roman art—which is classified by governmental structures and ruling dynasties.

C. Representations of figures, as well as architecture, adhere to the stylistic conventions of idealized proportions and spatial relationships. This embodies the culture's emphasis on harmony and order.

D. Well-established trade routes brought Greek artists into contact with diverse cultures, which influenced techniques and styles. The expansion of the empire into Asia influenced Greek artistic styles and had a great impact on Asian cultures as well.

E. Greek artists were the first to focus on humans and their potential (called humanism). The Greeks showed humans as perfect, representing the potential of humans to be god-like and to assume a naturalistic appearance for the first time ever.

Image 26. Athenian agora. 600 BCE–150 CE. (Archaic through Hellenistic Greek). Site plan.

 i. The site was the center of the city. It was a large open square where the citizens of Athens could gather. The space was used as a market as well as a site for elections, religious processions, military drills, performances, and other staged competitions.

 ii. Government buildings surrounded the agora.

Image 27. Anavysos Kouros. c. 530 BCE. (Archaic Greek). Marble with remnants of paint.

 i. Figures like this were used as grave markers. The base features an inscription containing the name of the deceased and information about his death.

 ii. The stiff, stylized pose is clearly influenced by Egyptian funerary statuary.

 iii. The face features what is known as the archaic smile, a stylistic tendency of the period.

 iv. It is not known if these are actual portraits or archetypes embodying the ideals of a warrior.

Image 28. Peplos Kore from the Acropolis. c. 530 BCE. (Archaic Greek). Marble, painted details.

 i. *Kore* is the Greek word for "maiden." Korai (maidens) may have served as votive offerings, in this case, to Athena.

 ii. Like all Greek female statuary, she is wearing a peplos draped over one shoulder.

 iii. The statue would have been brightly painted (traces of paint are still visible in some areas).

 iv. The stiff pose, archaic smile and stylized hair are artistic tendencies of the Archaic Greek period.

Image 33 (two images). Niobides Krater. c. 460–450 BCE. (Classical Greek). Clay, red-figure technique (white highlights).

 i. Known as the red figure technique, the figures are revealed as the color of the clay while the background and line work are painted with a glaze that turns black in the kiln.

 ii. White highlights were added after firing.

iii. This technique replaced the previous technique, known as black-figure, because the style allowed for better detailing and representation of the human form.

iv. It is believed that The Niobid Painter, as the decorator is referred to, was inspired by large frescoes seen in Athens and Delphi. Apollo and Artemis are shown in battle with the children of Niobe on one side. On the other side Athena and Heracles are depicted surrounded by soldiers.

v. The style of the painting represents an artistic move toward naturalism and includes the first use of foreshortening.

vi. Like many Greek vases, this one was found in an Etruscan tomb. Etruscans were avid collectors of Greek vases.

Image 34. Doryphoros (Spear Bearer). Polykleitos. Roman copy in marble of a Greek bronze original, 450–440 BCE. (Classical Greek).

i. Polykleitos wrote an essay on the mathematical aspects of human proportion called the *Kanon*. This sculpture, originally created in bronze, served as an illustration of his theories about proportion.

ii. It introduced the naturalistic contrapposto pose and served as the model for all following Greek Classical and later Roman sculptures.

iii. This artwork illustrates the point in Greek history when artists and patrons favored idealism over realism.

Image 35 (six images). Acropolis. Athens, Greece. Iktinos and Kallikrates. c. 447–410 BCE. (Classical Greek). Marble.

i. This is the best known acropolis in Greece. In 1801, when the region was controlled by the Ottoman Turks, many of the marble reliefs were taken to England.

ii. The site was sacred since at least the 6th century BCE, when a temple dedicated to Athena was built there.

iii. Built during the golden age of Athens, Pericles initiated and oversaw the construction which lasted for about 50 years. Phidias was the chief sculptor, and Iktinos and Kallicrates were the architects.

iv. The Acropolis plan shows the many temples and shrines located at the site. The north side housed temples of

earlier sects and gods, while the south side temples were dedicated to Athena.

v. The Parthenon embodies the Greek ideals of perfect proportions. The outer perimeter has a colonnade of Doric columns, the number of which is based on the formula $x = 2y + 1$. It originally housed a very large statue of Athena that is now lost.

vi. As found in all Greek architecture, architectural order governs not only the columns but also the relationship among all of the components of the structure. This reflects the emphasis on symmetry and harmony.

vii. This was built as a tribute to Athena for victory over the Persians following the Battle of Thermopylae (the Persians had burned Athens during the Persian War).

viii. The pediment are actually believed to be a metaphor for Athens beating Poseidon, alluding to the Athenian defeat of the Persians on water during the last battle.

ix. The Doric columns were made to bend in slightly and widen in the middle to create an optical illusion of perfection and height.

x. Helios, horses, and Dionysus came from the east pediment of the Parthenon and were part of a cycle depicting Athena's birth. Typical of classical style, the reclining male nude is naturalistic yet idealized.

xi. The Plaque of the Ergastines was from the frieze that decorated the exterior of the Parthenon. It depicts a high point of the Panathenaea festival that was held every four years in Athens, when six ergastines (the young women responsible for weaving the new peplos for the Athena statue) approached the statue.

xii. The Temple of Athena Nike was built over the remains of an earlier temple dedicated to Athena that was demolished by the Persians in 480 BCE. A four-column Ionic temple, it was built during the Peloponnesian War on an outcropping so Athenians could pay homage to the goddess of victory without having to climb.

xiii. Victory adjusting her sandal was originally located on the parapet of the Temple of Athena Nike and was meant to be seen from below. It is a high-relief marble that employs the Classical Greek wet drapery style that both

covers and displays the female form through elaborate folds of fabric that cling to contours of the figure as if they are wet.

Image 36. Grave stele of Hegeso. Attributed to Kallimachos. c. 410 BCE. (Classical Greek). Marble and paint.

i. Found in a public cemetery, this low relief grave stele depicts a noblewoman and her servant.

ii. The depiction illustrates the respected role that women played in the ancient Greek family.

iii. In Classical Greek style, the women wear robes that are revealing yet concealing, also known as the wet drapery style.

Image 37. Winged Victory of Samothrace. c. 190 BCE. (Hellenistic Greek). Marble.

i. This monument was probably an offering to commemorate a naval victory. The goddess of Victory is alighting on the prow of a ship with a strong wind blowing through her robe.

ii. It was originally placed in a rock niche dug into the hillside overlooking the theater of the Sanctuary of the Great Gods on the island of Samothrace. The original work probably featured a pool below it.

iii. The right side is much less detailed because the original placement allowed a limited view from the front left side.

iv. This piece embodies the Hellenistic style, which emerged after Alexander of Macedon ("Alexander the Great") conquered Persia in 334 BCE and brought new ideas to Greek art.

v. Hellenistic works were meant to make the viewer feel something and are identifiable as being more dramatic and engaging to the viewer.

vi. The wet drapery is reminiscent of the Classical style, but the drama and movement of the piece is entirely Hellenistic.

Image 38 (three images). Great Altar of Zeus and Athena at Pergamon. Asia Minor (present-day Turkey). c. 175 BCE. (Hellenistic Greek). Marble.

i. The altar and high-relief frieze were part of the Pergamon Acropolis and commemorate the victory of Zeus against

the giant sons of Gaia, Mother Earth, establishing a patriarchal culture.

ii. The victory of the gods over the titans was a reference to the Greek victories over the Gauls and the Persians.

iii. This piece embodies the characteristics of the Pergamene style including the depiction of dramatic suffering, the complicated composition, and the naturalistic figures in motion.

iv. The frieze makes visual reference to at least two earlier Classical works, one of which was part of the Parthenon, and was influential to many sculptors in antiquity.

v. The altar is a rare surviving example of the use of the golden ratio, 1:2.25, the same ratio used in the Parthenon.

Image 41. Seated Boxer. c. 100 BCE. (Hellenistic Greek). Bronze.

i. This is a rare surviving bronze sculpture from ancient Greece. It survived because it was deliberately buried, keeping it safe from the Romans.

ii. Created in the Hellenistic style, this work revisits a common theme of the Classical period while incorporating the dramatic emotion of the Hellenistic style.

iii. The battered face and body of the athlete along with the drama and intensity of emotion are hallmarks of the style. The realism of the period is in direct contrast to the idealized beauty of the previous era.

VII. ETRUSCAN ART OVERVIEW AND ARTWORKS FROM THE IMAGE SET

A. The Etruscans occupied the modern-day region of Tuscany in Italy.

B. By 351 BCE, Etruria was annexed by Rome, and the Etruscan style of architecture, along with that of ancient Greece, became the foundation of the Roman artistic tradition. Etruscan engineers pioneered the true arch before Rome adopted it and transformed it by using concrete.

C. Romans destroyed most Etruscan art and literature to reduce the importance of the Etruscan kings who had ruled the region. Most Etruscan art that remains was found below ground. Some Etruscan art was recorded by the Roman architect Vitruvius.

D. Nothing survives of the Etruscans' rich literary heritage except for Roman references to it.

E. The Etruscans had close contact with the Greek empire and were collectors of Greek vases, which were commonly used as funerary objects.

F. Etruscans were excellent metalworkers, especially in bronze, and they engaged in trade with many parts of the Mediterranean.

G. They believed in the same gods as those from Greece and Rome, but called them by Etruscan names.

Image 29. Sarcophagus of the Spouses. c. 520 BCE. Terra cotta.
 i. This sarcophagus was found in the Etruscan necropolis near Cerveteri, Italy. One of two surviving funerary complexes, the tombs and artworks found there provide the only surviving depictions of Etruscan daily life.
 ii. The elite reclining couple is depicted engaged in animated conversation while taking part in a banquet.
 iii. The work indicates that women of Etruria enjoyed more equality than their Greek counterparts, who would not have been depicted dining alongside a man.
 iv. The hand gestures and reclining pose were unique to Etruscan art and had a great influence on Roman sarcophagi.
 v. This work exhibits a more joyful approach to the afterlife than the funerary artwork of Ancient Greece.

Image 32. Tomb of the Triclinium. Tarquinia, Italy.
c. 480–470 BCE. Tufa and fresco.
 i. This tomb is from the Necropolis of Monterozzi, near Tarquinia, Italy.

ii. The fresco on the wall depicts a banquet scene and is reminiscent of scenes from red-figure Greek pottery of the period.

iii. Although Etruscan records do not exist, the frescoes lead many scholars to believe that, like Egypt, the Etruscans had strong beliefs in an afterlife.

Image 31 (three images). Temple of Minerva (Portonaccio Temple; Veii, near Rome, Italy) and sculpture of Apollo. Master sculptor Vulca. c. 510–500 BCE. Original temple of wood, mud brick, or tufa (volcanic rock); sculpture of terra cotta.

i. This is a rare surviving Etruscan temple dedicated to Menvra (Minerva in Rome, Athena in Greece).

ii. Etruscan temples differed from Greek temples. Although they used stone foundations, Etruscan temples were made of wood, mud brick, and terra cotta.

iii. Vitruvius wrote about Etruscan architecture in his work *De architectura* in the late 1st century BCE. Although the structures did not survive, the descriptions were highly influential on later Italian Renaissance architects.

iv. The original temple employed a 5:6 proportion and had a deep front porch with Etruscan columns.

v. The sculpture of Apulu (Apollo) is one of many that decorated the temple, originally placed on the ridge of the temple roof.

vi. Roofline sculpture and frontal porches are characteristic of Etruscan architecture. Also, Tuscan non-fluted columns are unique to the culture.

vii. The sculpture may have been made by Vulca, who was described by the Roman writer Pliny as having been summoned to Rome in the late 6th century BCE to produce terra cotta masterworks.

viii. The god is depicted as striding forward in an awkward pose, with an archaic smile, and is reminiscent of archaic Greek sculptures (which were influenced by Egyptian statuary).

 VIII. **ROMAN ART OVERVIEW AND ARTWORKS FROM THE IMAGE SET**

A. Although the Roman artistic tradition is based on Greek and Etruscan styles, a few technical innovations were entirely Roman.

B. Around 300 BCE, Roman architects began using a mixture of lime mortar, volcanic sand, water, and small stones to create segments of buildings. This is referred to as the concrete revolution.

C. This technical innovation allowed Roman architects to create domes, barrel vaults, and groin vaults. Aqueducts used to move water throughout the Roman Empire would not have been possible without concrete.

D. Christianity was born within the Roman Empire, although it was not practiced legally until 313 CE when it was legalized by Emperor Constantine. In 346 CE, pagan worship was outlawed, ending hundreds of years of polytheism in the Mediterranean.

E. Christian art was primarily covert until its legalization. As a result early Christian artists adopted iconography and symbolism already established within Roman art such as wings on angels, halos (from depictions of Apollo), Jesus clothed in a purple robe, etc.

F. The descent of the empire was gradual. In 393 CE, it was split along east-west lines and was never reunited.

G. Roman artistic styles changed dramatically over time. Veristic Republican period art that extolled the virtues of age and seriousness gave way to idealized Imperial art used for propaganda purposes. Late Imperial art is chaotic and reflective of destruction and frequent warfare.

Image 39 (three images). House of the Vettii. Pompeii, Italy. c. 2nd century BCE. (Imperial Roman) rebuilt 62–79 CE. Cut stone and fresco.

 i. The plan is typical of elite city homes of the Roman Empire. Houses in cities were built to take advantage

of natural light and air inside of the structure, utilizing courtyards and atria.

ii. Exterior windows were almost nonexistent to keep out the noise and filth of the street.

iii. The atrium of this house served as one of two central areas open to the sky with rooms connected to it, allowing natural light and air into the rooms.

iv. The frescoes contain graphically sexual scenes. Many scholars believe that this kind of artwork was popular among Pompeii's nouveau-riche elite. The owners of the house are believed to have been slaves early in their lives who became wealthy through industry.

v. Scholars have used the frescoes to study the transition from the third to the fourth style of painting in Rome.

vi. The lack of external views necessitated painting on the inside of villas, revealing advanced painting techniques such as atmospheric perspective.

Image 40. Alexander Mosaic from the House of the Faun, Pompeii, Italy. c. 100 BCE. (Republican Roman). Mosaic.

i. Originally found on the floor of a wealthy merchant's home, this mosaic is an example of a common style of floor decoration.

ii. Most scholars believe that it depicts a battle between Alexander of Macedon ("Alexander the Great") and the Persian King Darius III.

iii. Some believe that it was based on a now lost mosaic. Others believe it was based on a monumental Hellenistic Greek painting, mimicking that style when it was at its height.

iv. The spears in the image point to Alexander to reinforce his impending victory.

Image 42. Head of a Roman patrician. c. 75–50 BCE. (Republican Roman). Marble.

i. During the Roman Republican period, prestige came with age. An older, wrinkled face was revered for its exhibition of morality, courage, and experience as well as for the age and wisdom needed for participation in the Senate.

 ii. Family ancestry was important to Romans, and veristic (very realistic) portraits of grim-faced older men became a popular way of honoring distinguished family members.

 iii. Busts like these were proudly displayed in elite homes. Wax versions were carried during funeral processions.

 iv. The realistic and dramatic style was borrowed from the Greek Hellenistic style, while the idea of portrait heads came from an old Etruscan tradition.

Image 43. Augustus of Prima Porta. Early 1st century CE. (Imperial Roman). Marble.

 i. This is one of 300 portraits commissioned by Augustus during his 41-year reign.

 ii. In contrast to the earlier Republican portrait style, he preferred idealized youthful portraits of himself and his family that recalled the earlier Classical period of Greece.

 iii. The older, veristic style of portraiture fell out of favor during this period.

 iv. This is one of the earliest examples of art used for propaganda. Augustus displayed portraits of himself and his family all over the empire, evoking ideas of divinity and never-ending youth.

 v. This artwork, along with others like it, was used as propaganda to solidify his rule. Devices used included: his depiction as eternally youthful (affording him god-like qualities that allude to his divine right to rule); his bare feet (symbolizing his humility); his conservative haircut; his military garb with intricate breastplate (symbolizing his strength as a military leader); and his taking the pose of an orator.

 vi. The style is directly related to the classical Greek work *Doryphoros* by Polykleitos, which visually linked him to an earlier age of beauty and wisdom.

 vii. The inclusion of Cupid served as a proclamation of Augustus's divine ancestry and as a testament to the approval given to him by the gods.

Test Tip

Depictions of royal figures and emperors reflect the beliefs of the people governed. It is important to understand how beliefs were both reflected and shaped by these artworks.

Image 44 (two images). Colosseum (Flavian Amphitheater).
Rome, Italy. 70–80 CE. (Imperial Roman). Stone and
concrete.

i. Rome's largest amphitheater was begun under the
direction of Vespasian and finished under his son Titus.

ii. It was built for the citizens of Rome on the site of an
artificial lake created by the infamous Nero. The Flavian
rulers who created the structure were warriors who
wanted to please the people with gladiator battles.

iii. The structure was named for the location near Nero's
Colossus, a massive bronze statue.

iv. It had seats for 50,000 spectators and was used for
gladiatorial combats, mock sea battles, animal hunts,
executions, and dramas. An intricate drainage system
allowed the arena to be flooded for naval battles.

v. The columns use all three Greek orders, with Doric on
the first story, Ionic on the second, and Corinthian on
the third. The use of three levels later set the standard
for Roman buildings, including private homes. The
columns are purely decorative and serve no structural
purpose.

vi. Structural integrity came from barrel-vaulted arches made
of concrete. This set the standard for modern arenas.

vii. Roman engineers developed the velarium, used for shade
for the elite who sat in the topmost section.

viii. The bronze and marble began to be stripped away and
the numerous decorative sculptures stolen around
523 CE, when later emperors, embodying new Christian
ideals, declared it obsolete.

Image 45 (four images). Forum of Trajan. Rome, Italy.
Apollodorus of Damascus. Forum and markets:
106–112 CE; column completed 113 CE. Brick and
concrete (architecture); marble (column).

i. This forum was the largest and last imperial forum built in
Rome.

ii. Earlier forums created during the Republic (Forum
Romanum) were created for civic use. Imperial Roman
forums like this one were created for emperors to
celebrate their own greatness (starting with Caesar and
ending with Trajan).

iii. The complex, containing an enormous basilica, two libraries, a market, and a large temple, formed the political and governmental center of the Roman Empire.

iv. The basilica was a Roman invention, which was later adopted by Christians for worship (St. Peter's is an example).

v. The Column of Trajan was built in a small courtyard between the two libraries, one of which held Greek works and the other Latin works. It is decorated with a spiraling bas-relief frieze that commemorates Trajan's victory over the Dacians.

vi. The Market of Trajan is a six-story complex containing shops, offices, and depots. It was unequalled at the time and may be compared to a modern day shopping center.

vii. The Basilica Ulpia was a colossal structure with five naves divided by colonnades and a coffered ceiling.

Image 46 (two images). Pantheon. 118–125 CE. (Republican and Imperial Roman). Concrete with stone facing.

i. This is one of the best preserved of all Roman buildings and has influenced many famous architects from different time periods, including Michelangelo and Thomas Jefferson.

ii. It was first built under the direction of Marcus Agrippa as a commemoration of the victory over Egypt's Cleopatra and her Roman lover Mark Antony. It was rebuilt by the Emperor Hadrian, who dedicated it to all of the Roman gods after it was destroyed by fire.

iii. The oculus in the center of the dome served as a means for escape for the smoke from sacrificial burnings. It also allowed light to enter the windowless temple.

iv. The coffered ceilings were developed as a way to relieve the weight of the large dome with the oculus at the top.

v. The front, which is reminiscent of Greek temples, is reflective of Hadrian's interest in Greek culture. Hadrian was the first emperor to be shown wearing a beard in the Greek style, which later emperors followed.

vi. The circle and square exterior and interior mirror the Greek obsession with balance and perfection or harmony.

vii. In 609 CE, after 300 years of disuse, the Pantheon was consecrated as a church. As a result it was saved from the destruction other Roman buildings underwent during the early medieval period.

Image 47. Ludovisi Battle Sarcophagus. c. 250 CE. (Late Imperial Roman). Marble.

i. The style is the opposite of the rational and realistic classical sculpture that was favored in previous periods.

ii. The lack of realistic space and the dramatic and emotional subject matter makes it stylistically typical for late Imperial Rome.

iii. The movement and density of the composition link it to Greek Hellenistic, especially Pergamene, sculptures.

iv. The young Roman military commander who is the central figure in the composition is believed to be the deceased.

v. The deep relief, created using drill work, evokes the chaos and intensity of a Roman-Barbarian battle.

EARLY EUROPE AND COLONIAL AMERICAS 200–1750 CE

Note: The image set for this chapter can be found on pages 57–85 of the College Board's *AP Art History Course and Exam Description.*

I. EARLY CHRISTIAN/LATE ROMAN PERIOD

A. Overview

1. Early Christian art refers to art created during the time when the religion was illegal, as well as the transitional period between the fall of the Roman Empire and the Middle Ages.

2. One of the central beliefs of Christianity focuses on the second coming of Christ sometime in the future, when he will raise the dead, conduct a final judgment of all people, and renew the world.

3. Early Christianity included the belief that the soul of a deceased person is judged soon after death, with the pious going to heaven and the evil going to hell.

4. Christianity spread gradually throughout the Roman Empire but remained illegal until Emperor Constantine's Edict of Milan in 313 CE made the religion legal.

B. Artworks from the image set

Image 48 (three images). Catacomb of Priscilla. Rome, Italy. Late Antique Europe. c. 200–400 CE. Excavated tufa and fresco.

 i. Christians could not initially practice their religion openly, so they built what wound up being over

 90 miles of underground catacombs, just outside the city of Rome, for the purpose of burial and worship. These catacombs were decorated with frescoes depicting Christian subject matter.

ii. Pagan Roman citizens cremated their dead, and wealthy Romans commissioned elaborate marble sarcophagi to house the deceased's ashes before burial or entombment. Early Christians did not believe in this practice and preferred to bury or entomb their unburned dead.

iii. For early Christians the tombs represented a temporary resting place until the final resurrection by Jesus.

iv. The Catacombs of Priscilla, named for the donor of the land, was used as a burial ground from the 2nd century until late in the 5th century CE.

v. More than 40,000 tombs, including those of seven popes, are located there. After the 5th century they were no longer used for burial, and the remains of the martyrs and saints entombed there were taken to churches all over Europe as relics.

vi. The Greek Chapel is a large cubicle that contains several frescoes done in the Pompeian style using red and green lines to separate stories and create the impression of architecture.

vii. The Orant Fresco depicts a woman with her arms raised. Early Christians adopted the orant, which was a pagan symbol for the soul, to refer to the soul achieving glory after death. The prominence of the image reflects the importance of faith and the afterlife.

viii. Jesus as the "Good Shepherd" was a recurrent theme on the walls of the catacombs. Early Christians saw the shepherd as a representation of Jesus, who will search for every wandering child of God. In this fresco, Jesus holds the lost sheep on his shoulders as two other sheep look on. The "Good Shepherd" was another symbol derived from the pagan world. This adoption of pagan symbols for a new Christian purpose is an example of syncretism.

ix. The story of Jonah, although of Jewish origin, was also a popular theme in the catacombs because his escape

from death was considered to be a precursor to the resurrection of Jesus.

x. Many of the images depicted in the Catacombs evolved into popular themes in Christian art, seen for over 2,000 years.

xi. Many of the catacombs are decorated with paintings done in lunettes (arch shaped formations in the wall). This use of arches and lunettes exemplifies Roman pagan architectural styles adapted for Christian use.

xii. Some of the earliest Christian symbols coincided with Roman pagan symbolism. This was a deliberate use of syncretism to conceal illegal religious symbols. Examples include Jesus portrayed as a Roman scholar, Daniel mistaken for Orpheus charming the animals, etc.

Image 49 (three images). Santa Sabina. Rome, Italy. Late Antique Europe. c. 422–432 CE. Brick and stone, wooden roof.

i. Considered to be the best example of an early Christian church, Santa Sabina was built on the site of the Temple of Juno Regina using many of the materials from the earlier pagan temple.

ii. The plan is typical of a Roman basilica of the 5th century CE with a tall spacious nave, large clerestory windows, coffered ceilings, and additional windows in the rounded apse and façade, allowing for a very bright interior. These Roman civic architectural elements were adopted for use in Christian churches.

iii. The 24 marble columns were reused from the earlier Temple of Juno as were the 18 panels of narrative carvings installed in the church's narthex. Included in these panels is the world's earliest crucifixion scene.

iv. Originally, a large number of mosaics decorated the church, most of which are now gone.

v. One of the few remaining original mosaics is the dedicatory inscription. It is important not only because it tells of the founder and date of origin, but also because it expresses the doctrine of papal supremacy, which was still in development at the time.

II. BYZANTINE

A. Overview

1. Emperor Constantine moved the capital of the Roman Empire to a major intersection of east-west trade, the ancient site of Byzantium. He renamed it Constantinople (now called Istanbul). Historians would later call the territory the Byzantine Empire but at the time it was known as Romania.

2. A strong desire to separate from the pagan past led to new forms of Christian artistic expression using less realism and more symbolism.

3. Small relief carvings used for personal devotion and glittering mosaics on the walls of churches became popular ways to evoke the glory of heaven.

4. In 1,054 CE, the first major split occurred in the Christian faith when the Roman Catholic Pope, who oversaw the western remnants of the Roman Empire, and the Patriarch of Constantinople, who oversaw the Eastern remnants of the Roman Empire, excommunicated each other over religious and cultural issues. One of the issues that leaders of Eastern and Western Christianity disagreed over was the popular use of icons as objects of veneration among Eastern Christians.

5. Both sides claimed ownership of the classical tradition.

6. From 726 to 787 and from 815 to 843, during periods of iconoclasm, icons were banned in the Byzantine Empire, and many important works of art were destroyed. In 843, icons were restored as acceptable objects of worship, and for another 400 years art and architecture flourished in the Byzantine Empire.

7. In the 7th century, the area known as Syria-Palæstina was lost to powerful Arab armies, but the decline of the empire began in earnest with The Latin Occupation of 1204–1261, causing the political fragmentation and displacement of Byzantine nobility. In the mid-15th century, the last of the empire fell to the Ottoman Turks.

8. During the steady loss of territory that took place from the 13th through the 15th centuries, many Byzantine artists fled to the West. They had a profound impact on the art of Western Europe during the medieval period and beyond.

Test Tip

Throughout time, many artistic styles from diverse cultures have influenced each other. For example, Byzantine art had a profound influence on Islamic art, and Islamic art was influential in the development of Gothic architectural style. You should be able to explain the many ways that this kind of influence has occurred.

B. Artworks from the image set

Image 50 (two images). Rebecca and Eliezer at the Well and Jacob Wrestling the Angel, from the *Vienna Genesis*. Early Byzantine Europe. Early 6th century CE. Illuminated manuscript (pigments on vellum).

 i. This is the oldest well-preserved illustrated manuscript.

 ii. The pages are calfskin dyed with imperial purple and decorated with silver ink.

 iii. Written in Greek, this manuscript was probably produced in modern-day Syria or Israel.

 iv. The pages are from a once-complete book of Genesis with the text written above the illustrations.

 v. The illustrations make use of continuous narration.

 vi. The style of the paintings exemplifies the transition from the idealized realism of the ancient Greek world to the spiritual and symbolic style of the Middle Ages evident in the clear emphasis on the narrative and symbolic aspects of the painting rather than on realism.

Image 51 (five images). San Vitale. Ravenna, Italy. Early Byzantine Europe. c. 526–547 CE. Brick, marble, and stone veneer; mosaic.

 i. This is a typical Byzantine centralized church that has an octagonal plan, with a two-story ambulatory enclosing a central space beneath a large cupola. Attached to the west side is a narthex with a small choir and apse attached to the eastern side.

 ii. It was begun when the area was under pagan Goth rule and completed when the Byzantine Empire retook Italy. The mosaics are a testament to the change in leadership.

 iii. The apse mosaic shows Jesus in the early Christian style (youthful and clean-shaven) sitting on the sphere of the

world and handing San Vitalis, who was martyred on the site, a martyr's crown. Also pictured are Bishop Ecclesius, who, inspired by the churches he saw during a trip to Byzantium, began the construction of the church while the area was still under Goth rule.

iv. The Justinian panel mosaic is a visual testament to Justinian's religious, administrative, and military authority over the entire empire and especially over re-conquered lands. He is positioned to the right of Jesus, crowned and wearing the purple imperial robe of Ancient Rome with a halo around his head.

v. On his left is the Bishop Maximianus, who consecrated the church, along with the nearby church of Sant Apollinare Nuovo. On Justinian's right are members of the imperial court and a group of soldiers, one of whom holds a shield with the chi-rho symbol on it, all alluding to Justinian's role as head of church, state, and military.

vi. Justinian holds the bowl and bread of the Eucharist, while the clergy carry a censer, a gospel book and a cross. Justinian's humble gesture can be seen as an act of deference to Jesus, the only authority higher than himself, who appears in the adjacent apse mosaic.

vii. The Theodora panel depicts Justinian's empress, who was originally employed as a courtesan and actress. She is depicted holding the communion cup, completing the Eucharist ceremony. The three magi embroidered on her robe visually link the Emperor and Empress to the biblical kings who brought gifts to the baby Jesus.

viii. She is placed directly across from Justinian yet slightly off center. Her position, along with the inclusion of a pulled-back curtain, symbolize her inability to take part in certain church rituals reserved for men.

ix. The commissioning of this mosaic was a continuation of the Roman propaganda tradition. Many scholars believe that Justinian and Theodora never actually visited San Vitale.

x. The use of gold and the non-realistic space taken up by the figures are both typical of the Byzantine style.

Image 52 (three images). Hagia Sophia. Constantinople (Istanbul). Anthemius of Tralles and Isidorus of Miletus. 532–537 CE. Brick and ceramic elements with stone and mosaic veneer.

i. In 532, Emperor Justinian asked his imperial architects and mathematicians, Anthemius of Tralles and Isidorus of Miletus, to design a fireproof church to replace the 200-year-old one, originally built by Emperor Constantine, that had twice burned down.

ii. They used classical Roman construction methods to build a rectangular nave covered by a dome, which is just slightly smaller than that of the Pantheon in Rome, and which is carried on pendentives, which were a major architectural innovation conceived by Byzantine architects.

iii. The interior is heavily decorated with mosaics.

iv. For almost 1,000 years, the Hagia Sophia was the seat of the Orthodox Patriarch of Constantinople. Under the Ottoman Turks it became a mosque in 1453, and minarets were constructed on the outside of the structure.

v. On the inside, some of the Christian mosaics were replaced by Arabic inscriptions while others were left intact.

vi. In 1935, it became a museum of the Turkish Republic. The government of Turkey is debating converting the structure back into a church or possibly a mosque.

Image 54. Virgin (Theotokos) and Child between Saints Theodore and George. Early Byzantine Europe. Sixth or early 7th century CE. Encaustic on wood.

i. The Monastery of Saint Catherine, built during the reign of Justinian, is located in Egypt, at the place believed by Christians to be where God appeared to Moses.

ii. It is the oldest continuously inhabited Christian monastery, built on the site of the Chapel of the Burning Bush, which was constructed during the time of Constantine.

iii. According to the Koran, a letter of protection was given to the monastery by Mohammed. When Arab armies

conquered the territory, early in the 7th century, this was the only Christian site spared.

iv. In early representations, Mary was given the title of Theotokos, or god-bearer by Eastern Christians.

v. In this icon, Mary is depicted as the physical embodiment of the throne of wisdom with the infant Jesus on her lap.

vi. In typical Byzantine fashion she is the symbol of purity, with large eyes, a small mouth, and her hair and body concealed beneath a blue robe.

vii. The angels depicted behind the four holy people look upward toward the heavenly world.

III. ART OF THE WARRIOR LORDS/HIBERNO SAXON

A. Overview

1. After the death of Emperor Constantine, many western territories of the Roman Empire were lost to the numerous indigenous and migrating tribes of Europe.

2. The art of this period is a blending of the antique Roman style and the native tribal styles.

3. The Anglo-Saxons, who resided in modern-day Britain, contributed abstract depictions of animals and figures while the Celts contributed interweave or interlace designs.

4. Hibernians resided in modern-day Ireland, an area that was never conquered by Rome. The unique style of the Hibernians was a result of this isolation.

5. The majority of people in Western Europe during this time were illiterate, and monasteries became central repositories for books and documents, as well as for learning and literacy.

6. Most of the artwork that has survived from this period was linked to the Church, including illuminated manuscripts, reliquaries, and small sculptures. These works exhibit a blending of native styles brought by nomadic tribal groups with Roman Christian iconography.

B. Artworks from the image set

Image 53. Merovingian looped fibulae. Early medieval Europe. Mid-6th century CE. Silver gilt worked in filigree, with inlays of garnets and other stones.

 i. Intricate brooches (referred to as fibulae in the Roman regions), commonly made of bronze and iron and sometimes made of gold or silver with inlaid jewels, were used to fasten clothing, especially cloaks, in a time when buttons did not yet exist.

 ii. Although they were a practical item, those made of precious materials were also used as symbols of rank and were included in burials, along with other treasures and practical items.

 iii. These small, portable, and highly decorative items were highly valued by many people during this migratory period.

 iv. This pair comes from a wealthy woman's grave in France (then known as Gaul) during a time when the Merovingian dynasty ruled and Christianity had recently been embraced by the Frankish leaders (originally German nomadic invaders) of the region.

 v. The style of the work is typical of the period, employing intricate filigree designs, precious gem inlays, and zoomorphic elements (known as animal style).

Image 55 (three images). *Lindisfarne Gospels*: **St. Matthew, cross-carpet page; St. Luke portrait page; St. Luke incipit page.** Early medieval (Hiberno Saxon) Europe. c. 700 CE. Illuminated manuscript (ink, pigments, and gold on vellum).

 i. The British Isles consisted of many small kingdoms, each of which was ruled by a territorial king. Christianity arrived in the 6th century, and two major sects of Christianity helped convert scores of pagans.

 ii. The Celtic church in the north favored monastic rural life, while the Roman Catholic Church in the south was more conscious of discipline and moderation.

 iii. The illuminated manuscript known as the Lindisfarne Gospels was made and used at Lindisfarne Priory on Holy Island. Most illustrated manuscripts were made by a team of people; however, this one is the work of one man, a monk called Eadfrith, who was Bishop of Lindisfarne

from 698–721 CE. When he died, the work remained unfinished in some sections.

iv. The St. Luke portrait page was the opening page of the gospel of Luke. The style is typical of the early medieval period, favoring religious symbolism over realism. The decorative corners reflect the interlace patterns of the native tribal style.

v. The cross-and-carpet page of St. Matthew follows the portrait of Matthew in the gospel of Matthew. The fact that it looks like a carpet may be a reference to prayer mats, which were used in the region to prepare worshippers for prayer.

vi. The cross-and-carpet page help prepare the reader for the gospel message they are about to read. Each one contains a different form of the cross and uses the interlace patterns found on metalwork of the time.

vii. The incipit page of St. Luke is an opening page, in which the first letters of the text of the gospel are elaborately decorated using interlace and spiral patterns reminiscent of Anglo-Saxon metalwork and cloisonné.

IV. AL-ANDALUS/ISLAMIC ART

A. Overview

1. From 711–1492 CE, most of modern-day Spain and Portugal (known as Al-Andalus to inhabitants) was under Muslim or Moorish control. Christians and Jews were welcome to coexist with Muslims albeit with restrictions.

2. The cultural diffusion that resulted is regarded as one of the great heights of civilization in Europe during which libraries, colleges, and public baths were created and literature, poetry, and architecture flourished.

3. The artistic tradition of Islamic Spain had a prescribed aesthetic influenced by the conquered regions (Roman, tribal, Byzantine, and West Asian styles).

4. Artists creatively used Arabic calligraphy as a form of ornamentation, and the use of images of people and animals were discouraged due to religious beliefs.

5. The use of complex geometric or vegetal-inspired patterns was common. Symmetry and mathematical order were aesthetic qualities linked to religion.

B. Artworks from the image set

Image 56 (five images). Great Mosque. Córdoba, Spain. Umayyad. c. 785–786 CE. Stone masonry.

 i. Cordoba became the cultural capital of the region. Manuscripts from the ancient Greek and Roman world were studied and kept safe there while the rest of Europe ignored or burned them.

 ii. Built on the site of a Roman temple that had been converted into a church and then a mosque, the structure was completely rebuilt and subsequently expanded over 200 years.

 iii. The builders incorporated ancient Roman columns when creating the two-tiered symmetrical arches. They are a distinctive feature of the hypostyle prayer hall.

 iv. Horseshoe arches were a common feature of structures of the region built by the previous rulers, the Visigoths. They became a common feature of North African Islamic architecture.

 v. The building plan also included a courtyard with a fountain, an orange grove, and a covered walkway circling the courtyard.

 vi. Today the Great Mosque is a Catholic Church, and the original minaret is encased in a bell tower.

 vii. The use of crisscrossing ribs that make up the dome over the Mihrab are a precursor to the Gothic rib vaulting of Western Europe.

Image 57. Pyxis of al-Mughira. Umayyad. c. 968 CE. Ivory.

 i. This cylindrical box with a separate lid (known as a pyxis) was produced by a well-known workshop called Madinat al-Zahra.

 ii. It may have been a coming-of-age present from supporters to then 18-year-old al-Mughira, the brother of the Caliph (ruler), 'Abd al-Rahman III, who did not have an heir at the time.

 iii. This container is considered to be one of the most magnificent ivory carvings ever produced and is part of

a tradition of courtly luxury crafts. Similarly styled carved objects come from the Byzantine, Carolingian, and Ottonian courts of Christian Europe.

iv. The decorations contain a mix of princely iconography, moralizing imagery, symbolism alluding to sovereignty, and imagery alluding to punishment.

v. Scholars believe it was either an invitation to seize power by high officials of the court or a warning of punishment from supporters of the true line of succession.

vi. A pyxis, like many of the small ivory carvings produced at the time, is meant to be held and studied at close range.

vii. Eight years after the creation of this gift the owner was put to death when his brother, the Caliph, died.

Image 64 (three images). Golden Haggadah (The Plagues of Egypt, Scenes of Liberation, and Preparation for Passover). Late medieval Spain. c. 1320 CE. Illuminated manuscript (pigments on vellum).

i. This illustrated manuscript was made for use by a wealthy Jewish family residing in Barcelona, Al-Andalus. Many Jewish families resided peacefully alongside of Muslim citizens in the region.

ii. The book is used exclusively during the holiday of Passover and contains prayers and readings specific to the holiday.

iii. Haggadahs of the time were the most lavishly decorated of all Jewish sacred writings. Wealthy Jewish families of the time often demonstrated their good taste, wealth, and piety by commissioning works like this one.

iv. The pages are traditional vellum with heavy use of gold leaf in the backgrounds of the 56 small paintings.

v. The owner may have been an advisor, physician, or financier to the Counts of Barcelona and may have become enamored with courtly tastes.

vi. Many commissioned Jewish books of the time period reflect decorations done in the Gothic (European Christian) style.

vii. Though the Hebrew text was written by a Jewish scribe, the decorations are likely the work of European Christian artists given specific instructions by the scribe or patron.

viii. Like most Christian illuminated manuscripts of the period, the clothing and architectural elements in the paintings are in the modern style (for the time) allowing the readers to connect the biblical stories to their own lives.

ix. This idea reflects the tradition of personally connecting with the past by imagining oneself as a slave in Egypt, a ritual of Passover.

Image 65 (four images). Alhambra Palace. Granada, Spain. Nasrid Dynasty. 1354–1391 CE. Whitewashed adobe stucco, wood, tile, paint, and gilding.

i. The Alhambra was originally built as a fortress due to increasing conflict with Christian European monarchs and became a palace and small city under Islamic rule.

ii. The Court of the Lions with its adjoining side rooms and upper galleries was the innermost and most private courtyard of the palace when the region was under Islamic rule.

iii. A fountain with 12 lions provided water to four streams that broke the courtyard up into four equal segments with two small fountains at each end of the patio.

iv. Water features in Islamic architecture are meant to evoke imagery of oasis pools in the Arabian Desert. The filigree muqarna (honeycomb) arches above the small fountains are deliberately reminiscent of palm trees that allow light to pass through them, creating water-like patterns.

v. The Hall of the Sisters is a two-storied hall with walls completely covered in decoration. Like most Islamic architecture, the decorations feature geometric, floral, and vegetal patterns.

vi. Calligraphic borders, also common in Islamic architecture, are interspersed in the designs. A muqarna dome with over 5,000 cells allows light into the room through 16 latticed windows at the base.

vii. In 1492, when Catholic monarchs Ferdinand and Isabella conquered the city of Granada, the palace became a Christian court. Additional structures, including a church and monastery, were added. An additional palace was added by Emperor Charles V.

V. ROMANESQUE

A. Overview

1. In the 11th and 12th centuries Europe experienced economic growth, political stability, and an increase in population.

2. A prevalent belief in the apocalypse around the turn of the millennium led to relief when it did not occur. Nevertheless, Last Judgment scenes became popular decorations for the doors of churches.

3. Those who could not take part in the Crusades often went on pilgrimage tours. Large churches were built to accommodate the growing Christian population and large numbers of pilgrims while still allowing for regular Christian religious services.

4. Architects adapted the Roman basilica style to fit the new needs. They used the nave, barrel vault, transept, aisles, and apse of the early Christian style, but added ambulatories and radiating chapels to house sacred relics. Fireproof stone roofs were a necessity.

5. After the fall of the Roman Empire, the technique of making cement was lost, so churches were built using only stone and mortar.

6. For the first time since antiquity, large sculptures adorned façades, doorways, and capitals again.

7. The tympanum was invented to display biblical scenes over doorways, especially scenes depicting the Last Judgment. These were usually in the early Christian style, as they were more symbolic than realistic. These artworks conveyed important Christian ideas to a mostly illiterate population.

8. Mary became an important figure in religious art during this period. Images of her were inspired by the Byzantine Theotokos images. She was usually depicted as the queen of heaven, and her image often represented the Catholic Church.

9. Churches were made to be other-worldly places. People who could not read were able to learn from the many decorations depicting well-known Bible stories and important concepts about heaven and hell.

10. During this period more artists began to sign their work.

11. The Romanesque style is a mixture of Antique Roman (in the use of Roman style architecture, but minus the concrete construction) combined with the Insular Style (in the use of interlace and abstract animals) and the Byzantine style (seen in the emotional depictions of biblical stories and the bodies hidden under drapery).

B. Artworks from the image set

Image 58 (four images). Church of Sainte-Foy.
Conques, France. Romanesque Europe. Church: c. 1050–1130 CE; Reliquary of Saint Foy: 9th century CE, with later additions. Stone (architecture); stone and paint (tympanum); gold, silver, gemstones, and enamel over wood (reliquary).

i. This pilgrimage church is located high in the Pyrenees Mountains between Spain and France along the route to Santiago de Compostela in Spain.

ii. It was originally an abbey, but only small parts of the monastery still exist.

iii. Like most pilgrimage churches it has a cruciform plan with a barrel-vaulted nave lined with interior arches. The plan was symbolic and helped control the crowds of pilgrims by providing a route through the church toward the apse where radiating chapels holding saints' shrines could be visited. A door in the transept allowed for an easy exit after making ablutions.

iv. The Last Judgment scene on the tympanum above the main entrance provided an important message to worshippers.

 a. In the center the figure of Jesus enthroned sits in judgment with right hand upraised and left hand down.

 b. Mary, Peter, and an entourage of saints stand on Jesus' right side above a symbolic representation of the house of paradise holding the saved.

 c. The hand of god is visible pointing to a kneeling Saint Foy (Faith)

 d. Below Jesus, angels open graves allowing the dead to be judged. On Jesus' right, a carved door opens to Paradise. On his left, a monster's open mouth leads to Hell.

e. The symbolic house of Hell is a chaotic scene presided over by a monstrous devil, also enthroned.

f. Each of the damned represents a particular sin and was meant as a warning to worshippers and clergy.

v. The reliquary of Saint Foy is one of the most famous in Europe and was the object pilgrims came to see.

vi. Saint Foy was a young girl who was martyred for refusing to sacrifice to the pagan gods of Roman Gaul (France), and she was one of the most popular saints in southern France, ensuring the town of a steady stream of income from pilgrims.

vii. During this time period, large three-dimensional representations were not trusted due to an association with the pagan idolatry of the past, while smaller sculptures were tolerated.

viii. This reliquary, which holds the remains of the martyr, although small, was unusually sumptuous for the time period. Many of the precious gems, antique cameos, and intaglios were donated by pilgrims and were added to the artwork.

ix. The head may have come from a Roman sculpture of a child repurposed to signify the victory of Christianity over paganism.

Image 59 (two images). Bayeux Tapestry. Romanesque Europe (English or Norman). c. 1066–1080 CE. Embroidery on linen.

i. This embroidery may have been made in England or in France and was probably commissioned by Bishop Odo of Bayeux, the half brother of William the Conqueror.

ii. The Bayeux Tapestry tells the story of William the Conqueror, leader of the Normans, whose army won a victory over Harold II, leader of the Saxons, at the Battle of Hastings in 1066.

iii. William the Conqueror's conquest brought England under the control of a French court. Members of the aristocracy of England either submitted to King William or lost their holdings and fled abroad.

iv. The Bayeux Tapestry is considered to be the best historical record of medieval warfare and clothing, as well as customs.

 v. William the Conqueror brought both the feudal system of government and the Romanesque style of art and architecture to England when he conquered the region.

 ## VI. GOTHIC

A. Overview

 1. Gothic architects used novel devices to reach new heights and to create architecture that would allow worshippers to have a more transcendental experience than ever before.

 2. The style was heavily influenced by the voyages undertaken during the Crusades when Byzantine and Islamic architecture were viewed in situ.

 3. Pointed arches were devised in order to reach new heights in the nave area of the church. Flying buttresses were one of the defining architectural innovations of the era, invented in order to stabilize the pointed arches.

 4. Walls became much thinner due to greater incorporation of windows, which brought in more light and created a stronger association with heaven.

 5. Ribbed vaults carried the weight of the roof and allowed the walls to be opened up in order to make larger windows.

 6. Stained glass became the norm for filling these large windows. Since they were not structural, they had to be reinforced with crossbars. They served several purposes including depicting biblical and historical stories to the illiterate masses and providing colored light to the interior of churches, which created a mystical atmosphere.

 7. Towns all over Europe began to compete to reach new heights. In some cases, the height was too great. When Beauvais Cathedral collapsed in 1281 due to its inordinate height, it was rebuilt at a shorter scale. The new height set the standard for all future Gothic cathedrals.

 8. Stone masons who worked in the Gothic style traveled around Europe looking for work. This helped disseminate the French Gothic style.

 9. Gothic sculptural decoration was deeply rooted in classical art.

10. Jamb sculptures evolved throughout the period until they became almost three-dimensional. As classical philosophies were rediscovered during the Crusades, sculptures emerged from the walls in increasingly greater relief.

11. A new realism emerged that had not been seen since antiquity. This style was the precursor to the classical realism of the Renaissance.

12. The contrapposto pose returned to sculpture, but was less natural than in antiquity. In Gothic art the pose is usually called the Gothic S-curve.

B. Artworks from the image set

Image 60 (six images). Chartres Cathedral (Notre-Dame de Chartres). Chartres, France. Gothic Europe. Original construction c. 1145–1155 CE; reconstructed c. 1194–1220 CE. Limestone, stained glass.

 i. This church was an important Marian pilgrimage center that housed the tunic (Sancta Camisa) of Mary, said to have been given to the church by Charlemagne after a trip to Jerusalem.

 ii. The original cathedral was destroyed in 1020 and a Romanesque one replaced it. When that one burnt down in 1194, a new Gothic cathedral was built that preserved the earlier Latin cross plan.

 iii. The older crypt, west towers, and west façade were incorporated into the new building, which took 26 years to complete.

 iv. This is one of the first buildings to use flying buttresses to create a high nave and clerestory windows.

 v. The famous Black Madonna housed there originates from an earlier Druid shrine found on the site. It is a depiction of a woman with a child on her knees that originates from pre-Christian times. The crypt of the cathedral contains an ancient Druidic dolmenic chamber reported to be a place of power that originates from the magnetism of the Earth.

 vi. Many scholars believe that the proportions of this Templar cathedral are related to the Temple of Solomon in Jerusalem.

vii. The west portal, known as the Royal Portal, was completed by 1150. The jamb sculptures depict kings, queens, and figures from the Old Testament and are modeled after those at St. Denis.

viii. The sculptures are full of expression, gazing down on the visitor with condescension. These are a visible transition from Romanesque to Gothic. The elongation of the figures is in the Romanesque style while the realistic and emotive faces are in the Gothic style.

ix. The central tympanum is a typical Romanesque Last Judgment scene with Jesus enthroned in a mandorla (halo) holding the book of life and with his right hand raised in blessing to all who enter the cathedral. Symbols of the four evangelists surround him.

x. The left portal depicts the ascension of Jesus with symbols of the zodiac and labors of the months on the archivolts. The right portal depicts the descent of Jesus into the Earthly world.

xi. The life of Mary is depicted on the capitals of the columns on the left portal and on the register below the right tympanum. Scenes from the life of Jesus are depicted on the capitals of the right side columns.

xii. The Notre Dame de la Belle Verrière (Our Lady of the Beautiful Window) was one of the few windows to survive the fire that destroyed the earlier version of the cathedral.

xiii. The stained glass window depicts Mary as the Queen of Heaven sitting on a throne with a young Jesus on her lap. The smaller panels depict the stories of the Temptation of Christ and the Miracles at Cana.

xiv. Depictions of Mary as the Queen of Heaven were very popular during this period. They serve to visually link the monarchs of Europe with Mary and Jesus. Mary was also thought of as the patron saint of all mothers.

Image 61 (two images). Dedication Page with Blanche of Castile and King Louis IX of France and Scenes from the Apocalypse, from a *Bibles moralisée* (moralized bible). Gothic Europe. c. 1225–1245 CE. Illuminated manuscript (ink, tempera, and gold leaf on vellum).

i. Louis IX of France, commonly known as Saint Louis, was the only king to be canonized as a saint.

ii. He was an avid collector of books such as this costly moralized Bible, an illuminated manuscript containing selections of Biblical text with commentary and illustrations explaining the moral significance of the selections.

iii. As with most illuminated manuscripts of the period, the people are depicted in contemporary clothing.

iv. The dedication page depicts Saint Louis' mother, Queen Blanche of Castile, with her son in an architectural frame reminiscent of those seen on cathedral reliefs and on stained glass windows. This symbolizes Queen Blanche passing her Christian morals to her son so he can be a proper ruler.

v. Below them, in another frame, the monks who made the book are depicted engaged in their craft.

vi. The Scenes from the Apocalypse illumination accompanied verses from the book of Revelation.

vii. The bright colors and rondels were influenced by stained glass windows of the period.

Image 62. Röttgen Pietà. Late medieval Europe (Middle Rhine, Germany). c. 1300–1325 CE. Painted wood.

i. This is one of the first artworks to depict Mary holding her dead son following his descent from the cross.

ii. The work was made in Germany during a time of extreme suffering due to famine, war, and plague.

iii. The work is deliberately hideous, depicting Jesus as human and vulnerable and Mary as distraught. People who looked at this work were meant to feel a connection to their own suffering.

iv. Since many people were still distrustful of any beautiful three-dimensional imagery, an ugly, rather than pleasant, depiction of Jesus and Mary was considered to be a more pious way to connect to the figures.

v. Later, in Italy, Michelangelo used this northern form to create a completely different version of the theme.

VII. LATE MIDDLE AGES/PRE-RENAISSANCE

A. Overview

1. In 1204 Latin armies sacked Constantinople and took many valuable devotional objects to Italy and France. These objects, especially the icons, influenced Italian art of the period and had a far reaching impact.

2. Developments of this time period became the precursors to the Renaissance, including an emphasis on volume and spatial representation, an emphasis on value used to create form, and an emphasis on narrative

3. The French Gothic style was also influential to the art of Italy during this time period including French Gothic architectural motifs such as the pointed arch, increased naturalism in figures, and an emphasis on fluid forms.

B. Artworks from the image set

Image 63 (three images). Arena (Scrovegni) Chapel, including Lamentation. Padua, Italy. Unknown architect; Giotto di Bondone (artist). Chapel: c. 1303 CE; Fresco: c. 1305. Brick (architecture) and fresco.

 i. Giotto trained under Cimabue in Florence and is considered by many to be the father of modern European painting. Many scholars believe he was the architect of the chapel due to the ideal surface for the fresco cycle.

 ii. Giotto created a new kind of pictorial space incorporating realistic depth and using value to create realistic volume in the figures.

 iii. At the time of the commission, Giotto was considered to be the greatest painter in Florence.

 iv. Enrico Scrovegni, the patron, had the chapel constructed both as a way to make up for his father's reputation as a usurer (money lender), which had been written about in Dante's *Inferno*, as well as a means of showing off his family's wealth in an attempt to gain status. The theme of usury is worked into several of the scenes in the cycle.

 v. The patron wanted the chapel to be decorated with scenes from the life of Mary and Jesus. As was customary

for the time, the patron is depicted in the work giving the chapel to Mary.

 vi. While Giotto's early work is more influenced by the pre-Renaissance work of artists like Cimabue, this work was praised for its innovations including the naturalism and realistic emotions in the figures, the clear compositions and realistic space depicted in them, the use of value to create volume, and the stage-like settings that make each scene appear to be a heavenly drama.

VIII. RENAISSANCE – ITALY

A. Overview

1. The Age of Exploration, beginning in the late 15th century, helped to disseminate European ideas, forms, and practices globally. The collection of artifacts from far off places fueled ideas about race and nationality that still exist today.

2. The city-states of Italy prospered while most of the rest of Europe was still feudal. Since there was no monarchy, the wealth of Italy was in the hands of the merchants allowing for greater patronage of the arts.

3. Wealthy merchant families dominated politics, economics, and the arts, and prosperous merchants took pride in their achievements and formed powerful guilds.

4. The Renaissance in Italy is characterized by:

 i. An authentic interest in classical art, architecture, and writing that was spurred by the collapse of the Byzantine Empire and the rediscovery of classical works during the Crusades. Many of the ancient manuscripts that had been housed there were brought to Italy during this time period.

 ii. Excavations of the period turned up Greek and Roman artworks that also inspired artists.

 iii. A new celebration of the individual, called humanism, became popular.

 iv. People believed that talent and hard work should be rewarded with money and fame. For the first time since antiquity, artists began to regularly sign their work.

v. Portraits and self-portraits became popular ways to immortalize individuals.

IX. EARLY RENAISSANCE

A. Overview

1. Florence was the center of the early Renaissance in Italy, and the Medici family was the dominant force in Florence. The leaders of the Medici family built libraries, commissioned artworks, and donated money for the building of churches.

2. Florence became a haven for new ideas that were considered to be blasphemous in many other parts of Italy, and many artists were supported by the Medici family.

3. The Medici family sponsored the Platonic Academy of Philosophy, which merged ideas from the writings of Plato, Aristotle, and Pythagoras with Christian ideology.

4. The Golden Age of Florence ended with the death of Lorenzo the Magnificent and the subsequent rule of Girolamo Savonarola, who created a strictly Christian environment in Florence. Although his rule was short-lived, it caused Florence to lose the status of being considered the center of the Renaissance.

B. Artworks from the image set

Image 67 (two images). Pazzi Chapel. Basilica di Santa Croce. Florence, Italy. Filippo Brunelleschi (architect). c. 1429–1461 CE. Masonry.

i. Chapels like this one were paid for by wealthy families in order to show off their piety and to add prestige to their name.

ii. This one was commissioned by the Pazzi family whose wealth was second only to that of the Medici family in Florence.

iii. The brutal rivalry of the families is best remembered by the Pazzi plot to assassinate Lorenzo de Medici several years after this chapel was built.

iv. This small domed chapel, designed by Filippo Brunelleschi, is considered to be a high point in Early Renaissance architecture because of the marked contrast with the earlier Gothic style.

v. The architect drew on several architectural styles for the design, including classical elements and early Christian arches.

vi. The symmetry of the plan is considered to be the epitome of Renaissance rationality.

vii. The dome was completed after the architect's death according to his plans. Some parts of the building are incomplete, including the exterior decorations, due to the unexpected death of the architect.

viii. Around the dome, ceramic inserts created by Lucca Della Robbia add to the opulence of the interior.

Test Tip

The classical element remained characteristic during the early Christian period as a means to conceal Christian symbolism. Throughout all subsequent periods, classical styles were influential in ways that evolved as religious ideas developed. You should be able to explain how and why this occurred.

Image 69. David. Donatello. c. 1440–1460 CE. Bronze.

i. The sculpture was commissioned by Cosimo de'Medici for the Palazzo Medici.

ii. David was a symbol of the Republic of Florence because, like Florence, he was an underdog who was triumphant against his rival.

iii. The sculpture was an homage to antique Greek and Roman works. It was unprecedented for its time for a number of reasons, including the fact it was the first nude bronze sculpture created since antiquity, it had obvious erotic overtones, and it exhibited a true contrapposto pose.

iv. The artwork was originally placed in the courtyard on a pedestal so that the viewer was forced to look up at it.

v. David is depicted in the triumphant moment after defeating Goliath, wearing nothing but boots and a hat while holding Goliath's sword.

vi. The artist alludes to the sense of touch by depicting the details of a feather against David's inner thigh and his toe stroking the dead Goliath's beard.

vii. Many scholars believe that the effeminate qualities of the work symbolize male adolescence of the time period.

Image 70. Palazzo Rucellai. Florence, Italy. Leon Battista Alberti (architect). c. 1450 CE. Stone, masonry.

i. Family palaces like this one were built to show off the wealth and longevity of the family. Many are still owned by descendants of the original patrons.

ii. Alberti used pilasters, inspired by classical architecture, to create a symmetrical pattern on the façade of the palace.

iii. The palace was built from eight existing houses that were gutted and unified by the architect.

iv. Like the Medici palace, a bench was included that ran the entire length of the façade. The bench was used as a place for visitors to wait and for neighbors to gather.

v. In the 1460s, a matching loggia that was meant as a place to hold large family gatherings was built across the small piazza of the palace.

Image 71. Madonna and Child with Two Angels. Fra Filippo Lippi. c. 1465 CE. Tempera on wood.

i. Fra Filippo Lippi was a favorite painter and friend of the Medici family. He was a former Carmelite friar who had many affairs with women, most notably with a young nun, Lucrezia Buti, whom he ended up running away with and marrying. They had two children together, one of whom became a famous painter, Filippino Lippi.

ii. His early paintings were inspired by the style of Masaccio, but his later works including this one, had a unique style characterized by his use of soft light and the inclusion of detailed line work.

iii. Unlike many Renaissance painters, he was not interested in imitating classicism or creating realistic volume or anatomy.

iv. Some scholars believe that he used his wife and children as models from memory for this painting. He was one of the first artists to paint a baby Jesus using realistic proportions.

v. His style had an influence on several other artists including Botticelli, Pollaiolo, da Vinci and the Pre-Raphaelites of the 19th century.

Image 72. Birth of Venus. Sandro Botticelli. c. 1484–1486 CE. Tempera on canvas.

i. This painting was commissioned by the Medici family for their country villa and reflected the neo-platonic ideas of the patrons, which attempted to link classicism with Christianity.

ii. The theme of the work comes from Ovid's *Metamorphoses* and also has clear references to the neo-platonic poems of Agnolo Poliziano, a contemporary of the painter.

iii. The theme of the painting is the birth of love and the beauty associated with it, as the driving force of all life.

iv. The artist mixed alabaster powder, an expensive material, into his paint to make the colors brighter. This is one of the first paintings ever to be created on canvas (the prior conventional substrate was wood panel).

v. Many scholars believe that the theme of love reflects the Medicis' contribution to Florentine culture, allowing it, for a time, to become a uniquely tolerant city.

vi. This painting is unique because of its non-Christian theme and because of the style, which was highly influenced by Botticelli's teacher Fra Filippo Lippi, (whose son, Filippino, became a pupil of Botticelli's).

vii. Paintings like this one became a source of guilt for the artist after the influence and death of Savonarola, who changed his views about religion, corruption, and decadence. The artist's late works are religious and moralistic.

X. HIGH RENAISSANCE/LATER RENAISSANCE

A. Overview

1. After the death of Lorenzo de Medici, Florence's golden age ended, and Rome became the center of the Renaissance.

2. The Bonfire of the Vanities enacted by Savonarola caused many artists to move from Florence to Rome.

3. Pope Julius II commissioned many of the best-known works of the period in order to reinforce papal authority and leave a legacy of wisdom and good taste.

4. While still emulating classicism, most works of this period are more conservative than those created in Florence during the previous period.

B. Artworks from the image set

Image 73. Last Supper. Leonardo da Vinci. c. 1494–1498 CE. Oil and tempera.

 i. The fresco was commissioned for the refectory of Santa Maria delle Grazie.

 ii. Da Vinci used linear perspective to create the illusion of realistic space that is a continuation of the real refectory in which it is located. The result is the illusion of dining with Jesus and his disciples.

 iii. In a dramatic break from tradition, da Vinci placed Judas on the same side of the table as Jesus and depicted the disciples with real human emotions.

 iv. Experiments with pigments and the fresco process resulted in this work being heavily damaged by time and the elements. Recently a complete restoration was done on it, and many scholars are unhappy with the result.

 v. Da Vinci favored realism over symbolism. His use of the three windows and the sunset to symbolize the end of Jesus' earthly life was a method for using symbolism in a realistic manner.

Image 75 (4 images). Sistine Chapel ceiling and altar wall frescoes. Vatican City, Italy. Michelangelo. Ceiling frescoes: c. 1508–1512 CE; altar frescoes: c. 1536–1541 CE. Fresco.

 i. This huge fresco cycle was painted on a curved vaulted ceiling of the Sistine Chapel and was commissioned by Pope Julius II.

 ii. It depicts a narrative sequence of nine stories from the book of Genesis.

 iii. Jonah, an important figure to early Christians, is depicted over the altar.

iv. This work inspired a new style of painting called Mannerism, characterized by the use of bright colors, elongated forms, and swirling compositions.

v. The depiction of the birth of Adam demonstrates humanist philosophy, which placed God and man on an equal plane. This was heavily influenced by his previous patrons, the Medicis.

vi. The monumental forms are typical of the High Renaissance style, along with the use of trompe l'oeil (fool the eye) and grisaille underpainting over which color was added.

Image 76. School of Athens. Raphael. 1509–1511 CE. Fresco.

i. This painting, one of many commissioned by Pope Julius II for the reception rooms of the papal apartments, was one of four in the Stanza della Segnatura, or Room of the Signatures, which housed the Pope's personal library.

ii. Each one of the paintings illustrates one of the Pope's favorite art forms (philosophy, theology, poetry, and law). Together they represent the Renaissance harmony of classical antiquity and Christianity reflected in the eclectic collection of books and documents owned by the Pope.

iii. This fresco illustrates philosophy and depicts a gathering of ancient philosophers conversing with each other.

iv. The setting of the painting is similar to the designs for the new Saint Peter's Basilica with the vanishing point placed between the two central figures of Plato and Aristotle.

v. In the fresco, the central figure of Plato is a portrait of Leonardo da Vinci pointing upward toward the heavens, his reputed source of inspiration. Next to him is his student Aristotle, a portrait of the architect Giuliano de Sangallo gesturing toward the viewer. Both Plato and Aristotle bound copies of their most famous writings.

vi. The Greek philosopher Heraclitus, the only figure seated alone, is a portrait of a brooding Michelangelo.

vii. Raphael included at least two self-portraits, one on each side of the painting.

XI. THE VENETIAN SCHOOL

A. Overview

1. Giovanni Bellini, the originator of the style, was the first to use oil paint in Italy.
2. The Byzantine influence in Venice is evident in the use of luminous colors.
3. The style is characterized by the use of translucent glazes to create intense color and soft forms.
4. The preferred subject matter of the style was mythological, erotic, and often enigmatic. The Venetian style engaged the viewer more than any other style of the period.

B. Artwork from the image set

Image 80. Venus of Urbino. Titian. c. 1538 CE. Oil on canvas.

i. This painting was commissioned by the Duke of Urbino as a gift to his young wife.
ii. The beautiful woman is a symbol of marital obligations. The dog at her feet is the symbol of fidelity, the roses in her hand symbolize love, and the images of the maid and young girl in the background symbolize motherhood.
iii. The pose of the woman is similar to an earlier painting by Giorgione called Reclining/ Sleeping Venus (which Titian worked on), however this woman stares directly at the viewer. Both artists were Bellini's students.
iv. The background is a typical Renaissance era palace. Chests like the one shown were used for the storage of dresses, especially wedding gowns. The dark curtain adds to the concept of privacy.
v. The unapologetic nudity and directness of the gaze reflect the fact that the painting was intended for private viewing only.
vi. Mark Twain was influenced by this artwork when he wrote "*A Tramp Abroad.*"

Test Tip

Beginning in the Renaissance, artists' names become important. Be sure to take note of names, associated styles, and contextual information such as time periods from the Renaissance onward.

XII. LATER RENAISSANCE – MANNERISM

A. Overview

1. This style was initially inspired by the paintings and sculptures of Michelangelo and was a reaction against the perfection and many rules of the High Renaissance style.
2. In many ways this style is the opposite of the orderly, realistic Italian Renaissance style.
3. Works in this style are characterized by twisted and elongated figures, asymmetrical and deliberately unbalanced compositions, and ambiguous space. The use of expressive hand gestures, the lack of a clear focal point, acidic palette, and unusual representations of traditional themes were also hallmarks of the style.
4. Each Mannerist artist had his own style, and during the later years of the Renaissance, this style became the style preferred by wealthy patrons.

B. Artwork from the image set

Image 78. Entombment of Christ. Jacopo da Pontormo. 1525–1528 CE. Oil on wood.

i. This artwork embodies all of the hallmarks of the Mannerist style.
ii. The ambiguity of the scene combines ideas from traditional deposition scenes with Pietas. Most scholars agree that the depiction shows Jesus being lifted from his mother's lap. His body is in a similar twisted position as that of Michelangelo's Pieta.
iii. The two figures holding Jesus have been interpreted by many scholars as angels who, unaffected by the weight of the body, are in the act of lifting him toward God.

XIII. EARLY NETHERLANDISH ART

A. Overview

1. This term refers to artwork created from about 1420–1550 in the Burgundian Netherlands/Low Countries.

2. The work is characterized by extensive detail, the use of luminous colors, and the desire to capture everyday life. Secular and religious subjects are often mixed.

3. Because of the distance from Rome, less emphasis was placed on the classical style.

B. Artwork from the image set

Image 66. Annunciation Triptych (Merode Altarpiece). Workshop of Robert Campin. 1427–1432 CE. Oil on wood.

 i. This piece was commissioned for private devotion by wealthy patrons who have been depicted in the left panel as witnesses to this holy scene.

 ii. This is typical of the time period when artists often placed past events in contemporary settings. Here, the artist staged his scene in a middle-class Flemish home of the period.

 iii. The moment depicted is that before the annunciation when the archangel Gabriel has just entered Mary's room.

 iv. Many of the objects in the room symbolize Mary's purity.

 v. A tiny figure carrying a cross is a symbol of the unborn Jesus. The extinguished candle is a symbol of the incarnation.

 vi. Joseph, Mary's fiancé, is depicted in the right-hand panel working in a Flemish carpentry shop. The mousetraps he has made are a symbol of Jesus as the proverbial devil's bait.

 vii. Most annunciation scenes do not include Joseph, but during this time period several important members of the church, sometimes known as the cult of Joseph, were attempting to elevate Joseph's rank.

 viii. Symbols of the Jewish home appear alongside the Christian symbols. The Florentine vase with pseudo-Hebrew letters holds a trinity of lilies, one still a bud. Lions carved on the bench symbolize the Throne of Solomon, while the hanging laver and towel that look like a prayer shawl allude to Jewish handwashing practices.

 ix. Many scholars believe that this painting is a symbol of time, clocks having recently come into common use. The left panel is the present, the center is the past,

and the right is the future, since the mousetrap also symbolizes the future crucifixion.

x. Less than 100 years later, paintings like this one fell out of fashion due to the Protestant Reformation.

XIV. NORTHERN RENAISSANCE

A. Overview

1. In 1517, Martin Luther nailed his 95 Theses to the door of Castle Church in Wittenberg, Germany. In this document he listed his primary issues with the Catholic Church and formulated a new approach to Christianity.

2. At the time, northern European peasants were oppressed by a combination of the feudal system, foreign rulers, and the Catholic Church. As a result, Protestantism developed a large following in northern Europe.

3. The art of northern Europe was profoundly affected by the Protestant Reformation. In the countries that became predominantly Protestant large altarpieces were no longer painted, depictions of biblical scenes were frowned upon, and woodcuts or engravings were created to help spread the ideas of Protestantism.

4. Artists of the Northern Renaissance had some contact with Early and High Renaissance artists from Italy. Northern artists, however, were not as interested in emulating classical styles as they were in imitating the observable world around them.

5. Northern Renaissance artworks have a unique style, which includes a focus on moral subject matter, the use of oil paint to create luminous color, a lack of nudity (unless the work depicts Adam and Eve), and a lack of erotic subject matter (unless the work depicts the sin of lust).

B. Artworks from the image set

Image 68. The Arnolfini Portrait. Jan van Eyck. c. 1434 CE. Oil on wood.

i. This painting was created before the Protestant Reformation and contains many symbols that were well known to Catholics at the time.

ii. Van Eyck was one of the first artists to use oil paint. The use of this new medium quickly spread to Venice, Italy, and had a great influence on the Venetian style of painting.

iii. The subject of the painting is believed to be a wealthy Italian merchant and his bride, but the identities of the subjects have been debated.

iv. At the time of this commission, van Eyck was a court painter to Philip the Good, Duke of Burgundy. The painting may have been a gift to the couple from the Duke.

v. Van Eyck's signature is both personal and political, since he represented the Duke. It is unusual because it is signed, "Jan van Eyck was here" when the normal signature would have read "Jan van Eyck did this."

vi. The inclusion of two visitors in the mirror behind the couple is enigmatic. They may be witnesses, although none were needed, unless the wedding was between two people who were unequal in status.

vii. The many symbols found in the portrait combine secular and religious meaning. The dog represents fidelity, and the single candle represents the eye of God. Fertility is symbolized by the carving of Saint Margaret, patron saint of childbirth, on the back of the chair and by the cast off clogs that refer to the sacredness of the union. Around the mirror small paintings illustrate the life of Jesus.

viii. The ermine trimmed fur robe of the woman and the fur lined velvet cloak of the man as well as the expensive oranges on the dresser and well made furniture are visual indications of wealth. However, the small bedchamber and lack of expensive jewelry indicate that they are probably bourgeois or newly wealthy.

ix. The style, realistic space, and pictorial devices of this portrait influenced many other Northern Renaissance artists as well as later European artists including Velazquez.

Image 77 (two images). Isenheim altarpiece. Matthias Grünewald. c. 1512–1516 CE. Oil on wood.

i. This altarpiece was commissioned for the hospital chapel of Saint Anthony's Monastery in Isenheim, Germany. The hospital treated many victims of ergotism

(called St. Anthony's Fire at the time), which explains the presence of Saint Anthony in the artwork.

ii. It is a complicated structure with three views.

iii. The first view, with wings closed, is a crucifixion scene.

iv. The second view, with the wings open, includes an annunciation scene, a resurrection scene, and an angel concert.

v. The third view, with inner wings open, contains three carved wooden statues and scenes of Saint Paul and Saint Anthony.

vi. The painting was meant to bring peace to patients and visitors of the hospital.

vii. This piece is one of the last of the Northern European altarpieces, which fell out of favor after the Protestant Reformation.

Image 74. Adam and Eve. Albrecht Dürer. 1504 CE. Engraving.

i. Dürer was one of the few Northern European artists to study in Italy, where he studied classical art, and was drawn to the systems of proportion and measurement that were popular there.

ii. This work is influenced by Italian Renaissance work in the use of the contrapposto pose, the depiction of the figures with detailed musculature, and the use of delicate values.

iii. This work also reflects his northern heritage in the setting, which is a northern forest, and the moralizing tone of the work.

iv. The animals are moralistic symbols that were popular in northern artworks.

Image 79. Allegory of Law and Grace. Lucas Cranach the Elder. c. 1530 CE. Woodcut.

i. This piece expresses the doctrinal differences between Catholicism and Protestantism.

ii. This can be considered to be propaganda since it was made to be printed and distributed for use as a teaching tool.

iii. A tree divides the picture plane with Moses, Adam, and Eve on the left representing the laws of the Old Testament, and a sinful man being hounded by the devil. The branches on the left side of the central tree are bare.

 iv. On the right side of the tree, leaves indicate hope. The inclusion of the birth, life, death and resurrection of Jesus illustrates his role as the savior of man. His blood is converted into baptismal water cleansing the sinful man.

 v. Viewers of the time period would have recognized all of the symbols found in the work and would have understood this artwork as an illustration of the basic Lutheran doctrine, which states that the gospel alone is necessary for salvation.

Image 83. Hunters in the Snow. Pieter Bruegel the Elder. 1565 ᴄᴇ. Oil on wood.

 i. This painting was one of a cycle of six seasonal paintings commissioned by a wealthy Antwerp banker.

 ii. Although Bruegel had studied the Italian Renaissance style, he chose to use the simpler native Netherlandish style for this series.

 iii. He was one of the first artists to depict genre scenes, or scenes of everyday life. In this case a typical northern winter is depicted as difficult, as indicated by the hunters returning with only a small rabbit and the broken inn sign, yet enjoyable, as revealed with the people ice skating in the background.

 iv. The use of an elevated viewpoint and atmospheric perspective to depict space is typical of his artistic exploration of the interplay between humans and nature.

 v. He combined an alpine landscape, probably from sketches made while traveling, with a northern scene to form a composite landscape.

XV. OTTOMAN ART OF THE ERA

A. Overview

 1. By the middle of the 16th century the Ottoman Empire controlled a huge area, from Central Europe to the Indian Ocean, including the majority of the former Byzantine Empire.

 2. The artistic heritage of the many conquered lands contributed to the golden age of the Ottoman Empire.

3. The Ottoman Empire was part of the larger ongoing European struggle for territory.

B. Artwork from the image set

Image 84 (three images). Mosque of Selim II. Edirne, Turkey. Sinan (architect). 1568–1575 CE. Brick and stone.

 i. This mosque is considered to be one of the highest achievements of Islamic architecture and was built as a symbol of Ottoman power by Sultan Selim II and was designed by Mimar Sinan, his chief architect.

 ii. Eight pillars in square shells of walls create an octagonal supporting system for the large dome, with four semi domes at the corners of the square behind the arches that connect the pillars. At the front is a large court with a central fountain, and four minarets surround the building.

 iii. The interior was designed so that the mihrab is visible from any location. This was an unconventional innovation at the time of construction.

 iv. Three hundred eighty-four windows allow more light into the interior than any other mosque of the time.

 v. Around the mosque are annexes that align axially to the mosque. This complex (called a kulliya) contained a library, school, hospital, baths, market, etc.

 vi. This structure was meant to rival the Hagia Sophia. The architect placed it higher to make it appear larger and to visually symbolize Islamic dominance over Christianity.

XVI. NEW SPAIN/THE NEW WORLD

A. Overview

1. Beginning in the 15th century, the Catholic monarchs of Spain defeated Islamic forces, emboldening Spain to search for glory and riches in undeveloped parts of the world. It also fueled the Inquisition.

2. The population of native people of the New World was decimated by newly introduced diseases from Europe and by war with, and subsequent enslavement by, the Spanish conquerors.

3. Spanish artistic styles and religious beliefs had a huge impact on the art and religion of the New World.

B. Artwork from the image set

Image 81. Frontispiece of the Codex Mendoza. Viceroyalty of New Spain. c. 1541–1542 CE. Pigment on paper.

 i. Twenty years after the conquest of the New World, this codex was created by native scribes under the supervision of missionary priests, who added the Spanish annotations.

 ii. The patron of the work was Antonio Mendoza, the first Spanish viceroy of New Spain (Mexico City was the capital), who intended to send it to the Spanish King, Emperor Charles V. The work never made it to Spain. It was seized by pirates and brought to France, where it was sold.

 iii. The first two sections of the book were copied from several works created before the Spanish conquest. The first section is a detailed history of Mexico City (Tenochtitlán) including information about its founding and rulers including the last ruler, Montezuma.

 iv. The second section is a summary of tributes given by the 33 provinces to the capital of the Aztec empire.

 v. The third section details the everyday lives of native Mexicans (Aztecs) from birth until death.

 vi. The frontispiece contains information about the founding of Tenochtitlán (Mexico City) including a schematic diagram showing the city divided by diagonal canals. The founders believed that the division of the city into quarters aligned with the four cardinal directions mirrored the organization of the universe.

 vii. The central symbol of the eagle on a cactus relates to the Aztec myth in which the patron god, Huitzilopochtli, instructed the founders to look for an eagle on top of a cactus growing from a rock. Since the sign was observed in the middle of Lake Texcoco, the city was built on an island in the middle of the lake.

 viii. Below the cactus the shield indicates that the area had to be conquered. A small temple and symbols of agriculture refer to the original main temple (rebuilt as the Temple Mayor) and the fertile land of the area.

ix. The ten men depicted represent the leaders who led the ancestors to the site. The name glyphs attached to them are done in a manner typical of manuscripts created before the Spanish conquest. The gray man is a priest with a red ear, a symbol of ritual bloodletting, with ash-covered skin and a speech scroll coming from his mouth.

x. The glyphs surrounding the page are indicators of years. The one with the dagger above it was the first year of the new 52-year cycle, at the start of which a human sacrifice was made to ensure that the sun would rise each day.

xi. At the bottom of the page hierarchical scale is used to depict early conquests of two settlements around Lake Texcoco by Aztec warriors.

XVII. BAROQUE ART

A. Overview

1. The Counter-Reformation began around 1530 and was intended as a way to turn people away from Protestantism back to the Catholic Church. During the Council of Trent, which took place from 1545–1563, a set of principles designed to reinvigorate the Catholic Church and wipe out the corruption that had led to Martin Luther's movement were put into place.

2. Many artworks were commissioned by the church as part of this effort. The Council of Trent issued a decree in response to Mannerist and Venetian artworks that prohibited anything considered to be erotic, disorderly, or profane in religious art. In an effort to prevent idolatry, the decree stipulated that the subject of the artwork was more important than the artwork itself.

3. In Spain, the Catholic monarchs, who had recently re-conquered the lands held by Islamic forces, launched the Inquisition and sent missionaries to the New World as part of the Counter-Reformation.

4. The artwork of this period builds on Renaissance innovations. It is characterized by dramatic theatricality, grandiose design and scale, ornate decoration, and emotion intended to draw viewers into the work.

B. Baroque Italy – Artworks from the image set

Image 82 (three images). Il Gesù, including Triumph of the Name of Jesus ceiling fresco. Rome, Italy. Giacomo da Vignola, plan (architect); Giacomo della Porta, façade (architect); Giovanni Battista Gaulli, ceiling fresco (artist). Church: 16th century CE; façade: 1568–1584 CE; fresco and stucco figures: 1676–1679 CE. Brick, marble, fresco, and stucco.

i. This church was built to be the center of the newly-founded Society of Jesus (the Jesuits) by Ignatius Loyola.

ii. The façade is considered to be the first of the Baroque style, and was designed to convey the harmony and solemnity of the Catholic Church.

iii. The architect deliberately drew on classical elements to visually equate the church with the order and scholarly pursuits of the ancient Greeks and Romans. The wider nave was created to allow more space while bringing worshippers closer to the service for a more personal experience.

iv. The plan combines the grand dome of Renaissance architecture with the extended nave of Franciscan and Dominican churches. The elimination of the narthex reflects a new simplicity.

v. The Triumph of the Name of Jesus painting adorns the nave vault. It depicts the loyal and pious supporters of Jesus ascending to heaven while the impious are cast down.

vi. The use of trompe l'oeil techniques make the ceiling appear to be open to the sky.

Image 85. Calling of Saint Matthew. Caravaggio. c. 1597–1601 CE. Oil on canvas.

i. This painting was commissioned for the Contarelli Chapel located inside the church of San Luigi dei Francesi in Rome.

ii. The painting has a moralistic tone, depicting the story of the tax-gatherer Levi, later known as Saint Matthew the Apostle, being summoned by Jesus.

iii. The style of the work is unique because of the use of non-idealized figures and the incorporation of tenebrism, or the extreme contrast between light and dark that contributes to the ambiguous setting for the scene.

iv. This painting influenced many other artists of the Baroque period, who were known collectively as Caravaggisti.

 v. In typical Baroque fashion, the artist concentrated on conversion and encouraging a return to the Catholic church.

Image 88 (three images). San Carlo alle Quattro Fontane. Rome, Italy. Francesco Borromini (architect). 1638–1646 CE. Stone and stucco.

 i. The architect wanted to embody the Baroque style in his design.

 ii. He designed alternating concave and convex bays on the ground level of the building.

 iii. The upper level contains concave bays. The concave and convex elements create the illusion of movement as well as a play of light and dark.

Image 89 (three images). Ecstasy of Saint Teresa. Cornaro Chapel, Church of Santa Maria della Vittoria. Rome, Italy. Gian Lorenzo Bernini. c. 1647–1652 CE. Marble (sculpture); stucco and gilt bronze (chapel).

 i. This sculpture was commissioned by the Cornaro family of Venice.

 ii. This is part of a multimedia installation that was a new approach to sculpture which included painted balconies, which resemble theater boxes, containing relief portraits of the patrons watching the dramatic scene.

 iii. A hidden window in the ceiling above created a spotlight on the work, and the use of bronze rods reflected the light from the hidden window.

 iv. The theatrical style of Bernini's work was partially due to his work as a set designer prior to his church commissions.

 v. The theme of an ecstatic moment and conversion reflects the goals of the patron to bring people back to the church.

 C. Baroque Belgium – Artwork from the image set

Image 86. Henri IV Receives the Portrait of Marie de' Medici, from the Marie de' Medici Cycle. Peter Paul Rubens. 1621–1625 CE. Oil on canvas.

 i. This is one of a series of paintings commissioned by Marie de Medici for her Paris home depicting her life.

 ii. The painting depicts the Greek god of marriage presenting a portrait of the patron to her future husband, King Henry IV of France. Jupiter and Juno are depicted in the clouds watching the scene.

 iii. The painting received much negative attention because of Rubens' placement of a real person among Greek gods.

 iv. She is depicted as powerful, evident in the fact that she is the only figure staring directly at the viewer. This aspect of the work was not well received either, since most women of the time were depicted as modest.

 v. Rubens was well known for his style, which depicted typical Baroque movement and tactile sensation through the inclusion of curvaceous women.

D. Baroque France – Artwork from the image set

Image 93 (five images). The Palace at Versailles. Versailles, France. Louis Le Vau and Jules Hardouin-Mansart (architects). Begun 1669 CE. Masonry, stone, wood, iron, and gold leaf (architecture); marble and bronze (sculpture); gardens.

 i. King Louis XIV of France rebuilt his father's hunting lodge, located in a small village near Paris, into a grand palace.

 ii. Most of the aristocracy, including government officials, were forced to move to Versailles during his reign, transforming the small hamlet into a suburb of Paris.

 iii. The king ordered that all furnishings for the palace be made in France.

 iv. In typical Baroque fashion the palace is very ornate. The palace contains 2,143 windows, 1,252 fireplaces, 67 staircases, and 1,400 garden fountains.

 v. The Hall of Mirrors was designed as the showpiece of the palace. It has a grand narrative showing King Louis XIV's aspirations.

 vi. A wall of mirrors diffuses the daylight, adding to the effect.

 vii. From the central window of the hall of mirrors a visitor was able to view the gardens, which included a grand canal. Thousands of workers transformed the wooded landscape into an enormous manicured garden.

E. Baroque Spain/ New World – Artworks from the image set

Image 91. Las Meninas. Diego Velázquez. c. 1656 CE.
Oil on canvas.

i. This piece has many levels of meaning.

ii. It is a portrait of Princess Margarita, painted for the King, who wanted to "see" his daughter every day at the age of five, posing with her favorite playmates.

iii. It is also a self-portrait. Velazquez is dressed in a fine suit with the emblem of the Order of Santiago on his chest, a symbol that was painted in later, after he received the invitation to join the order.

iv. This painting serves to portray Velazquez's unusually high status for an artist and even includes a portrait of the King and Queen, who are reflected in the mirror.

v. Velazquez included many allusions to the optical world in this work including:

a. The inclusion of the back of the canvas on which he is depicted but which the viewer will never see.

b. The mirror on the back wall that reflects the King and Queen.

c. The paintings that resemble Rubens' work hung on the walls of the studio.

d. The door in the back that opens onto the rest of the palace.

vi. Velazquez was influenced by the devices used by van Eyck in the Arnolfini Portrait and in typical Baroque fashion, he brought the viewer into the painting.

vii. There is no one focal point in the work, and the viewer is being observed by the figures depicted while viewing the artwork.

Image 90. Angel with Arquebus, Asiel Timor Dei. Master of Calamarca (La Paz School). c. 17th century CE.
Oil on canvas.

i. This painting was created in the Spanish colony of Peru and represents a popular theme of the time.

ii. The Council of Trent forbade angelic depictions except for those of Michael, Gabriel, and Raphael, but this ban was not enforced in New Spain. This angel is named Asiel Timor Dei (Fears God).

iii. Images like this one combine celestial, military, and aristocratic symbols to create a being that represented the triumph of Catholicism over the native religions of the New World.

iv. The gun pictured is an arquebus, first created in Spain in the 15th century. It was the first gun able to be shot from the shoulder.

v. The armed angel represented the Catholic Church's view of itself during the Counter-Reformation as the soldiers of God and protectors of faithful Catholics.

vi. Images of angels like this were meant to take the place of native deities of the region, helping to fill the void created by a monotheistic religion. Firearms did not exist in New Spain prior to the Spanish colonization, and many natives associated them with the supernatural.

vii. The ornate clothing and feathered hat are reminiscent of the dress of native aristocrats prior to the colonization. Feathers had always been reserved for the nobility and used during religious rituals.

viii. During this time gold and silver were prohibited from being used in the clothing of nobility and was restricted to use in military garments.

Image 94 (two images). Screen with the Siege of Belgrade and hunting scene. Circle of the González Family. c. 1697–1701 CE. Tempera and resin on wood, shell inlay.

i. This artwork combines two elite Mexican artistic forms. Folding screens (biombas) decorated with shell-inlay paintings (enconchados) are unusual. These two forms of art were not usually combined, and both were influenced by the influx of East Asian trade goods into Mexico at the time.

ii. This work was commissioned by the viceroy of New Spain, probably for his palace in Mexico.

iii. The scene was taken from a Dutch print depicting the Great Turkish War that lasted from 1683–1699. It served to visually connect New Spain with the power of the Habsburgs.

iv. The screen divided a room to make the area feel more intimate. The hunting scene on the reverse was also based on an older European print.

Image 95. The Virgin of Guadalupe (Virgen de Guadalupe). Miguel González. c. 1698 CE. Based on original Virgin of Guadalupe. Basilica of Guadalupe, Mexico City. 16th century CE. Oil on canvas on wood, inlaid with mother-of-pearl.

i. This work was made by one of the best known painters of enconchados (shell inlay paintings).

ii. The technique used for this work was influenced by the large number of decorative goods entering Mexico from East Asia. The shell inlay provided a luminescence that could not be created with paint.

iii. The subject is the Virgin of Guadalupe with the symbol of Mexico, an eagle on top of a cactus, below her.

iv. The image is derived from a local legend in which Mary revealed herself to a native, Juan Diego, in 1531. He saw her three times in a ring of fire, and when he told his story to the local bishop the image became popular among the native population.

Image 97. Spaniard and Indian Produce a Mestizo. Attributed to Juan Rodríguez Juárez. c. 1715 CE. Oil on canvas.

i. Paintings such as this one were known as pinturas de castas (caste paintings) and attempted to show the unique inter-ethnic mixing that was common in New Spain.

ii. The subject is modeled on depictions of Mary, Joseph, and Jesus but shows a native woman with a Spanish man and their offspring (known as a mestizo).

iii. The implication from paintings such as this is that those with more European blood are closer to the top of the social hierarchy, with pure-blooded Spaniards at the top.

iv. Many of these paintings were comissioned by elites who viewed this inter-ethnic mixing as alarming and undesirable.

XVIII. DUTCH GOLDEN AGE

A. Overview

1. Upon taking the throne, King Philip II of Spain imposed the Inquisition and levied new taxes on the Netherlands.

His actions provoked riots and convinced many Dutch people to convert to Calvinism, a form of Protestantism.

2. The threat to the Spanish Empire by the Ottomans during the 16th century drew resources away from the Burgundian Netherlands and helped fuel the Dutch Revolt.

3. A war for control of the Netherlands ended in 1581 when the seven northern provinces gained their independence. The Dutch Republic began a golden age of prosperity and artistic creativity.

4. Dutch art of this time period is characterized by the predominance of non-religious subject matter such as portraits, still-lifes, lively genre scenes, and landscapes.

5. Some of the Netherlandish painting traditions nevertheless continued, including attention to detail, extreme realism, and the use of layers of oil paint to create luminous color.

6. New ideas about painting that emerged during this time include the use of loose brush strokes, a painterly technique not seen before, as well as the study of natural light and the rendering of fabrics in a very realistic way.

B. Artworks from the image set

Image 87. Self-Portrait with Saskia. Rembrandt van Rijn. 1636 CE. Etching.

i. Rembrandt depicted himself and his wife wearing historical clothing. He depicted himself as a draftsman.

ii. This is one of more than 75 self-portraits produced by Rembrandt. In all but two of them he is wearing fanciful costumes.

iii. This is the only image Rembrandt ever made of himself with his wife, although she modeled for him numerous times. She died at the age of 30 after 13 years of marriage.

iv. Rembrandt was the first artist to make the printmaking medium of etching popular. He is considered to be one of the best to use the medium.

v. Rembrandt explored the medium and developed a unique style that has a spontaneous quality due to his experiments with soft grounds and different papers.

vi. Rembrandt often reworked his plates to create multiple versions of a single plate. Three versions of this image exist.

Image 92. Woman Holding a Balance. Johannes Vermeer.
c. 1664 CE. Oil on canvas.

i. This genre painting is a religious allegory about judgment. The woman's pose and robe are reminiscent of Mary. The Last Judgment scene behind her, the jewels on the table and the empty scale are reminders of the importance of the spiritual over the material. The subject of balancing scales as an allegory for the last judgment was a popular theme in Dutch Baroque art.

ii. The painting was originally owned by a Delft bookseller, Jacob Dissius, who owned at least three other works by Vermeer.

Image 96. Fruit and Insects. Rachel Ruysch. 1711 CE. Oil on wood.

i. Ruysch was one of the few successful female painters of the Baroque period. She was a court artist in Bavaria for eight years.

ii. Her father was an anatomist and botanist who had a large collection of exotic flowers and specimens in his home. She specialized in paintings depicting lush flower bouquets.

iii. Because of their fleeting beauty, flowers were popular elements of vanitas paintings, which served as a reminder that life is short and precious.

XIX. ENGLAND DURING THE 18TH CENTURY

A. Overview

1. England's economy was prosperous, and consumerism was becoming popular among the wealthy.

2. Puritan ideas were fading, and many of the wealthy were engaged in self-serving enterprises.

3. The region was still recovering from the past chaos of the English Civil War.

4. More people were literate, and religious uniformity was in decline. Sexual promiscuity and a decline in family values, combined with a rise in crime, worried moralists.

B. Artwork from the image set

Image 98. The Tête à Tête, from Marriage à la Mode.
William Hogarth. c. 1743 CE. Oil on canvas.

i. This is one of a series of moralizing paintings on the topic of aristocratic marriages and the new ideas about consumerism associated with the elite.

ii. Engravings were made from the paintings, which, due to the nature of the process, reversed the compositions. They were sold as installments.

iii. This series dealt with the topic of arranged marriages and marriages of convenience. They also commented on the general lack of morals being observed among the upper and middle classes.

iv. The couple appears uninterested in each other, and various symbols allude to infidelity including the dog sniffing another woman's cap in the man's pocket. The woman appears tired after a night of cards and possibly an extramarital tryst.

v. The style of the décor is overly ornate and includes a mix of styles that seem ostentatious.

vi. The servant is holding a stack of unpaid bills indicating that the couple is irresponsible.

LATER EUROPE
AND **AMERICAS**
1750–1980 CE

Note: The image set for this chapter can be found on pages 88–104 of the College Board's *AP Art History Course and Exam Description.*

I. OVERVIEW

A. The scientific inquiry and philosophy of The Enlightenment of the 18th century marked the beginning of global change that resulted in industrialization, urbanization, migration, revolutions, and wars.

B. During the 18th century both the English and French Royal Academies of Art were established. These institutions dictated European artistic style and aesthetics.

C. Modernism, which began in the late 19th century, gave rise to many new artistic styles, all highly influenced by the rapid changes brought about by the Industrial Revolution, new technology, and by wars. The aesthetics of many of these movements were responses both to modern society and to other artistic styles.

D. Modern art movements were often self-defined. Beginning in the late 19th century, artists were no longer bound to the *Salon* system or to the academies. These styles are known as avant-garde.

E. Church patronage declined, while corporate and private patronage grew. From the mid-20th century onward, art became one of the most stable commodities in the world.

II. ROCOCO

A. Overview

1. In 1715, King Louis XIV of France died and the reign of King Louis XV began a new period in French high society. The nobility returned to their hotels and townhouses in Paris, the upper class reasserted their social and economic privileges, and aristocrats commissioned art that reflected their tastes.

2. The Rococo style was used in painting, sculpture, furniture design, silverware, ceramics, and interior decoration and is characterized by: pastel palettes; frivolous, erotic and lighthearted subject matter; a dominance of swirls and shell forms in decorative arts; the use of soft, feathery brushstrokes; and an interest in mythological subject matter.

3. A unique subject matter that emerged from this style captured the many decadent parties that took place among the aristocracy. This is known as the fâte-galante genre.

4. The style fell out of fashion when the French Revolution began due to its link with the perceived decadence of the monarchy.

5. During the period of the French Revolution, many formerly rococo artists embraced the Neoclassical style.

B. Artwork from the image set

Image 101. The Swing. Jean-Honoré Fragonard. 1767 CE. Oil on canvas.

i. Fragonard studied under Boucher, an earlier Rococo artist, and built upon his master's style.

ii. His work often portrayed witty commentaries on the frivolity of the upper class utilizing pastel colors and a hazy appearance that gives the impression of a dream world.

iii. In this painting, a young aristocrat is positioned so that he can catch a glimpse of his lover's legs as she swings above

him, reflecting the sexual promiscuity and flirtatiousness of the upper class.

iv. Cupid and other cherubs, symbols of love and lust, are depicted in the painting as sculptures in the garden.

 III. THE AGE OF ENLIGHTENMENT/THE AGE OF REASON

A. Overview

1. This time period was characterized by a new way of thinking about the world that emphasized rational thought over faith.

2. The era began in England and France and was based largely on the ideas and work of many academics whose work began more than two centuries earlier.

 i. The earlier (16th –17th century) scientific ideas and methods of Nicolaus Copernicus, Johannes Kepler, Galileo Galilei, Sir Francis Bacon, Sir Isaac Newton, Adam Smith, and René Descartes inspired a new way of testing theories and gathering evidence.

 ii. The 18th century French philosophical writings of Voltaire, Diderot, Montesquieu, and Rousseau placed an emphasis on rational thought over faith and tradition.

3. The growth of cities and the urban working class helped fuel the new ideas as did an increase in literacy.

B. Artwork from the image set

Image 100. A Philosopher Giving a Lecture at the Orrery. Joseph Wright of Derby. c. 1763–1765 CE. Oil on canvas.

i. This work embodies the ideas of the era, characterized by a shift away from faith-based ideas about the universe and toward a scientific approach.

ii. The orrery is a mechanical model of the solar system.

iii. Wright became the unofficial painter of the Age of Reason, and his depictions of scientists and philosophers, done in a manner that was previously reserved for biblical figures, were a reflection of the period.

iv. In this painting two young boys and an older girl, a woman, and three men are listening to a lecture on the

mechanisms of the solar system. The gas lamp that stands for the sun in the mechanism serves as the light source in the painting.

v. Wright was influenced by the academic style that was popular in France, which held history painting in high regard. He reinvented the style by applying it to modern subjects placing modern history on par with past events.

vi. The dramatic lighting and scale of the work are reminiscent of religious works by Caravaggio during the Baroque period, but the subjects are ordinary people being enlightened about new and modern ideas.

vii. This deliberate appropriation of a Baroque-era style was a reflection of his desire to depict scientific conversion as the modern equivalent of religious conversion.

NEOCLASSICISM

A. Overview

1. The style, which came to dominate European painting, sculpture, architecture, and decorative arts in the late 18th century, is characterized by a renewed interest in classical antiquity.

2. The new field of archeology led to an increased observation of antique works.

3. The Grand Tour of Italy to see the works of the masters became a favorite vacation theme for the upper class of this period.

4. The emphasis of the era on a rational scientific approach to life rather than on religion and faith had a major impact on the aesthetics of the style.

5. Artists who were part of this artistic movement combined classical artistic style with heroic subject matter. Many of them studied in Italy in order to study classical works in person.

6. Artworks in this style are characterized by an emphasis on historic subject matter with contemporary settings and costumes and an emulation of Renaissance-era rationality, especially in the use of formal compositional devices.

7. The moralizing tone of the style was the exact opposite of the Rococo style and was inspired by the philosophical ideas of Voltaire who championed exemplum virtutis (moral examples) in art.

B. Artworks from the image set

Image 105. Self-Portrait. Elisabeth Louise Vigée Le Brun. 1790 CE. Oil on canvas.

i. Le Brun was the favorite portrait artist of Queen Marie Antoinette in France. The Wueen's support gained Le Brun a place at the French Royal Academy of Art before the French Revolution.

ii. Once the French Revolution began she was forced to move to Italy where she became well known for her portraits of Italian, Russian, and Austrian aristocrats.

iii. Le Brun painted several self-portraits during her career. This was the first one she created after leaving France. This portrait was painted in Florence and Rome for the Uffizi Gallery, as an addition to their collection of well-known artists' self-portraits.

iv. She depicted herself as happy and youthful while working on a portrait of her former Queen, Marie Antoinette, who she painted from memory or sketches.

Image 103. The Oath of the Horatii. Jacques-Louis David. 1784 CE. Oil on canvas.

i. This painting became the standard by which all Neoclassical paintings were judged. When it was first shown, it was considered to be groundbreaking because of its complete departure from the Rococo style.

ii. David chose to depict the tense moment before the fight between the Horatii (representing Rome) and the Curiatti (representing Alba).

iii. The painting depicts the moment when the Horatii are swearing their allegiance to Rome while receiving weapons from their father.

iv. One of the crying sisters was married to a Curiatti. The fact that she is depicted with the Horatii symbolizes the importance of familial loyalty over marriage ties.

v. This painting was commissioned by King Louis XVI and was intended to remind viewers that loyalty to the state (symbolized as family) trumped individual loyalties (symbolized as marriage).

vi. Fifteen years after this painting was completed, David became the official artist of the French Revolution. He was also aligned with Napoleon I but went into exile during the Bourbon revival.

Image 107. La Grande Odalisque. Jean-Auguste-Dominique Ingres. 1814 CE. Oil on canvas.

i. This painting was commissioned by Caroline Murat, Queen of Naples and sister of Napoleon Bonaparte.

ii. Ingres was inspired by the reclining female nudes of the Renaissance but reinvented the subject as a member of a Turkish harem.

iii. Although the anatomy is unrealistic, the fabrics were painted precisely.

iv. The style of the painting is considered to be the transition from the Neoclassical to the Romantic.

v. Ingres worked in Rome from 1806–1824 because his work was harshly criticized when it was shown in the Paris Salon.

vi. Ingres was influenced by the Mannerist style of painting.

Image 104. George Washington. Jean-Antoine Houdon. 1788–1792 CE. Marble.

i. This sculpture was commissioned by the Virginia legislature and installed in the Capitol rotunda in 1796, the year that Washington published his Farewell Address.

ii. Houdon was world renowned as a sculptor whose work embodied the ideals of the period (truth, simplicity, and grace).

iii. Houdon depicted Washington with a mixture of Neoclassical idealism and down-to-earth naturalism reflecting a uniquely American ideal.

iv. Washington requested that he be dressed in his Revolutionary War uniform rather than in a toga.

v. Behind him, a farmer's plow acts as a support, and he holds a civilian walking cane to remind the viewer of his roots as a farmer.

vi. He is leaning on a fasces, the Roman symbol of civil authority, depicted as a bundle of 13 rods with arrows between them, representing the original American colonies as well as the strength that is found in unity.

vii. His officer's sword is hanging on the fasces, just out of reach of the subject, indicative of his retirement.

viii. The Neoclassical style was embraced by the American founding fathers because of the visual link to the style of ancient Greece and Rome, which was perceived as being tied to the idea of democracy.

ix. The Greek contrapposto stance and far away gaze were visual references to Greek democratic ideals.

x. Thomas Jefferson, who was ambassador to France at the time, introduced both Houdon and the Neoclassical style to the founding fathers of the United States.

Image 102 (two images). Monticello. Virginia, U.S. Thomas Jefferson (architect). 1768–1809 CE. Brick, glass, stone, and wood.

i. Jefferson called his home in Virginia his "essay in architecture."

ii. He had no formal training as an architect, but he researched Roman and Renaissance styles extensively and designed the home with many European attributes, including an octagonal dome.

iii. He was a fan of the Maison Carée, in France, and he modeled many of his designs, including that for the University of Virginia, on that structure.

iv. At a time when most people ordered bricks from England, Jefferson chose to make his own from clay found on his land. He also used local timber, stone, and locally made nails.

v. His time in France as an ambassador inspired the style of Monticello. His influence later infused the Neoclassical style of Palladian architecture into the buildings of the new seat of government of the United States.

vi. Jefferson was an innovator in agriculture, an inventor, and a collector. His home had a unique gathering of plants, homemade inventions, and artworks brought from Europe.

V. ROMANTICISM

A. Overview

1. This artistic movement began as a reaction against the constraints of the Neoclassical style in France and England.

2. The artworks are not linked by a common artistic style but are characterized by a desire to express personal emotions inspired by the ideas of the French philosopher Rousseau, who rejected reason in favor of intuition.

3. A renewed link to the mysteries of religion and faith made the style the antithesis of the rational and scientific thought of the Enlightenment.

4. Romantic artists were inspired by a variety of sources including medieval art, nature, and the iconic writings of masters such as Shakespeare and Dante.

5. Romantic artists often depicted chivalrous heroes and miraculous events of the Middle Ages as well as natural phenomena such as raging rivers, storms, and misty mountains.

6. Romantic artists rejected the history painting of the Neoclassical style in favor of imaginary and exotic subjects.

Test Tip

Make sure that you can explain the political and philosophical differences between late 18th century styles of Neoclassicism and Romanticism.

B. Artworks from the image set

Image 106. Y no hai remedio (And There's Nothing to Be Done), from Los Desastres de la Guerra (The Disasters of War), plate 15. Francisco de Goya. 1810–1823 CE (published 1863). Drypoint etching.

 i. This print is from Goya's series, *The Disasters of War*, about the Spanish War of Independence from France.

 ii. The leading general of the Spanish army asked Goya to record the horrors imposed on the country by Napoleon's troops. His set of 80 etchings recorded atrocities committed by both sides in the conflict.

iii. In this etching, a bound and blindfolded man awaits his death by firing squad. A corpse lies next to him as a reminder of his fate.

iv. Goya chose to depict only the barrels of the guns of the executioners on the right side of the print to symbolize the lack of humanity exhibited by the French troops.

v. The horror and raw emotion of some of the prints were not well received by the public. This print was published in 1863, 35 years after the artist's death.

Image 108. Liberty Leading the People. Eugène Delacroix. 1830 CE. Oil on canvas.

i. This painting is a visual commemoration of the July Revolution of 1830, known as the Trois Glorieuses (Three Glorious days), against the anti-republican reign of Charles X, the last Bourbon king of France.

ii. Delacroix saw this painting as his contribution to the uprising. King Louis-Philippe, who gained the throne as a result of the uprising, kept the work out of public view either because of its perceived inflammatory message or because critics of the time had rejected it.

iii. The pyramidal composition depicts the crowd breaking down the barricades and making a final assault on the enemy.

iv. Delacroix depicted the personification of Liberty as an ancient Greek winged Victory figure yet included details symbolic of the lower class. The red cap (known as a Phrygian cap) symbolized freedom (because of its association with the caps worn by slaves in ancient Rome). The flag in her right hand and the infantry gun and bayonet in her left hand evoke the French Revolution of 1789.

v. The young boy behind her wears the student's black velvet beret and brandishes cavalry pistols.

vi. The man wearing the red ribbon and carrying an infantry saber is a factory worker, indicated by his apron.

vii. The man in the top hat represents the fashionable bourgeois and may be either the artist or a close friend of his. He is carrying a double-barreled hunting rifle.

viii. The towers of Notre Dame Cathedral are visible in the background, placing the scene in Paris, although their position is incorrect, and the houses are imagined.

Image 111. Slave Ship (Slavers Throwing Overboard the Dead and Dying, Typhoon Coming On). Joseph Mallord William Turner. 1840 CE. Oil on canvas.

i. This painting was first shown at the Royal Academy in London in 1840 during the same time as an Anti-Slavery League meeting attended by Crown Prince Albert. Seven years earlier slavery had been abolished in Britain. Ten years later, slavery was abolished in the rest of Europe.

ii. Turner was sympathetic to the Abolitionist movement, and this painting depicts the harsh reality of the slave trade. It also symbolizes the opposition of nature and civilization.

iii. At this time, it was common for slavers to throw dead or dying slaves overboard in order to be reimbursed for them by the insurance company, since they were considered to be lost cargo.

iv. The work is meant to evoke both sympathy and outrage, yet it also symbolizes the romantic views about the power of nature.

v. The loose brushwork and emotive power of Turner's colors inspired later Impressionist and Abstract Expressionist artists.

VI. HUDSON RIVER SCHOOL

A. Overview

1. A group of American artists, influenced by Romanticism in Europe, wanted to bring a similar style to the United States. They were based in New York City, but often worked in the nearby Catskill Mountains of upstate New York.

2. The art movement became the first uniquely American school of painting.

3. Their goals included the documentation of the many unspoiled landscapes of America, especially of the newly added West.

4. The artworks are a visual representation of the American idea of Manifest Destiny combined with the fearsome depictions of nature created by Romantic artists like Turner.

5. Since many Europeans mocked American artists for lacking a classical heritage, Hudson River School artists embraced the natural beauty of the continent as their unique heritage.

B. Artwork from the image set

Image 109. The Oxbow (View from Mount Holyoke, Northampton, Massachusetts, after a Thunderstorm). Thomas Cole. 1836 CE. Oil on canvas.

 i. Cole is regarded as the father of the Hudson River School style. He arrived in New York from England in 1825 with the idea of becoming a landscape painter. His first paintings to become well known were made from sketches done while sailing up the Hudson River.

 ii. Cole went on several tours of Europe and brought the Romantic style back with him to the United States, but applied it to depictions of great American landscapes.

 iii. In this painting, Cole juxtaposed the wild against the settled areas of the landscape.

 iv. Cole included himself in the middle ground symbolizing his role in this uniquely American style and subject matter.

 v. The high horizon line allowed artists to paint sweeping land views, which emphasized Manifest Destiny and the potential of the continent.

VII. LATE 19TH CENTURY AND EARLY 20TH CENTURY DEVELOPMENTS IN ARCHITECTURE

A. Overview

1. Due to new production methods developed as a result of the Industrial Revolution, cast iron began to be used in the late 18th century in Britain. The result was the construction of fireproof mills and factories, large iron and glass conservatories built for the Queen and aristocracy of England, and the creation of prefabricated architectural components, which speeded up the process of some building projects.

2. Although cast iron is a strong material in compression, its ability to withstand tension is weak due to impurities. When it failed it did so in an explosive manner and with little warning.

3. In 1856, Sir Henry Bessemer designed the Bessemer process in Britain, the eventual result of which was mass-production of cheap steel. The new material, stronger and more durable than iron, was soon used for railroad ties, building supports, tools, etc.

B. Artworks from the image set

Image 112 (three images). Palace of Westminster (Houses of Parliament). London, England. Sir Charles Barry and Augustus W.N. Pugin (architects). 1840–1870 CE. Limestone masonry and glass.

 i. A huge fire in 1834 destroyed a large part of the palace. The event was immortalized by J.M.W. Turner, who made several paintings depicting the fire.

 ii. Several styles were proposed for the rebuilding, including the Neoclassical style. The association of the style with both the United States and also general revolutionary and anti-monarchy sentiments led it to be rejected in favor of the Perpendicular Gothic style of the 15th century.

 iii. The Perpendicular Gothic style was considered to be beautiful and mysterious, which appealed to the Romantic ideals of the time.

 iv. The new design incorporated the surviving Westminster Hall, the Undercroft Chapel, and the Cloisters.

 v. Barry won the commission after a public competition and recruited Pugin, who was an expert in Gothic architecture. The building was not completed until 10 years after Barry's death.

 vi. The layout was custom-designed for use by the English Parliament. It linked the three elements of Parliament by placing the Throne Room, the Lord's Chamber, and the Commons Chamber in a straight line.

 vii. The new structure towered over most of the existing structures of the city and had a large influence on the design of many later public buildings.

Image 124 (three images). Carson, Pirie, Scott and Company Building. Chicago, Illinois, U.S. Louis Sullivan (architect). 1899–1903 CE. Iron, steel, glass, and terra cotta.

 i. The building was considered to be very advanced for its time because of its notably large windows, allowing for the display of goods, and its clear geometry.

 ii. This is an example of the Chicago Style of architecture created by Sullivan, who is famous for his motto "form

follows function." Sullivan is credited with inventing the skyscraper.

iii. Paradoxically, Sullivan also is well-known for his highly detailed ornamentation of buildings. He considered ornamentation at the base of a building to be functional because he felt that it would attract consumers.

iv. The ornament on the building is Art Nouveau, a style that embraced natural decorative elements.

 VIII. MODERNISM

A. Overview

The 19th century brought many changes to European civilization. These include:

1. The Industrial Revolution, during which Britain led the way by providing cheap labor, new farming methods, medical advances (which resulted in a population explosion), a highly developed banking system, and an abundance of scientists.

2. Increased urbanization and new forms of transportation, which resulted in the alienation of individuals.

3. A long history of abuse, which resulted in urban working class misery and led to the formation of labor unions.

4. A growing economy, which allowed the bourgeoisie to enjoy increased prosperity and leisure time.

5. The emergence of Socialism as an attempt to cure modern society's ills.

6. A new collection of styles of art collectively known as "modernism." Art made from the 1860s and after is known as "modern" or "modernist" and is characterized by the following:

i. The artists' desire to depict the ideas and images of their time in a realistic manner.

ii. A critical reflection on art and aesthetics with less emphasis on realistic depictions.

iii. An open acknowledgment of the illusions and artifices of art.

iv. Increasing independence, and an eventual break from, official exhibitions such as the Salon shows.

v. Less emphasis on patronage and more on artists exploring their unique visions of the world. This is sometimes called "art for art's sake."

Test Tip

It is important to understand the meaning of the terms "modern" and "modernist" as well as why these styles were a complete change from all previous periods of art history.

IX. PHOTOGRAPHY

A. Overview

1. Photography was a controversial new medium considered at first to be more mechanical than artistic because of the link to the Industrial Age associated with mass production.

2. The earliest photography process was both time-consuming and messy and did not produce a high-quality image.

3. The invention of the daguerreotype and subsequent revisions of the process allowed exposure times to evolve from 15–30 minutes in 1839 to 10–60 seconds in 1842.

4. In 1888, George Eastman developed the first snapshot camera, making photography accessible to the public.

5. Portraiture became the first popular subject matter for photographers.

6. In the late 19th century, the new developments in photography allowed painters and sculptors to turn inward for aesthetic approaches and to free themselves from realism.

7. Some artists who retained a realistic style embraced photography as a means of obtaining references for their work.

B. Artworks from the image set

Image 110. Still Life in Studio. Louis-Jacques-Mandé Daguerre. 1837 CE. Photograph.

i. This was one of the first successful prints made after perfecting the daguerreotype process.

ii. Unlike earlier processes, this one captured a wide range of values and details.

iii. Daguerre was inspired by 17th century Dutch still-life paintings but, instead of symbolizing the vanity of life, he refers to the morbidity of art using the new medium of photography.

iv. The inclusion of objects that have a textural quality is also a reference to Dutch Baroque still lifes.

Image 117. The Horse in Motion. Eadweard Muybridge. 1878 CE. Photograph.

i. Muybridge was the first to document movement using a series of trip wires and cameras.

ii. This set of images was a revision of an earlier attempt at a series commissioned by Leland Stanford (founder of Stanford University). He had a wager with a colleague over whether a horse in full gallop is ever airborne and wanted Muyridge to prove him correct.

iii. The series was highly respected and was published in scientific journals.

iv. This series led to the artist's invention of the zoopraxiscope, which was an early form of a motion picture projector.

Image 127. The Steerage. Alfred Stieglitz. 1907 CE. Photograph.

i. Stieglitz was a major force in the elevation of photography to the status of fine art. He ran an art gallery and published photographic journals, which helped prove the artistic worth of the new medium.

ii. This work is considered to be the first modernist photograph. Prior to this photo, photographers tried to emulate painters in style and subject matter.

iii. In creating this work, Stieglitz embraced the medium as a tool to be used to depict modern life. His work influenced numerous photographers.

iv. Modernist ideas are reflected in the realistic portrayal of upper and lower class immigrants arriving together amidst the dark tones that reflect the pollution generated by the Industrial Age.

The link between the invention of photography and modern art is important. Make sure that you can explain why this is so.

X. REALISM

A. Overview

1. Realism was characterized by a disenchantment with Romanticism, which was perceived as unrealistic to the lives of everyday people.

2. It was the first art movement to embrace the idea of art for art's sake rather than art created for a patron and is accordingly considered to be the first of the avant-garde art movements of the era.

3. The artworks provided a critical view of the new industrial world and the greed of the wealthy. Subject matter often exhibited sympathy with the working class.

4. Wealthy collectors at first did not embrace the movement's desire to depict a truthful vision of modern life.

5. The influence of the new medium of photography is evident in the cropped compositions and the massing of values.

6. The term "realism" refers more to the depiction of realistic events than to the style of painting.

B. Artworks from the image set

Image 113. The Stone Breakers. Gustave Courbet. 1849 CE (destroyed in 1945). Oil on canvas.

i. Courbet turned from his wealthy bourgeoisie upbringing and embraced a Bohemian lifestyle.

ii. This genre painting reflects Courbet's desire to paint ordinary French people. He rejected the glamorous style favored by most French artists and patrons of the time period.

iii. In this painting, the artist depicted two men in tattered clothing engaged in hard labor, with a dignity usually reserved for religious scenes or for depictions of the upper class.

iv. The boy seems too young and the man too old for the difficult task, symbollizing the start and end of the difficult life of a French peasant.

v. The composition, with very little sky depicted, isolates the men and makes them appear trapped.

vi. Unlike Millet, who idealized the peasant life, Courbet depicted the harsh reality of the working poor of France.

Image 114. Nadar Raising Photography to the Height of Art. Honoré Daumier. 1862 CE. Lithograph.

i. Daumier was known for his realist genre scenes and his satirical drawings now known as political cartoons.

ii. In this lithograph first published by *Le Boulevard* in 1863, Daumier depicted the well-known photographer (and friend of his) Nadar creating the first aerial photographs.

iii. The drawing is a witty comment on both the success of the new medium, which was only 23 years old at the time, and the debate about the artistic value of the medium.

Image 115. Olympia. Édouard Manet. 1863 CE. Oil on canvas.

i. Manet is generally considered to be the first truly modernist painter.

ii. His deliberately shocking work was influential to the group of artists who would later be called the Impressionists.

iii. Some of Manet's paintings were inspired by classical works and re-imagined in modern settings in order to comment on modern society.

iv. Manet was inspired by the work of Venetian school artists Giorgione and Titian. Unlike the reclining female nudes of the Venetian school, though, Olympia is not a mythological figure, nor is she meant to be viewed in private.

v. The painting was considered to be scandalous at the time because the nude woman is obviously a prostitute (the name "Olympia" was commonly used by prostitutes at the time) and because she is unabashedly looking directly at the viewer.

vi. Unlike the Romantic paintings by Ingres, Olympia is not depicted as originating from an exotic locale.

This reminder of the harsh reality of modern European society was considered to be distasteful.

vii. The deliberate reference to Titian's Venus of Urbino offended critics. Manet replaced the loyal dog of the original painting with a cat, symbol of independence and a symbol for brothels.

viii. The flowers presented to Olympia contrast the clothing meant to cover Venus of Urbino.

ix. The large scale of the work defied convention for the subject matter.

x. The artistic style of the work was influenced by the new medium of photography, with bold brush strokes, simplified forms, and massed values.

xi. The style of Manet's paintings influenced the Impressionist style, but the subject matter of his works clearly links him to the Realists.

XI. IMPRESSIONISM

A. Overview

1. The first Impressionist exhibit was held in Paris in 1874 under the original name of the group, the "Anonymous Society of Painters, Sculptors, Printmakers, etc."

2. Each member had a unique style and point of view, but they were united in their desire for independence from The Salon (the annual or bi-annual art exhibition of the Académie des Beaux-Arts).

3. The Impressionists were united in their emphasis on depictions of modern life and their rejection of established European styles.

4. The Impressionists embraced new experimental and avante-garde ideas and incorporated new techniques such as short, choppy brushstrokes, the use of pure, bright color, and the depiction of the effects of light.

5. Like many modernist art movements, Impressionism was influenced by the availability of photography, which allowed artists to depict the world as they chose to.

6. There is a sense of spontaneity in their artwork, combined with carefully planned compositions that reflect the influence of the medium of photography.

7. The use of new synthetic pigments and ready-made paint allowed them to paint outdoors, known as plein air painting, an idea that originated with the Barbizon School artists.

8. The movement had a short lifespan. By 1886, many of the original Impressionists had moved on to more personal styles of painting.

9. In 1853, after more than 200 years, Japanese ports reopened to trade with the West, and woodcut prints by Japanese masters of the ukiyo-e (floating world) tradition, as well as other East Asian objects such as fans, kimonos, etc. became easily available in Europe. These prints and items had a significant effect on the artwork of most of the Impressionists (as well as on the Post Impressionists) and was later referred to as Japonisme.

B. Artworks from the image set

Image 116. The Saint-Lazare Station. Claude Monet. 1877 CE. Oil on canvas.

 i. This was one of a series of paintings Monet did depicting the Saint-Lazare train station.

 ii. In this series he continued his earlier efforts to explore atmospheric effects, from the rendering of billowing steam to light's play with color.

 iii. After years of painting the countryside, Monet decided to paint a series of urban landscapes. The choice of a train station is symbolic of the time period and the many changes taking place in transportation.

Image 119. The Burghers of Calais. Auguste Rodin. 1884–1895 CE. Bronze.

 i. Rodin won the commission for this sculpture for the town of Calais by submitting an unconventional design.

 ii. The sculpture depicts a story from the Hundred Years War with England, when six distinguished citizens of Calais went into voluntary captivity to save the town from destruction by King Edward III.

iii. Rodin based his depiction on the writings of Froissart, who chronicled the event.

iv. Rodin chose to depict the men as miserable and dejected rather than heroic and unafraid. Each one is contemplating his own future.

v. Rodin designed the work to be viewed almost at ground level, so the viewer could be closer to the drama.

Image 121. The Coiffure. Mary Cassatt. 1890–1891 CE. Drypoint and aquatint on laid paper.

i. In 1890, the École des Beaux-Arts in Paris held an exhibition of Japanese ukiyo-e woodblock prints. The exhibit inspired several Impressionist artists to experiment with printmaking as well as to incorporate the style of Japanese prints.

ii. This print is one of only a few nudes by Cassatt, who was well-known for her depictions of women and children.

iii. Cassatt made a series of ten prints for an exhibit at a Paris gallery in 1891.

iv. The private moment depicted in this work, the spare composition, the tilted perspective, and the simplicity of both line and form are all directly influenced by the Japanese prints that she admired.

XII. POST-IMPRESSIONISM

A. Overview

1. In the 1880s, a group of artists decided to break away from the Impressionists by expressing emotion and symbolism in their work. They chose to turn away from capturing optical phenomena and incorporated more of their imaginations in their work.

2. They retained some of the aesthetics of Impressionism in the use of bright colors, the freedom from traditional subject matter, and the use of color to define form. Some artists also used short, choppy brushstrokes.

3. Most Post-Impressionist artists worked in isolation and continued to depict modern society in individualized ways.

4. Like the Impressionists, many of the artists who worked in this style were inspired by Japanese prints.

B. Artworks from the image set

Image 120. The Starry Night. Vincent van Gogh. 1889 CE. Oil
on canvas.

 i. Van Gogh was mostly self-taught and was one of the most
productive artists of his time.

 ii. Many of his paintings explored traditional subject
matter such as landscape, portraiture, and still life using a
non-traditional approach to the medium of painting.

 iii. The bright colors and loose brushwork that he used were
inspired by the work of the Impressionists and Pointillists
that he met in Paris. He developed a style that made use
of his emotional and psychological response to his subject
matter.

 iv. This work is a combination of direct observation, emotion,
and imagination.

**Image 123. Where Do We Come From? What Are We? Where
Are We Going?** Paul Gauguin. 1897–1898 CE. Oil
on canvas.

 i. This painting depicts the artist's fascination with Tahitian
life and culture, with which he became familiar while
searching for a place to work in isolation from modern
society after he became disillusioned with his career as a
stockbroker in Europe.

 ii. The symbolism represents the cycle of life from birth
through old age.

 iii. This is a very personal artwork done prior to a suicide
attempt.

 iv. Gauguin is known for his masterful use of color for
emotive potential.

Image 125. Mont Sainte-Victoire. Paul Cézanne. 1902–1904 CE.
Oil on canvas.

 i. This is one of many paintings that included Mount Sainte-
Victoire and was created during the last years of Cézanne's
life.

 ii. In this work, as in his earlier still lifes and other paintings,
Cézanne was exploring the use of color to create form and
volume.

 iii. This is one of the many paintings that ignore mathematical
perspective in favor of a more perceptual approach.

 iv. Cézanne's attempt to show multiple viewpoints would inspire the Cubist art movement of the 20th century.

Image 122. The Scream. Edvard Munch. 1893 CE. Tempera and pastels on cardboard.

 i. Munch was influenced by the Post-Impressionist artworks that he viewed, but he was not officially part of the group because he lived and worked in Norway rather than in Paris.

 ii. The work is one of four versions of the image that he created between 1893 and 1910.

 iii. The image was originally part of a series called *Frieze of Life* that explored modern existence. This one uses angst and alienation as the central theme.

 iv. Munch's work is considered to be associated with the symbolists of the 1890s and is thought to be a precursor of 20th century Expressionism.

Many art movements of the mid-19th century and beyond were reactions to previous art movements as well as to technological innovations and current events. You should understand where each style falls in the continuum of art history and be able to explain the external influences on the style.

XIII. AUSTRIAN SECESSION

A. Overview

1. Society changed rapidly during that late 19th and early 20th centuries. The Second Industrial Revolution occurred when new technologies were developed in the areas of steel production, chemicals, power, and communication.

2. Due to advances in medicine and agriculture, Europe's population grew from 193 million in 1800 to 423 million in 1900.

3. Millions of people immigrated to the United States, and more people lived in cities than in rural areas.

4. The art of this period is part of the fin de siècle (end of the century or era) culture and is characterized by decadence, excitement about the impending changes, and despair over unavoidable changes and the end of an era.

5. In 1897, a group of Austrian artists who objected to the conservatism of the Vienna art establishment created their own exhibition space.

6. The group had a liberal policy and allowed French Impressionist works to be exhibited alongside Austrian works.

7. The style of the artwork is heavily based on the Art Nouveau works done in France, Britain, Belgium, and America.

8. In 1905, Gustav Klimt and other artists left the Vienna Secession due to differences of opinion over artistic concepts.

B. Artwork from the image set

Image 128. The Kiss. Gustav Klimt. 1907–1908 CE. Oil on canvas.

 i. Klimt's unique style combines elements of symbolism, Arts and Crafts, and Art Nouveau.

 ii. He became a sought after portrait painter who specialized in depicting Viennese society ladies.

 iii. This piece depicts the melding of two people in a style that is emotional and decorative.

 iv. The use of gold leaf and the highly decorated surface is inspired by medieval book covers, illuminated manuscripts, and Byzantine mosaics.

 v. The simplified composition and shapes were influenced by Japanese prints.

XIV. THE 20TH CENTURY

A. The 20th century was marked by technological innovations as well as political upheaval.

B. Some of the impact of technological innovations was seen in the following:

1. The airplane (1903), the rocket ship (1931), the helicopter (1939).

2. Moving pictures (1903).

3. Einstein's Theory of Relativity (1905), Freud's theories about sexuality (1905).

4. The automobile (1908).
5. Plastic (1909).
6. Discovery of penicillin (1928).
7. Atomic weapons (1930s–1940s).

C. Some of the political and economic upheavals included:

1. The Chinese Revolution (1911).
2. World War I (1914).
3. The Irish uprising (1916).
4. The Russian Revolution (1917).
5. The stock market crash (1929).
6. Italian Fascism (1922).
7. The Indian Uprising (1930).
8. World War II and the Holocaust (1939).
9. The Spanish Civil War (1936).

D. Many different art movements emerged during this period, and all are characterized by a desire to be modern, a response to current events, an influence of new ideas and innovations, a sense of uncertainty caused by the many political upheavals of the time, and a desire to make art for art's sake.

E. Americans were introduced to modern European art in 1913 at the Armory Show in New York City. Over 1,200 works by more than 300 artists were exhibited. The artwork horrified most of the American public but inspired many American artists.

XV. FAUVISM

A. Overview

1. The Fauvist style was the first of the French avant-garde movements of this period.
2. Led by French artists Henri Matisse and André Derain, the Fauvists broke from Impressionism and Post-Impressionism and sought a new form of perception.

3. Referred to as "fauves" (meaning wild beasts) by critics, this group's style is characterized by bold brushstrokes, unrealistic vibrant color often used straight from the tube, and a rejection of traditional three-dimensional space.

4. Fauvism, and later Cubism and Expressionism, were highly influenced by African sculpture. In the late 1800s, Africa was divided up among the European powers, and thousands of African art objects were brought to Europe. These objects were considered to be primitive at the time.

5. Avant-garde artists were among the first to see aesthetic value in African artworks. They were drawn to the abstraction of human figures, the integration of form and function, the use of exaggeration, and the use of simple and sometimes decorative forms.

B. Artwork from the image set

Image 131. Goldfish. Henri Matisse. 1912 CE. Oil on canvas.

i. This is one of several paintings of goldfish, which were introduced to Europe from East Asia in the 17th century.

ii. This painting, like many Fauvist artworks, uses color in a way that was initially considered to be jarring.

iii. The placement of complementary colors in close proximity to each other makes each one more active than they would otherwise be.

iv. Like most of Matisse's paintings, this work breaks with traditional approaches to color.

XVI. CUBISM

A. Overview

1. Led by Spanish artist Pablo Picasso and French painter Georges Braque, Cubists sought a new approach to space that built on the ideas of Post Impressionist artists like Cézanne.

2. Picasso was highly influenced by African as well as Iberian (Spanish) native art and even incorporated mask-like faces in many of his paintings.

3. Cubist artwork is characterized by the use of fragmented forms, the depiction of multiple angles at once (rather than a single viewpoint), simplified depictions of objects, and the desire to challenge viewers' notions about reality and perception.

4. The Cubist invention of a new technique known as collage was influential to many 20th century artists.

B. Artworks from the image set

Image 126. Les Demoiselles d'Avignon. Pablo Picasso. 1907 CE. Oil on canvas.

i. In this painting, Picasso builds on Manet's Olympia, completed 44 years earlier, by using an aesthetic style directly related to African art to depict prostitutes.

ii. Like Olympia, they stare directly at the viewer, unashamed of their nudity, and, like Manet's painting, the work offended viewers initially.

iii. The final painting was the result of more than 100 preparatory sketches and several reworkings. The final work was the first to use what would later be called the Cubist style.

iv. Picasso compared this work to the creation of fetishes or weapons in so-called primitive cultures, in which spirits are given form.

v. This painting was mostly unseen for 39 years after its initial showing in a Paris gallery, but was later embraced by the Surrealists.

Image 130. The Portuguese. Georges Braque. 1911 CE. Oil on canvas.

i. This painting depicts a guitar player on a dock, broken up into smaller elements and rearranged.

ii. The central idea of Cubism was the attempt to show numerous viewpoints simultaneously. The result often seems abstract but actually is not.

iii. The letters Braque added to the painting make the viewer aware of the surface of the painting as a constructed object rather than an illusion of reality.

Image 129. The Kiss. Constantin Brancusi. 1907–1908 CE. Limestone.

 i. Although Brancusi was not actually a Cubist, this work was inspired by the geometric forms he saw in Cubist paintings.

 ii. Like other artists of the time period, he was influenced by the so-called primitive art of Africa. He also studied Assyrian and Egyptian art and incorporated their methods of direct carving into his work. He was the first modern sculptor to do this.

 iii. Rodin, who Brancusi had assisted earlier in his career, had produced a realistic artwork of the same title about twenty years earlier. Brancusi's version of the theme was an attempt to depict a modern approach focused on the essence of the idea.

 iv. Brancusi's artwork was influential to many 20th century artists including the Minimalists of the 1960s.

XVII. PRAIRIE STYLE

A. Overview

 1. Created by American architect Frank Lloyd Wright, who had worked with Louis Sullivan, the style was inspired by the large horizontal expanses of the American Midwest.

 2. Wright's work is characterized by designs that blend with their surroundings; designs that allow freedom of movement and incorporate outdoor spaces; the inclusion of a hearth at the center of the home; and the use of cantilevered construction.

B. Artwork from the image set

Images 139 (three images). Fallingwater. Pennsylvania, U.S. Frank Lloyd Wright (architect). 1936–1939 CE. Reinforced concrete, sandstone, steel, and glass.

 i. This vacation home was designed for the Kaufmann family and appeared on the cover of *Time* magazine in 1938. The clients were very interested in modern art and in Wright's work. Wright surprised them with a plan that placed the house on top of the waterfall located on

the property. The use of cantilever construction allowed Wright to hang the house over the falls.

ii. In typical Wright fashion, the design is in harmony with nature and appears to be part of the waterfall and rocks.

iii. The house was inspirational to many later architects.

XVIII. EXPRESSIONISM

A. Overview

1. One group of Expressionists that was formed in 1905 was called Die Brücke (The Bridge) because they wanted to be the bridge between the past and the future. The name and idea were inspired by Friedrich Nietzsche's *Thus Spoke Zarathustra*. The group was led by German artists Ernst Ludwig Kirchner and Emil Nolde, who sought to show their displeasure with the effects of industrialization on Germany.

2. The other Expressionist group was called Der Blaue Reiter (The Blue Rider), formed in 1911 and led by Russian artist Vassily Kandinsky and German artist Franz Marc. They sought to express inner truths through color and abstraction.

3. Expressionist artwork is characterized by the expression of inner feelings about the modern world; the use of Fauvist-inspired intense color; and the influence of Symbolism, especially the work of Munch.

4. Artworks from so-called primitive cultures like Africa and Central Asia were influential to these artists because of their perceived honesty and simplicity.

B. Artworks from the image set

Image 133. Self-Portrait as a Soldier. Ernst Ludwig Kirchner. 1915 CE. Oil on canvas.

i. In this painting, made two years after Die Brücke disbanded, Kirchner depicted himself dressed in uniform with an amputated arm and a nude model behind him.

ii. Kirchner had volunteered to serve in the German military in World War I (The Great War) but he was discharged

for health reasons. The painting was completed when he returned home.

 iii. The amputation is a metaphor for his artistic difficulties after his discharge.

 iv. The angular forms of the work are derived from African masks and figures.

 v. Although Kirchner's work was well received internationally, it was rejected by Adolf Hitler in 1933, along with all modern art. The Nazi Degenerate Art exhibition of 1937 included 32 of Kirchner's artworks. The rejection drove Kirchner to suicide in 1938.

Image 134. Memorial Sheet for Karl Liebknecht. Käthe Kollwitz. 1919–1920 CE. Woodcut with white and black ink added.

 i. Kollwitz was not an official member of either Expressionist group, although she was influenced by their aesthetics.

 ii. This image was made in response to the assassination of the Communist leader Karl Liebknecht in 1919, during a time of social upheaval in Germany.

 iii. After the subject's death during a failed Communist uprising, his family commissioned Kollwitz to create this artwork.

 iv. The composition is deliberately evocative of Christian lamentation scenes.

 v. Like many of Kollwitz's works, the focus of this piece is on common people, in this case the workers, affected by tragedy and conflict.

 vi. Kollwitz was the first woman accepted into the Prussian Academy of Arts, which provided her with a studio, income, and professorship. She often depicted the unique concerns of women and children in her work. In this print she placed a woman holding a baby among the mass of workers paying respect to the deceased.

 vii. Although she did not align herself officially with the Communist party, her work often portrayed the downtrodden and less fortunate in modern society.

 viii. After the death of her son in World War I, she made many artworks depicting the effects of war on regular citizens.

Image 132. Improvisation 28 (second version). Vassily Kandinsky. 1912 CE. Oil on canvas.

i. This painting is one of the first modern abstract artworks.

ii. The painting is a marked departure from Kandinsky's earlier landscapes though it still retains a narrative quality. This is one of many paintings that portrayed apocalypse (on the left side) and salvation (on the right side).

iii. Kandinsky was influenced by music, especially the compositions of Wagner, and he often named his paintings using musical terms.

iv. It is believed that Kandinsky had a condition called synesthesia, allowing him to see sound and hear color.

v. Kandinsky's work used color as an expressive tool. His work was influential to many 20th century artists.

XIX. DADA

A. Overview

1. World War I (The Great War) of 1914–1918 had a devastating effect on European life. New technologies created terrible weapons of mass destruction that killed approximately 10 million people.

2. The modern form of warfare resulted in a newly classified psychological condition known as "shell shock," or what is currently called post-traumatic stress disorder. In addition, there were widespread feelings of disillusionment with the modern world and technology, coupled with anxiety about the future.

3. The *Dada Manifesto* was written in 1918 by Tristan Tzara, a Romainian-born French poet and essayist. Begun simultaneously in Zurich, Switzerland, and New York City, the Dada art movement was a direct reaction to World War I.

4. Many artists fled Europe for Zurich or New York, and, while waiting out the war, they created an art movement that defied all of the artistic traditions of the past and showed their distrust of the modern world.

5. Dada artwork is characterized by a sense of humor, absurdity, and satire combined with an embracing of ideas about randomness and chance.

6. The use of innovative materials such as found objects, photos, and sound, and new techniques such as collage, photomontage, and assemblage, were a departure from traditional media.

B. Artwork from the image set

Image 144. Fountain (second version). Marcel Duchamp. 1950 CE. (original dated 1917). Readymade glazed sanitary china with black paint.

i. This artwork, known later as a readymade, was created for inclusion in the first annual exhibition in New York of the American Society of Independent Artists, of which Duchamp was the director.

ii. When the work was rejected, despite the fact that all artists who paid the entry fee were supposed to be exhibited, Duchamp resigned as director.

iii. Duchamp submitted the work under a fictitious name (R. Mutt), and Alfred Stieglitz photographed it soon after its rejection. The original was lost soon after but was re-made several times starting in 1938.

iv. Louise Norton, who some scholars believe may have given Duchamp the idea for the work, wrote a defense of the artwork as a letter to the editor of a Dada art journal called *The Blind Man*. In her defense, she compared the work to images of meditating Buddhas from East Asia and to Cézanne's paintings of curvaceous women. It was one of several articles defending the work that were published in art journals.

v. This artwork marked the beginning of a new approach that questioned what can be considered art.

vi. Duchamp considered this artwork to be a piece of anti-art, and like all Dada artworks, it embraced the absurd in order to call attention to societal constructs about art.

 XX. NEOPLASTICISM/DE STIJL AND BAUHAUS

A. Overview

1. Led by Dutch artists Piet Mondrian and Theo van Doesburg, Neoplasticism and De Stijl sought to create a rational utopian society through the use of geometric abstraction. The style applied to architecture, industrial design, furniture design, and fine art.

2. The style was an attempt to make sense of a world that had been turned upside down by World War I.

3. The artwork is characterized by the desire to create a new reality based on a principle of vertical and horizontal lines of various thicknesses, along with the use of geometric forms (particularly squares and rectangles) combined with blocks of primary colors on a white ground.

4. Inspired by Russian Constructivism and De Stijl artworks, German architect Walter Gropius created the Bauhaus school in Germany, which had a huge impact on design and architecture. He published *The Proclamation of the Bauhaus* in which he described his vision for a guild-like school that combined architecture, furniture design, industrial design, textile design, typography, and fine arts. It called for a crafts-based curriculum that would allow the creation of beautiful, functional objects and classes taught mostly by avant-garde fine artists.

5. Bauhaus work is characterized by a desire to create beautiful objects for mass production; a desire to create rational works that were the exact opposite of the highly emotional German Expressionist works; the use of simplified forms; and architecture that makes use of steel-frame construction and glass.

6. When it became popular across Europe, especially as an architectural style, Bauhaus became known as the International Style mostly due to the original name's association with Germany during a time of widespread anti-German sentiment.

7. International Style architecture is devoid of ornamentation and uses straight lines, asymmetry, and sleek designs. The goal was to create architecture that was functional, beautiful, and efficient.

8. During the years of World War II, all of the key figures of the Bauhaus, which was rejected by the Nazi regime, emigrated from Germany to Britain, the United States, and Palestine

(called Israel after 1948) where their work and their modernist philosophy influenced numerous young architects and designers.

B. Artworks from the image set

Image 136. Composition with Red, Blue and Yellow. Piet Mondrian. 1930 CE. Oil on canvas.

 i. Mondrian's early work was in the Cubist style. His pursuit of an honest and pure style led him to create a unique aesthetic using only the primary colors plus white and gray with black horizontal and vertical lines separating squares and rectangles.

 ii. Although the colors appear to be flat, Mondrian used textural brushstrokes in his paintings.

 iii. Mondrian wrote extensively about his artistic theories, and although his work was appreciated almost exclusively by fellow artists during his lifetime, his style inspired many designers from the 1960s onward.

Image 135 (two images). Villa Savoye. Poissy-sur-Seine, France. Le Corbusier (architect). 1929 CE. Steel and reinforced concrete.

 i. This is an early example of the International Style of architecture created in a suburb of Paris.

 ii. The home was designed to be a machine for living and features a modular, asymmetrical design raised on stilts to make use of the land underneath.

 iii. It is completely devoid of historical ornament and was deliberately painted white to evoke purity and simplicity.

 iv. The interior features an open plan with spiral staircases and ramps connecting floors.

 v. The ribbon windows are reminiscent of industrial architecture and provide lots of light.

 vi. The roof contains a garden, and the garage is integrated into the house.

Image 146. Seagram Building. New York City, U.S. Ludwig Mies van der Rohe and Philip Johnson (architects). 1954–1958 CE. Steel frame with glass curtain wall and bronze.

 i. This is one of the best examples of curtain-wall architecture, although Lever House, located across the street, was the first to use this technique.

ii. This office building prompted new city codes that required public space on the ground floor to make up for the height. The building contains a plaza with two fountains in front.

iii. The bronze and dark glass that make up the non-weight bearing exterior created a dramatic effect that inspired many later architects.

XXI. SURREALISM

A. Overview

1. The *Manifesto of Surrealism* was written by poet and critic André Breton in 1924. Influenced by the ideas of Sigmund Freud, it began as a writers' movement and quickly spread to art.

2. Led by German artist Max Ernst, Belgian artist René Magritte, and Spanish artists Joan Miro and Salvador Dali, the group sought to express the working of the subconscious mind through visual arts.

3. Many Dada artists gravitated toward Surrealism after World War I.

4. Surrealist artwork is characterized by a realistic style coupled with dreamlike imagery, the use of automatism to tap into the subconscious, provocative and often erotic imagery, and a disdain for convention.

B. Artwork from the image set

Image 138. Object (Le Déjeuner en fourrure). Meret Oppenheim. 1936 CE. Fur-covered cup, saucer, and spoon.

i. This artwork was made for the first Surrealist exhibition dedicated to objects and was inspired by a conversation with Pablo Picasso and his mistress Dora Maar at a Paris café.

ii. When Picasso admired her fur covered bracelet and made the remark that anything could be covered in fur, the artist decided that even her teacup and saucer would benefit from the texture.

iii. Oppenheim used Chinese gazelle fur to cover an ordinary cup, saucer, and spoon, transforming it from a utilitarian object into a sculpture.

iv. Oppenheim did not intend for the work to have overly psychological or sexual meaning. Her intentions were centered on the texture of the fur versus the ceramic form as well as the absurdity of the combination.

v. Many viewers and critics brought their own interpretations to Oppenheim's artworks, which caused distress to the artist. She felt that the sexual connotations imposed on the work were because she was female, and she stopped producing art for a number of years.

XXII. SOVIET AVANT-GARDE

A. Overview

1. Led by Russian artist Vladimir Tatlin, who sought to make a new art form free from all of the traditions of the past and highly influenced by the Russian Revolution, the Constructivists sought to turn away from bourgeoisie ideas about art in the early 20th century.

2. Constructivist artwork is characterized by the use of new industrial materials such as steel and plastic, complete abstraction, and universal meaning.

3. The establishment of the USSR in 1922 was celebrated by numerous artists and intellectuals who saw it as the answer to many of the problems of modern society.

4. Photomontage, a technique first embraced by the Dada artists, became a favorite technique of artists seeking to serve the ideals of the USSR.

B. Artwork from the image set

Image 137. Illustration from *The Results of the First Five-Year Plan*. Varvara Stepanova. 1932 CE. Photomontage.

i. This artwork was published in a magazine called *USSR in Construction*, which was made for distribution in France, Britain, and the U.S. to show the achievements of the regime under Stalin.

ii. This photomontage depicts symbols of the success of the new nation including a portrait of the founder Lenin, an electrical tower, and crowds of people celebrating the new country.

iii. The limited color is deliberately reminiscent of the Soviet flag, and the image is a carefully constructed piece of propaganda. The letters CCCP are USSR in the Russian alphabet, and the 5 symbolizes the five-year plan.

iv. Although the five-year plan resulted in extreme poverty and famine for many citizens, propaganda images like this one focused only on the positive effects.

XXIII. LATIN AMERICAN AND AFRICAN AMERICAN ART

A. Overview

1. During the latter half of the 20th century, artists began to draw on their cultural heritage for inspiration.

2. Many Latin American and African American artists of the 20th century combined European modernist aesthetics with ethnic subject matter.

B. Artworks from the image set

Image 99. Portrait of Sor Juana Inés de la Cruz. Miguel Cabrera. c. 1750 CE. Oil on canvas.

i. Sor Juana Inés de la Cruz was a Mexican nun and writer who is now regarded as the first American feminist. She chose to enter a convent rather than marry, in order to pursue intellectual activities.

ii. Despite her talents as a writer, she was forced to give up her library and her writing due to restrictions placed on women, especially nuns, by the church. She died soon afterward while caring for victims of an epidemic.

iii. In this posthumous portrait, Cabrera depicted her among her treasured books and writing instruments.

Image 118. The Valley of Mexico from the Hillside of Santa Isabel (El Valle de México desde el Cerro de Santa Isabel). Jose María Velasco. 1882 CE. Oil on canvas.

i. Velasco studied at the Real Academia de San Carlos in Mexico, which was modeled after European art academies.

ii. This painting depicts the sweeping landscape of Mexico, incorporating the emotional content reminiscent of the German Romantic aesthetic.

iii. Velasco was part of a group of Mexican artists who tried to assert their independence from Spain (gained in 1821) by fusing European painting styles with native symbolism.

iv. The twin mountains in the background of the painting were important in Aztec mythology and were characters in a story about an ill-fated romance between Princess Iztacchihuatl and the warrior Popocatepetl.

v. Lake Texcoco, where the Aztec city of Tenochtitlán was located, is in the painting, as is the small hill in the middle ground where the story of the Virgin of Guadalupe who appeared to Juan Diego in 1531 originated.

vi. Velasco did several paintings of this landscape. In this one he included a small group of indigenous people travelling to the city, symbolizing the precarious relationship between the inhabitants and their native land.

vii. In the late 19th century Velasco's Romantic landscape paintings were displayed in the Mexico pavilion of several World Fairs.

Image 143. *Dream of a Sunday Afternoon in the Alameda Park.* Diego Rivera. 1947–1948 CE. Fresco.

i. This fresco, like most of his artworks, is a symbol of Rivera's desire to reveal the true history of Mexico, rather than the one told by the Spanish conquerors.

ii. He deliberately included people of all classes and physical attributes to counter the inherited prejudice against the indigenous people of Mexico.

iii. Alameda Park was the first park built in Mexico City, and in the late 19th century it became a popular destination for people of all classes in which to relax and stroll on the

weekends (a new concept that emerged from the labor laws of the late 19th century).

iv. Many of the figures Rivera included in the painting are historical figures from different periods in Mexican history. Sor Juana Inés de la Cruz, Hernan Cortez (whose explorations led to the Spanish conquest), Porfirio Diaz (whose dictatorship led to the Mexican Revolution), and other historical figures share the space with both upper and lower class people.

v. In the center, Rivera painted himself as a child with his future wife, Frida Kahlo, behind him, holding a yin and yang symbol. He is holding the hand of the figure of La Calavera Catrina ("Elegant Skeleton"), whose other hand grasps Jose Guadalupe Posada, the Mexican artist who originally created her and whose work was inspirational to Rivera.

vi. Skeleton figures were part of Aztec art before the Spanish conquest. Mictecacihuatl, the Queen of the Underworld in Aztec mythology, was always depicted as a skeleton. By adding Victorian clothing to the skeletons, Posada introduced satire of the Euro-centric upper classes of Mexico to his calaveras. His calavera figures may also have been inspired by memento mori (reminders of death) depicted in European art since the medieval period.

vii. Rivera's calavera may be a reference to the Aztec mother goddess Coatlicue. He depicted her wearing a feather boa reminiscent of the sacred feathers used in Aztec ceremonies honoring the god Quetzalcoatl, Coatlicue's son. She is depicted wearing European costume, as Posada depicted her in his well-known artwork.

viii. The mural is composed like a timeline, with the left side depicting the Spanish conquest, the middle showing the fight for independence and the revolution, and the right showing modern achievements.

Image 140. The Two Fridas. Frida Kahlo. 1939 CE. Oil on canvas.

i. Kahlo was a mostly untrained painter who found refuge from pain and sadness in the creation of art.

ii. This work, like most of Kahlo's artwork, puts her inner feelings on view. One of her many self portraits, this was completed during the time of her divorce from the painter Diego Rivera.

 iii. In this work she painted herself as two people. One Frida wears a Victorian wedding dress and is clamping the vein that leads through two hearts and ends in a miniature portrait of Rivera as a child. The other Frida is wearing the indigenous dress preferred by Rivera during their marriage.

 iv. Her work often referred to anatomy as metaphors for emotions as well as reference to her serious health problems.

 v. Kahlo's father was German and her mother was Mexican. Her artwork often reflects her dual European and Mexican identities by her costume.

Image 142. The Jungle. Wifredo Lam. 1943 CE. Gouache on paper mounted on canvas.

 i. Lam painted this after his return from Europe where he was a member of the Surrealist art movement.

 ii. In this work he depicted an emotional representation of the history of slavery in his native Cuba. He was the grandson of an Afro-Cuban slave on his mother's side. His father was a Chinese immigrant who came to Cuba in search of work.

 iii. The figures in the painting are reminiscent of African masks and sculptures with stylized sugar canes scattered among them. They are symbols of Afro-Caribbean culture, particularly the practice of Santeria, which is a mix of African spiritual ceremonies with Catholic symbolism.

 iv. Lam deliberately painted images of his native country that were evocative of the oppression of Afro-Cubans and the opposite of the stereotypes perpetuated by tourism of the era.

Image 141. The Migration of the Negro, Panel no. 49. Jacob Lawrence. 1940–1941 CE. Casein tempera on hardboard.

 i. Lawrence was inspired by the Harlem Renaissance of the 1920s and 1930s, and he often attended lectures and did research on African American history.

 ii. In 1940, he began the monumental task of painting a series of works depicting African American history.

iii. In this panel the artist depicts the unexpected prejudice that African Americans faced when they moved to the Northern United States. The yellow zigzagged line divides African American and Caucasian diners in a public dining space.

iv. Each panel was accompanied by a caption that helped tell the story in an objective manner.

v. While the text has an objective tone that reads like a textbook, the images are infused with emotion.

XXIV. ABSTRACT EXPRESSIONISM

A. Overview

1. World War II (1939–1945) had a great impact on society and on art. Millions of lives were lost, and many global borders were redrawn.

2. Several art movements were created during this time period. Although each one is unique, all had the following characteristics in common:

 i. They were created by American artists or by European artists working in America.

 ii. They were inspired by the postwar mindset and social changes.

 iii. They often utilized new, non-traditional art materials such as acrylic paint (invented in the early 1970s), airbrush, etc.

 iv. They draw little or no inspiration from classical art.

3. The early 20th-century American art movements of Regionalism and Social Realism were similar in style to the Socialist Realism popular in the USSR, but reactions to the Cold War and the McCarthy Era instilled amongst American artists a desire for an artistic approach that was the exact opposite of these prior movements.

4. The new avant-garde art movement, centered in New York City, attracted many European artists. As a result, the center of the art world shifted from Paris to New York City.

5. Abstract Expressionism had two varieties:

 i. Gestural Abstraction or action painting, which was led by Jackson Pollock and Willem de Kooning, was a style characterized by an energetic and expressive application of paint.

 ii. Chromatic Abstraction or color field painting, which was led by Mark Rothko and Barnett Newman, was a style characterized by the use of blocks and lines of color to express emotion.

 6. Abstract Expressionist sculptors, led by David Smith and Louise Nevelson, used three-dimensional media to create abstract works.

 7. All of the Abstract Expressionist styles were united by certain characteristics, including a questioning of the rationality that had brought about two world wars and the meaning of human existence as well as the emphasis on process versus product.

 8. Inspired by the Surrealists, they sought to tap into the subconscious mind. They broke with all of the preceding classical traditions and created purely abstract art.

B. Artwork from the image set

Image 145. Woman, I. Willem de Kooning. 1950–1952 CE. Oil on canvas.

 i. This painting combines many archetypal images of women, from fertility figures to pinup girls, into one image.

 ii. The energy seen in de Kooning's brushworks is typical of the Abstract Expressionist aesthetic.

 iii. He reworked this painting several times over a two-year period.

XXV. HARD EDGE OR POST PAINTERLY ABSTRACTION

A. Overview

 1. Created as a reaction to Abstract Expressionism and led by Frank Stella, they sought to use crisp lines and solid colors to express emotion.

2. Their work is characterized by a lack of recessional space, the use of canvases of different sizes and shapes, pure abstraction, and the lack of the painterly techniques used in the Abstract Expressionist works.

B. Artwork from the image set

Image 149. The Bay. Helen Frankenthaler. 1963 CE. Acrylic on canvas.

 i. Frankenthaler used unique methods of painting that involved soaking the canvas in diluted paint, or pouring the diluted paint, and/or lifting and turning a wet canvas to allow the paint to drip.

 ii. Although she was inspired by the drip paintings of Jackson Pollock, Frankenthaler's new method of avoiding brushwork and gesture inspired many other artists.

 iii. The intention of her work was to be the opposite of representational. She wanted the viewer to focus purely on the colors and shapes found in the work.

XXVI. POP ART

A. Overview

1. Led by Andy Warhol, Pop artists sought to create work inspired by American popular culture. Their work is characterized by the use of or reference to recognized imagery and modes of communication such as advertising, comic books, television, newspapers, and magazines.

2. Pop artists sought to point out that art is a commodity like any other. Pop artworks often depict a satirical view of popular American culture and consumerism by using recognizable imagery.

B. Artworks from the image set

Image 148. Narcissus Garden. Yayoi Kusama. Original installation and performance 1966 CE. Mirror balls.

 i. Although not officially a Pop artist, Kusama's artwork preceded and was highly influential to the Pop artists and the Minimalist artists of the 1960s and beyond.

ii. Many of her artworks utilize repetition of design elements, bright colors, and simple shapes. Some scholars believe that the repetition of design elements is related to obsessive tendencies.

iii. Her work includes paintings, sculptures, and installations and often deals with issues of the individual in relation to the built environment.

iv. This work was originally shown at the Italian pavilion of the 1966 Venice Biennale. The 1,500 silver mirror balls displayed on a lawn was the opposite of the room installations she was working on during that time period.

v. This artwork offered reflections of everything around it in contrast to previous installations that aimed at allowing the viewer to blend in and lose themselves in the patterns and color of the work contained in a space.

vi. Kusama was ejected from the exhibition when she began to offer the balls for sale at a price of 1200 lire (about two American dollars). Biennale officials accused her of selling her art like a vendor would sell hot dogs or ice cream.

vii. Many scholars believe that this artwork was actually a piece of performance art when it was shown in 1966. It has been interpreted as a comment on the commercialization of art.

viii. The installation has been shown in several other contexts and has taken on new meaning based on each location.

Image 147. Marilyn Diptych. Andy Warhol. 1962 CE. Oil, acrylic, and silkscreen enamel on canvas.

i. This is one of 20 or so works Warhol made in the months after Marilyn Monroe's death in 1962.

ii. All of the artworks in the series use an appropriated publicity photo from the 1953 movie *Niagara*.

iii. Like many of Warhol's artworks, this explores the concept of celebrity as it relates to consumerism in the United States of America.

iv. The contrast between the brightly colored images and the black and white ones may refer to the relationship between life and death or the public persona versus the private life of celebrities.

v. The use of gold is deliberately reminiscent of Byzantine icons.

Image 150. Lipstick (Ascending) on Caterpillar Tracks. Claes Oldenburg. 1969–1974 CE. Cor-Ten steel, steel, aluminum, and cast resin; painted with polyurethane enamel.

i. Oldenburg is well known for his large-scale sculptures of ordinary objects, which allow them to take on new meaning.

ii. Like Warhol and other Pop artists, he was interested in commenting on American politics and consumerism through art. This piece was his first sculpture made to be exhibited outdoors and is a comment on the Vietnam War, which was escalating at the time that this artwork was created.

iii. This sculpture was originally commissioned by students from the Yale School of Architecture as a means to disrupt a public space, to create a political statement, and to be used as a platform for public speakers to stand on while making anti-war speeches.

iv. The inclusion of the lipstick was in commemoration of Yale becoming a coeducational university, allowing female students into the undergraduate programs for the first time the same year that this work was installed.

v. The original site of the sculpture was among the columns of the schools' World War I memorial. By placing it there, Oldenburg, along with the students who commissioned it, made a subversive statement about the war.

vi. The red lipstick portion was originally made to be deflated when the platform was not in use and inflated to get students' attention before a rally.

vii. The current version was created of more permanent materials when the original one was damaged by deterioration and vandalism.

viii. Scholars have noted the mixture of male and female symbols in the work as well as the contrast between the sensual nature of the lipstick and the morbid aspects of the tank.

XXVII. EARTHWORK

A. Overview

1. Led by Robert Smithson, Earthwork artists sought to raise awareness of the environment through their art.

2. Their work is characterized by site-specific artwork, often placed in remote locations, and the use of natural materials or materials that interact with the landscape.

3. They continued the debate started by Duchamp about the definition of art. The desire to question assumptions about art combined with the desire to make art not meant to be displayed in galleries and museums (often with references to Neolithic site-specific works such as Stonehenge) challenged traditional notions about where and how art should be displayed.

B. Artwork from the image set

Image 151. Spiral Jetty. Great Salt Lake, Utah, U.S. Robert Smithson. 1970 CE. Earthwork: mud, precipitated salt crystals, rocks, and water coil.

i. This earthwork was constructed to take advantage of the changing water levels of the lake at various times of the year.

ii. Originally the work was mostly black, but salt encrustation has turned it white. The lake is naturally pink or red due to the bacteria and algae that thrive in the saline water.

iii. Smithson leased the site for a small annual fee and contracted the construction with money given to him by a New York gallery. The sculpture is now owned by the state of Utah.

iv. This work gained international recognition and was inspirational to many artists.

v. In creating this work, Smithson was challenging traditional notions about art, a subject that he had written about since 1964.

 LATE ARCHITECTURE

A. Major Work

> **Image 152 (two images). House in New Castle County.** Delaware, U.S. Robert Venturi, John Rauch, and Denise Scott Brown (architects). 1978–1983 CE. Wood frame and stucco.

i. This house was custom built for the client's needs, which included a music room and large windows for bird watching.

ii. The style was modeled after 18th-century barns of the area.

iii. Venturi's work was influential to many modern architects and is considered to be the exact opposite of the International Style that had been popular since the mid-20th century.

iv. This house, like many of his designs, is inspired by buildings from the past. Unlike the International Style architects, he embraced decorative elements purely for aesthetic purposes in this and most of his works.

v. Post-modern architecture is notable for the return of classical or other old elements in a new way. Antique elements are often exaggerated or modified to allow new meaning.

Many modern art movements were partially inspired by non-European artistic styles. You should be able to explain these many connections as well as be able to compare the original style with the modern appropriation of it.

INDIGENOUS AMERICAS
1000 BCE–1980 CE

Note: The image set for this chapter can be found on pages 111–118 of the College Board's *AP Art History Course and Exam Description.*

I. OVERVIEW AND COMMONALITIES

A. The artistic traditions of the regions and cultures known as Indigenous America are among the world's oldest artistic traditions.

B. It has recently been proven that the people of this region travelled to the American continents from Asia via the Bering Strait. The artistic traditions of the region were developed between 10,000 BCE and 1492 CE, when it is believed European contact first took place.

C. The artwork of the region is further categorized as Ancient American (referring to Pre-Columbian art created south of the present-day United States-Mexico border) and Native North American (referring to art made north of the present-day United States-Mexico border).

D. The artistic traditions of all cultures of this region share similar traits including:

1. An artistic unity with the natural world.
2. A sense of cosmic geometry combined with an emphasis on the cardinal directions.

3. Extensive use of visionary shamanism.

4. A high spiritual value placed on animal-based materials such as feathers, bones, shells, and hides, combined with imported trade materials (incorporated after European contact) such as glass beads, machine-made cloth, and turquoise.

5. A stylistic focus on the essence rather than the actual appearance of subject matter.

6. A strong functional, participatory, and active aspect to most artistic objects.

E. Although the European invasions changed the people and the artistic traditions of the region, indigenous descendants of most of these ancient cultural groups still exist. Many still speak the ancient languages and create artworks using traditional methods or styles. Some have blended old ideas with new to create novel artistic styles, while many draw upon the persecution by colonial forces in their current artwork.

F. Information about Ancient American cultures from the area south of the United States-Mexico border comes from a variety of sources including archeological excavations, ancient hieroglyphs, European colonial written accounts, and present-day traditions, religious beliefs, and myths.

G. Information about Native North American cultures comes from archeological excavations, written ethno-historic documents, and both oral and written tribal history.

II. ANCIENT AMERICA

A. Ancient Central Andes refers to present-day southern Ecuador, Peru, western Bolivia, and northern Chile between 8800 BCE and 1534 CE.

B. The cultures of this area had distinct individual styles, but placed an emphasis on surviving and interacting with the three distinct ecosystems of the Andean mountains, the narrow desert coast, and the Amazon rainforest.

C. Concepts of individualism were not as important as were group efforts.

D. The people of Andean South America placed an emphasis on trade in exotic materials and had a definite hierarchy of materials. Feather-work, textiles and greenstones (like jade) were at the top; metalwork, bone, obsidian, and stone were in the middle. Ceramics and wood were at the low end of the hierarchy.

 1. Chavín - Artwork from the image set

 Image 153 (four images). Chavín de Huántar. Northern highlands, Peru. Chavín culture. 900–200 BCE. Stone (architectural complex); granite (Lanzón and sculpture); hammered gold alloy (jewelry).

 i. This architectural complex is located in a high valley of the Peruvian Andes between the desert coast and the Amazonian lowlands.

 ii. The quarried stone buildings were built on artificial terraces with an intricate system of vents and drains incorporated into them.

 iii. The complex was used as a pilgrimage center.

 iv. Due to the cultural exchange that took place there, it became an important center of ideological, cultural, and religious convergence.

 v. An old stone temple was incorporated into a newer complex with a circular plaza for large gatherings of worshippers.

 vi. The complex contains many bas-relief sculptures featuring anthropomorphic and zoomorphic symbols.

 vii. The Lanzón Stela is located in a central chamber beneath the old temple and was used to carry the sound of the conch shell trumpet to the circular plaza aboveground. Carved on the stela is the central deity of the Chavin culture.

 viii. Gold played a large part in the lives of the Chavin people. The gold jewelry, which represented status, was believed to allow the wearers to transform into sacred beings with superhuman powers.

2. Inka/Inca - Artworks from the image set

Image 159 (three images). City of Cusco, including Qorikancha (main temple/church and convent of Santo Domingo) and Walls at Saqsa Waman (Sacsayhuaman). Central highlands, Peru. Inka culture. c. 1440 CE. Sandstone.

i. Cusco was the capital and religious center of the Inka Empire. It is believed that the city was laid out in the shape of a puma, a sacred animal, with the temple complex placed at its head.

ii. The main temple was built to honor Inti, the sun god, and was constructed using ashlar masonry with gold decoration.

iii. The temple required worshipers to approach after fasting, barefooted and sometimes with loads on their backs.

iv. The walls at Saqsa Waman (Sacsayhuaman) were part of a complex built after 1438.

v. About 20,000 people worked on Saqsa Waman over a 50-year period.

vi. Imperial taxes were imposed and were paid by giving precious materials or by engaging in manual labor.

vii. Later, the plaza and temples of the Saqsa Waman complex were used as a fortress against the Spanish invasions.

viii. When the Spanish conquered the region, the complex was taken apart and the stones were used to build colonial buildings. The main temple was incorporated into the church and convent of Santo Domingo.

Test Tip

The concept of victors repurposing architecture was common globally throughout history. Examples include Islamic conquerors who converted churches into mosques and shrines, Christians who converted Roman basilicas into churches, and Spanish conquerors who converted pre-Columbian temples into churches. You should be able to discuss why this occurred, as well as be able to give examples of sites where this occurred.

Image 160. Silver and gold maize cobs. Inka culture c. 1400–1533 CE. Sheet metal/repoussé, gold and silver alloys.

i. This is one of only three of these small sculptures still in existence.

ii. It is believed to have come from the main temple of Cusco, where according to reports from the explorer Pizarro, there was a garden planted with golden maize. Pizarro reported that the garden was used three times a year for rituals related to the sowing and harvesting of maize.

Image 161 (3 images). City of Machu Picchu. Central highlands, Peru. Inka culture. c. 1450–1540 CE. Granite (architectural complex).

i. This architectural complex is located 7,000 feet above sea level in an isolated area.

ii. The complex contains the remnants of baths, houses, palaces, and temples along with agricultural areas.

iii. It is believed that about 1,200 people could have lived and worked here.

iv. The site may have been used as a remote retreat for the royal family and their servants.

v. The observatory was built so that the edges line up with celestial events on the horizon. The Intihuatana Stone is situated so that on midday of March 21 and September 21 the sun is directly overhead, casting no shadow, and therefore is "tied" or "hitched" to the stone.

Image 162. All-T'oqapu tunic. Inka culture. 1450–1540 CE. Camelid fiber and cotton.

i. Textiles were valued as wealth, and tunics were the most valuable of all of the textiles.

ii. T'oqapu are the small rectangular designs.

iii. Tunics like this were used exclusively by kings.

iv. The many different designs are believed to represent different clans and may be a symbol of the ruler's reign as well as the unity of the empire.

v. Tunics like this one were made by sacred female weavers who lived in convent-like settings.

E. Ancient Mesoamerica refers to the area that is now known as Mexico, Guatemala, Belize, and Western Honduras between 15,000 BCE and 1521 CE.

F. The cultures of this area had distinct individual styles but used similar calendars, built pyramidal stepped pyramids, oriented architecture in relation to sacred mountains and celestial bodies, and placed a high value on green colored materials, such as jadeite and quetzal feathers.

G. Ancient Mesoamerican groups included three distinct cultures: the Olmecs (first millennium BCE); the Mayans (first millennium CE); and the Mexicas, also known as the Aztecs (1428–1521 CE).

H. The artistic styles of these groups differed greatly, but shared some similarities including the creation of monumental earthworks and temples; the repeated enlarging and renovating of sacred sites; predominantly post-and-lintel architecture that included brightly painted relief sculptures; creation of plazas for large gatherings; and elaborate burial rituals.

1. Mayan – Artwork from the image set
 Image 155 (three images). Yaxchilán. Chiapas, Mexico. Maya culture. 725 CE. Limestone (architectural complex).
 i. This architectural complex is located in modern-day Mexico, high in the green hills above the Usumacinta River.
 ii. The complex is known for the stone lintels set above the doorways of stone structures, stelae, and stairways, all carved with hieroglyphs and pictures describing the history of the city.
 iii. Many of the carvings are now in the possession of the British Museum.
 iv. Lintel 25, structure 23 depicts Lady Xook, wife of the ruler Shield Jaguar II, in a hallucinatory state after a ritual bloodletting (a form of sacrifice). She is envisioning a Teotihuacán serpent, which may be an ancestral spirit.
 v. This relief was part of a building constructed after a 150-year absence of new construction. It may have

been part of a building program meant to reinforce Shield Jaguar II's divine ancestry and their subsequent right to rule.

vi. For unknown reasons, the text is in mirror image (reverse).

2. Aztec – Artworks from the image set

Image 157 (four images). Templo Mayor (Main Temple). Tenochtitlan. Mexica culture (Aztec). 1375–1520 CE. Stone (temple); volcanic stone (The Coyolxauhqui Stone); jadeite (Olmec-style mask); basalt (Calendar Stone).

i. This temple is located in modern-day Mexico City and was once the main temple of Tenochtitlán, the capital of the Aztec empire.

ii. The temple was built in honor of Huitzilopochtli, god of war and Tlaloc, god of rain. It was the center of religious life for over 300,000 residents of the city.

iii. The temple is site-specific, having been built on the spot where, according to local lore, an eagle was seen perched on a cactus while eating a snake.

iv. The temple is a high stepped pyramid with an altar on top.

v. Human sacrifices, believed to keep the sun moving across the sky, were once made on the altar, with the heart of the victim taken from the living body and placed in an eagle shaped stone bowl. The body was then thrown down the steps, possibly to the Coyolxauhqui Stone on the lower platform.

vi. The Coyolxauhqui Stone depicts the moon goddess who was believed to rule the world every night until each morning when her brother, Huitzilopochitli, kills her for slaying their mother.

vii. Human sacrifices emulated religious myths and were believed to help keep the world in balance.

viii. The temple also included a wall of skulls covered in stucco, two life-sized sculptures of Aztec warriors in full regalia, and sculptures of many other deities.

ix. Carved serpent heads on the staircase guarded the entrance to the high altar.

x. The calendar stone, probably commissioned by Moctezuma sometime between 1502 and 1521, was likely part of a table-like structure located somewhere near the temple. The center of the stone represents the five successful creations of the world after natural disasters, including the current incarnation of the world.

xi. The first ring of the calendar stone represents the 260 days of the calendar cycle, each of which represented a different god or goddess. The second ring represented the seasons and the subsequent sacrifices required during each period and was used as an agricultural calendar. The outer ring represents the sky and the 52 years that made up a complete cycle of the first two interlocking rings.

xii. The Olmec-style mask dates to an earlier period and culture. It is not known if it was given to the temple as tribute or was inherited/appropriated from the earlier culture.

xiii. Masks were used extensively in rituals and were placed in tombs. The wearers or owners of masks were believed to obtain power from both the material used and the god represented.

xiv. Sometimes masks were given as tribute to leaders and others were given as warning to enemies.

xv. After the Spanish conquest of 1521, the temple was almost completely destroyed. In 1790, the calendar stone was removed and slated to be part of the main stairway to a colonial Catholic church as a symbol of the triumph of Christianity over the older pagan religion. It ended up being placed on the cathedral tower instead.

Image 158. Ruler's feather headdress (possibly of Moctezuma II). Mexica culture (Aztec). 1428–1520 CE. Feathers (quetzal and cotinga) and gold.

i. Headdresses like this one were worn by royals, priests, dignitaries, and honored warriors.

ii. It was believed that masks and headdresses linked wearers to the gods and allowed them to take on supernatural powers.

iii. Originally the headdress would have been more three-dimensional to fit around the wearer's head.

iv. The feathers of the quetzal and cotinga birds used in the headdress, which were gathered from the lowland rainforests, were highly prized for their color and rarity and were collected as taxes/tribute. They represented the god Quetzalcoatl, the feathered serpent, who could move through all three of the worlds: sky, earth, and underworld.

v. The headdress was taken to Spain after the Spanish conquest and, although considered at the time to be the property of the ruler Moctezuma, scholars now believe that it most likely was not. The ruler would have worn a turquoise crown instead.

III. NATIVE NORTH AMERICA (NATIVE AMERICAN)

A. Overview

1. All labels for the people of these cultures were created by Europeans. There is no proper indigenous term for these people because they did not know themselves by a collective name. They were made up of many different tribes and nations who had contact as well as conflict with each other.

2. The tribal artistic practices can be broken up into broad stylistically similar categories known as Arctic, Northwest Coast, Southwest, Plains, Eastern Woodlands, and others.

3. Some of the long-standing values and artistic practices found in all of the cultures of Native North America include the use of geometric patterns; the inclusion of visionary figures or animals; the implementation of ideas about harmony with nature; respect shown to elders; a belief in shamanism; and participation in large community rituals.

4. Objects were made for tribal leaders, community members, or family.

5. Audiences for objects were usually the entire community, although some objects had restricted use for religious or political reasons.

B. Artworks for the image set

Image 154. Mesa Verde cliff dwellings. Montezuma County, Colorado. Anasazi. 450–1300 CE. Sandstone.

i. The more than 600 structures of this architectural complex were built in caves and under cliffs between 1190 and 1300, by the Anasazi people, the ancestors of modern-day Pueblo people.

ii. Prior to building these, the Anasazi of this region lived on top of the mesa.

iii. The structures range from small storage areas to villages of more than 150 rooms.

iv. The people who resided here farmed the mesa top while living in these protected chambers.

v. In 1903, the complex was made into a National Park by President Theodore Roosevelt.

Image 156. Great Serpent Mound. Adams County, southern Ohio. Mississippian (Eastern Woodlands). c. 1070 CE. Earthwork/effigy mound.

i. This earthwork is located on a ridge and is approximately 1,330 feet long and on average 4 feet high.

ii. It is the largest of the Native North American earthworks. Others are located in Wisconsin, Minnesota, Iowa, and Illinois and depict animals well known to the native people such as bears, deer, and felines.

iii. This one is believed to represent a serpent swallowing an egg, a lunar eclipse, or a mythical horned serpent.

iv. The function and symbolism of the mound is not definitively known, although there are burial mounds located nearby.

v. There were probably many more of these animal shaped mounds that were plowed under during the westward expansion and colonization by European settlers, which began in 1803.

Image 163. Bandolier bag. Lenape (eastern Delaware) tribe. c. 1850 CE. Beadwork on leather.

i. This work originated from the Lanape tribe, which was part of the larger Algonquin nation.

ii. Bags like this were symbols of prestige. The style was initially copied from the European settlers' cartridge bags.

iii. They were made by women primarily for men to wear, although in some clans they were worn by women; in others, they were worn by a woman to honor a deceased male.

iv. They were sometimes used as gifts or trade items. Each one was unique in decoration.

v. The glass beads used to decorate them were acquired from European settlers during trade.

vi. The beads were considered to be a sacred material and held great symbolic value for the natives due to their permanence, bright colors, reflective properties, and round shape.

vii. The European settlers regarded glass beads as cheap trade goods.

Image 164 (two images). Transformation mask. Kwakiutl, Northwest coast of Canada. Late 19th century CE. Wood, paint, and string.

i. This type of mask is unique to the native people of the Northwest coast.

ii. Masks like this one were used in ritual dances that were often part of multi-day potlatches (celebrations/ gatherings) during which many tribes would gather together and exchange gifts.

iii. Each clan was associated with a sacred animal such as a raven, thunderbird (a mythical supernatural bird), eagle, wolf, bear, orca, etc.

iv. Masks like this one helped preserve and convey traditional stories. They helped the dancer to take on the personality of the spirit(s) depicted during the dance.

v. This mask depicts a thunderbird and a human.

vi. Hidden strings allowed the wearer to open and close the mask during the ritual dance.

Image 165. Hide painting of Sun Dance. Attributed to Cotsiogo (Cadzi Cody), Eastern Shoshone, Wind River Reservation, Wyoming. c. 1890–1900 CE. Painted elk hide.

i. Hide paintings like this one were traditionally used as robes or as tepee walls.

ii. They were painted with figural or geometric designs on elk, deer and buffalo hides by the people of the Plains tribes.

 iii. This one affirmed native identity by combining the narratives of the buffalo hunt with the wolf dance.

 iv. It depicts an earlier time when buffalo were plentiful and warriors hunted with bows and arrows.

 v. Parts of the ceremony depicted were outlawed by the U.S. government at the time this object was made.

 vi. The combination of different sacred ceremonies was meant to attract a buyer and was most likely intended to be sold to tourists.

Image 166. Black-on-black ceramic vessel. Maria Martínez and Julian Martínez, Tewa, Puebloan, San Ildefonso Pueblo, New Mexico. c. mid-20th century CE. Blackware ceramic.

 i. Julian Martínez was part of a mid-20th century Puebloan excavation team, while Maria Martínez cooked for the team.

 ii. They both studied the ancient black-on-black pottery found during the excavation.

 iii. After much experimentation, they found a way to create similar works using a low oxygen environment.

 iv. Maria made the vessels and Julian painted them. Others helped in the preparation and creation of each vessel; each artisan added their signature to each piece they worked on.

 v. They shared the style with the Pueblo people, and it became a popular and sought-after commodity.

 vi. Most of the vessels were made for sale, and the unique style brought both fame and money to the Pueblo community.

IV. INDIGENOUS AMERICAN ART – INFLUENCE ON MODERN ART

A. The artistic style of ancient Mesoamerica was influential to the sculpture of 20th century artist Henry Moore and architect Frank Lloyd Wright.

B. The 20th century Mexican muralist Diego Rivera incorporated themes and styles from the ancient Mexica (Aztec) into his artwork.

C. Nineteenth-century artist Paul Gauguin and 20th-century artists Josef Albers and Paul Klee were influenced by ancient Peruvian textiles and ceramics.

D. The influence of native North American art on modern art is minimal. This is mostly due to a history of suppression and prejudice by the dominant European culture.

E. Recently, several Native North American artists have incorporated ancient artistic styles and techniques into their artworks. Others have used art as a means for telling the story of the suppression and forced assimilation of their people.

Test Tip

Several modern artists were influenced by the Indigenous arts of the Americas. The influence was related mostly to style and aesthetics, not to symbolism and meaning. You should be able to discuss this kind of appropriation in depth.

AFRICA
1100–1980 CE

Chapter

9

Note: The image set for this chapter can be found on pages 122–128 of the College Board's *AP Art History Course and Exam Description.*

I. OVERVIEW

A. African artworks exist as a combination of objects, acts, and events created using a range of media and materials.

B. The artworks in the image set were created by recognized artists, many of whom are considered by their people to be supernaturally ordained. They reflect the belief systems of the society in which they were created.

C. Artworks are expressive rather than representational and reflect a concern with intellectual and societal beliefs rather than with the natural or physical world.

D. The majority of artworks are created for specific purposes in daily or ritual practices.

E. Context and function are important parts of each artwork.

F. Artworks are an integral part of social life and serve to mark identity, reflect status, convey history, mark leaders' accomplishments, and/or commemorate cycles of human experience.

G. Aesthetic choices and artistic expression reflect the personal identity, social status, and relationships of the patron. Geometric designs and colors used are often symbolic and differ from region to region.

H. The characterization of African artwork as "primitive" by outsiders, especially collectors, is the result of ignorance and prejudice. As a result artists' names, contextual information, and dates of creation are often missing from existing artworks held by major museums.

II. ARTWORKS FROM THE IMAGE SET

Image 167 (two images). Conical tower and circular wall of Great Zimbabwe (great stone houses). Southeastern Zimbabwe. Shona peoples. c. 1000–1400 CE. Coursed granite blocks.

i. This is a Shona African Iron Age site that once contained a settlement that covered about 1,800 acres and housed about 18,000 people.

ii. The structures are of mortarless stone. Several on the site are believed to have been the homes of rulers from various periods. According to Shona tradition, the successor to the throne improves upon and rules from his home rather than from the home of the deceased.

iii. Some of the structures, including the circular wall, have geometric patterns incorporated into the stonework.

iv. Flowing curves dominate the architectural style of the structures. The high walls were probably used to separate the royal families from the commoners of the settlement.

v. The grandeur and superb workmanship of the site led Europeans of the 19th century to believe that local people could not have designed or constructed the site. These beliefs were proven false in the early 20th century.

vi. Great Zimbabwe had very little contact with Islamic traders and, unlike the exterior/northern regions of Africa, was not influenced by the Arab/Islamic style.

Image 168 (two images). Great Mosque of Djenné. Mali. Founded c. 1200 CE; rebuilt 1906–1907. Adobe.

i. The first Great Mosque of Djenne was built in the 13th century by Djenne's first Muslim ruler (King Mansa Musa), who destroyed the palace located on the site to proclaim his new faith to his subjects.

ii. The original mosque fell into ruin, and the current mosque was built 1906–1907 on the site of the original using the monumental Sudanic style.

iii. The mosque is at the center of the town's marketplace, and while the exterior is unique to the region, the interior contains standard features such as a qibla wall and mihrab.

iv. Next to the structure are several large tombs of great Islamic scholars of the region.

v. This structure is evidence of the great impact Islamic culture had on the region. Djenne, as well as Timbuktu, became great centers of Islamic learning, disproving the theory that little advancement was occurring in Africa prior to European colonization.

Image 169 (two images). Wall plaque, from Oba's (King's) Palace. Edo peoples, Benin (Nigeria). 16th century CE. Cast brass.

i. Over 900 plaques of this style are in museum collections around the world. They were taken from the Oba's palace during the late 19th century after the British conquered the region.

ii. The plaques were probably made in pairs and attached to pillars in the audience hall of the Oba's palace in Benin City.

iii. They depict Benin court rituals during the 16th century, celebrate historical events, and convey ideas about royalty.

iv. The Oba, directly descended from the founder of the Benin dynasty, was the spiritual and secular ruler of the kingdom. He was considered to be a living deity who had the right to control exports such as ivory, slaves, etc., and trade with the Europeans.

v. Palace craftsmen created artwork using an official style.

vi. The style disregards naturalistic depictions in favor of symbolism. Dress, insignia, and status symbols are faithfully rendered, while heads of figures are unnaturally large (due to the belief that the head was the most important part of the body) and legs are shortened. Hierarchical scale is used to indicate rank.

vii. The ringed necklace denotes the ruler, and a similar one is still worn by the current Oba of Benin.

viii. Much of the jewelry and ceremonial regalia depicted was made from natural objects such as coral and leopard teeth as well as brass.

Image 170 (two images). Sika dwa kofi (Golden Stool).
Ashanti peoples (south central Ghana). c. 1700 CE.
Gold over wood and cast-gold attachments.

i. Stools are the most important artistic form of the Ashanti people.

ii. This stool is believed to have come from the sky to the first chief ruler in order to unite the Ashanti nation. It is considered to be the symbol of the kingdom.

iii. Two brass bells and two gold bells are attached to the stool. Four golden enemies below the stool represent defeated enemies of the kingdom.

iv. This stool replaced all older chieftains' stools and all other objects related to political authority. These objects were collected by Okomfo Anokye, the chief priest, and buried during a ceremony meant to unite the people under one ruler.

v. Although stools in Ghana are made for kings to sit on, this stool is not meant for that purpose. It represents a link to the ancestors and is believed to be the soul of the people. Not meant for actual use, it is laid on its side on a blanket to prevent anyone from using it.

vi. This stool is cherished as the most sacred possession of the Ashanti people, who each pay allegiance to it every year.

vii. Ghana controlled the trans-Sahara trade route and was therefore extremely wealthy. Goods such as this stool were symbols of wealth and status.

Image 171 (two images). Ndop (portrait figure) of King Mishe miShyaang maMbul. Kuba peoples (Democratic Republic of the Congo). c. 1760–1780 CE. Wood.

 i. Ndop figures are idealized portraits of individual Kuba rulers. It is believed that figures like this one were created to honor and represent the spirit of the ruler.
 ii. This one is believed to be the oldest still in existence.
 iii. The ruler is depicted with the symbol of his rank, a drum with a severed hand on the front of it. He is wearing the belts, armbands, ornaments, and projecting headdress that denotes his rank.
 iv. He is depicted sitting cross-legged on a raised platform with a short sword in his left hand, with the handle out in a nonagressive manner.

Image 172. Power figure (Nkisi n'kondi). Kongo peoples (Democratic Republic of the Congo). c. late 19th century CE. Wood and metal.

 i. Figures like this were created to house specific spirits and forces (known as animism) and were the result of a collaboration between the sculptor and the ritualist/shaman.
 ii. The mpu headdress depicted was worn by kings and priests. The stance is an aggressive or challenging one, representing consequences of breaking societal rules.
 iii. The nails around the chin once held a beard, a sign of seniority.
 iv. The central cavity held medicinal matter relevant to the spirit's power.
 v. The metal pieces embedded in the figure document the many affairs the figure presided over, including the sealing of vows, the signing of treaties, and the vanquishing of enemies.
 vi. This is an example of the use of artwork in shamanism, a practice that allows the practitioner to interact with the spirit world through the use of animistic artworks.

Image 173. Female (Pwo) mask. Chokwe peoples (Democratic Republic of the Congo). Late 19th to early 20th century CE. Wood, fiber, pigment, and metal.

i. This mask represents an attractive young woman adorned with tattoos, earrings, and an elaborate hairstyle.

ii. The name Pwo indicates that the woman depicted has given birth.

iii. Masks like these are popular masks used in dances performed by men in feminine clothing that honor the founding female ancestor of the clan.

iv. When the dancer to whom the mask belongs dies, the mask is buried with the dancer.

v. The reddish brown patina was created by mixing red clay with oil. White kaolin clay was used for the half-closed eyes.

vi. The geometric patterns on the face represent a common style of tattoos. The cross originated from medals distributed by Portuguese monks during the 17th century. The eyebrow tattoos represent arrogance, and the tattoos under the eyes represent tears.

vii. This is an example of the matriarchal nature of many African societies.

Image 174 (two images). Portrait mask (Mblo). Baule peoples (Côte d'Ivoire). Late 19th to early 20th century CE. Wood and pigment.

i. Mblo masks were part of elaborate public ceremonies meant to honor a distinguished member of the community. The stylized face represents the artistic double or namesake of the honoree.

ii. Each of these masks is unique and exhibits a range of designs. In this case, the figure has been crowned with a group of horns.

iii. The high forehead and downcast eyes represent intellectual ability.

Image 175 (two images). Bundu mask. Sande Society, Mende peoples (West African forests of Sierra Leone and Liberia). 19th to 20th century CE. Wood, cloth, and fiber.

i. Masks like these are associated with the Sande Society, a group of women initiated into the group with an elaborate months-long ceremony.

ii. The mask was worn by higher-ranking members of the society and, along with the long costume that accompanied it, was meant to disguise the entire body of the wearer.

iii. The mask was worn during initiation ceremonies, anniversaries, during funeral rituals, and while justice was meted out.

iv. Each mask represents a different spirit and, even when representing a male ancestral spirit, contains idealized female features.

Image 176. Ikenga (shrine figure). Ibgo peoples (Nigeria). c. 19th to 20th century CE. Wood.

i. Figures like this one were created for personal shrines for Igbo and Benin people.

ii. The figure honors the power and skills of the male owner's right hand, the hand that holds his tools and sword.

iii. All Ikenga figures feature a horned figure, a reference to aggressive male animals, but vary in style and decoration. Some are tall (six feet) while others are only a few inches high.

iv. Some figures are more naturalistic while others are completely abstract.

v. Decorative patterns and carvings represent symbols of power such as a sword and trophy head. Many figures are depicted sitting on a stool, a symbol of prestige.

Image 177 (two images). Lukasa (memory board). Mbudye Society, Luba peoples (Democratic Republic of the Congo). c. 19th to 20th century CE. Wood, beads, and metal.

i. Memory boards like this one served to illustrate important information of the Luba people and are associated with regional mbudye associations, councils of men and women who help kings and chiefs maintain order and discipline.

ii. Each board is unique and is believed to have been designed through divine revelation.

iii. Only the most senior members of the council, who have mastered all of the levels of historical knowledge, can interpret these boards.

iv. The information conveyed on the board alludes to ancestral deities and illustrates historical events and territorial areas of local chiefdoms.

Image 178 (two images). Aka elephant mask. Bamileke (Cameroon, western grassfields region). c. 19th to 20th century CE. Wood, woven raffia, cloth, and beads.

i. Elephant masks like this one were worn by powerful members of the Kuosi society, which included only royals, wealthy citizens, and high-ranking warriors of the region. The society was an important part of the chieftain's court.

ii. The glass beads and cowrie shells used to create the geometric designs on the mask were acquired through trade with Europeans, usually in exchange for slaves.

iii. The long cloth panel and large ears attached to the mask are meant to evoke the features of an elephant, representing royalty and power, incorporated into a stylized human face.

iv. The colors are symbolic, with black representing the relationship between the living and the dead, white representing the ancestors and medicine, and red associated with women, life, and royalty.

v. The triangular stripes or designs represent leopards, another symbol of royalty and strength.

vi. The mask, accompanied by an elaborate costume, was worn during ceremonial dances.

Image 179. Reliquary figure (nlo bieri). Fang peoples (southern Cameroon). c. 19th to 20th century CE. Wood.

i. Figures like this one guarded family reliquary boxes that contained the skulls of ancestors and linked the Fang people to their past.

ii. They were meant to guard the contents of the box from the forbidden gaze of women and uninitiated boys, and they represent admired qualities such as tranquility, vitality, and the ability to hold opposites in balance.

iii. The head is usually symbolic of an infant while the body represents that of an adult. Bulging muscles contrast with a serene, expressionless face and a symmetrical pose.

Image 180. Veranda post of enthroned king and senior wife (Opo Ogoga). Olowe of Ise (Yoruba peoples). c. 1910-1914 CE. Wood and pigment.

i. This sculpture was originally part of the inner palace courtyard of a king in Nigeria.

ii. The artist is one of the most important artists of the Yoruba people.

iii. The artist used hierarchical scale in depicting the enthroned king in front of his senior wife.

iv. The size and strength of the woman indicates the importance of women in Yoruba society. In this depiction she literally holds up the veranda roof and provides support to the throne.

v. The senior wife stood in this position and placed the crown on her husband's head during coronation ceremonies.

vi. The high conical crown on the king's head represents the divine right to rule as well as the link to past rulers, who still exercise power from the spiritual world.

vii. The long-beaked bird on top of the crown symbolizes supernatural abilities and female ancestors/deities known to the Yoruba as "our mothers."

viii. Other, smaller figures represent less important members of the court paying homage to the king.

III. AFRICAN ART – INFLUENCE ON MODERN ART

A. During the era of European colonization and imperialism in Africa, many collectors brought African artworks to Europe.

B. Modern artists of the late 19th and early 20th century embraced the artistic style of these artworks. They believed that the so-called primitive aspects of the works gave them an honesty that linked them to modernist ideals.

C. The Cubists were among the first to be overtly inspired by African artworks.

D. The abstraction found in African art was influential to modern artists.

E. The animism and other contextual religious symbolism of African artworks were mostly ignored by modern artists in favor of an appropriation of the abstraction and "primitive" honesty of the work.

F. In the late 20th and early 21st centuries, many African artists have reclaimed their artistic heritage and have even appropriated European artworks and styles in order to visually comment on the effects of European imperialism in Africa.

Test Tip

Ancestor worship is a major element of African culture. This is similar to other areas of the world, especially East Asia. You should be able to discuss this commonality and offer examples of this from diverse cultures.

WEST AND CENTRAL ASIA
500 BCE–1980 CE

Note: The image set for this chapter can be found on pages 132–137 of the College Board's *AP Art History Course and Exam Description.*

I. OVERVIEW

A. The region forms a large part of the Silk Road that connected the ancient Greco-Roman world to Asia. Numerous cultural interchanges have occurred in this region.

B. The arts of this region were created for a variety of local and global patrons. Textiles and ceramics were important commodities that linked Europe to Asia.

C. Art from this region tended to favor a highly decorative style due to Islamic influence, which mostly prohibited the use of figurative imagery.

II. GRECO-ROMAN AND BUDDHIST ART

A. Overview

1. Buddhism, which originated in India in the 6th century BCE as a reaction to the strict caste system of Hinduism, did not develop a missionary component, yet monks and supportive monarchs spread its ideas throughout Asia.

2. In each new region, a form of Buddhism developed that incorporated local traditions and beliefs.
3. Pilgrimage is an important component of Buddhism. The carved caves of Central Asia and the stupas and monasteries of Tibet are important forms of Buddhist architecture.
4. The earliest forms of Buddhist art represented the Buddha in the form of abstract symbols such as a wheel or a lotus. As Buddhism spread, figural imagery began to be used to depict various forms of the Buddha as well as teachers, attendants, practitioners, and deities.
5. Buddhist figural sculptures that were carved or cast from metal are often the object of veneration in shrine settings. They are also subjects in paintings and drawings.
6. The ancient kingdom of Gandhara encompassed modern northeast Afghanistan and northern Pakistan. The art of Gandhara was heavily influenced by the Greco-Roman figural style. The conventions developed there influenced Buddhist art throughout Asia.

B. Artworks from the image set

Image 181 (three images). Petra, Jordan: Treasury and Great Temple. Nabataean, Ptolemaic, and Roman. c. 400 BCE–100 CE. Cut rock.

 i. Much of the city of Petra was carved directly into the sandstone cliffs.
 ii. The region became an important part of the spice trade and a major stop on the road from Arabia to Syria.
 iii. The city was established as the center of the Kingdom of Nabataea by a formerly nomadic Arab tribe.
 iv. The city came under Roman rule during Emperor Trajan's reign and later became part of the Eastern Roman Empire and then the Byzantine Empire.
 v. When the city came under Roman rule, new structures were built and existing structures were either incorporated or modified utilizing Roman structural innovations and techniques.
 vi. The Treasury was carved in the early 1st century as a tomb for a Nabataean King. While much of the city was destroyed by earthquakes, the tombs remained mostly intact.

vii. The Great Temple may have been built by craftsmen imported from Alexandria who used a combination of native and Greco-Roman styles.

viii. In 363 CE, a large earthquake destroyed the Great Temple, and a new one was built using some elements from the original structure.

Image 182 (two images). Buddha. Bamiyan, Afghanistan. Gandharan. c. 400–800 CE. (destroyed in 2001). Cut rock with plaster and polychrome paint.

i. These Buddhist sculptures were done in the Gandharan style, which blended Greco-Roman aesthetics with Buddhist symbolism.

ii. Even before the sculptures were built, the many caves of the area served as accommodations for caravans carrying goods from China to the Roman Empire.

iii. Originally, the robe of the larger of the two was painted red. It was known as Salsal (light shines through the universe) representing the Vairocana (Wisdom) Buddha and possibly the male aspects of the universe.

iv. The smaller sculpture was originally multi-colored with a blue robe and was known as Shamama (Queen Mother), possibly representing female aspects of life. Some people believe it depicted the Shakyamuni (Original) Buddha.

v. The main bodies of the sculptures were carved directly from the sandstone cliffs with details made using mud and straw coated with stucco. The faces and hands were originally covered in copper, making them visible for miles.

vi. When Genghis Khan conquered the region in 1221 CE and slaughtered all of the inhabitants of Bamiyan, he left the sculptures intact. The Mughal Emperor Aurangzeb tried to destroy them in the late 17th century, but did not succeed. In the 18th century the Persian Nadir Shah shot them with arrows and, in 2001, they were destroyed by the Taliban.

Image 184. Jowo Rinpoche, enshrined in the Jokhang Temple. Lhasa, Tibet. Yarlung Dynasty. Believed to have been brought to Tibet in 641 CE. Gilt metals with semiprecious stones, pearls, and paint; various offerings.

i. This statue of the Shakyamuni Buddha at age 12 is Tibet's most revered icon and is located in Lhasa, Tibet.

 ii. It was made in India and brought to Tibet in 641 CE by the Chinese Princess Wencheng, who married Dharma King Songsten Gampo. A temple was built to house the icon.

 iii. Originally the sculpture was in the style of Nirmanakaya (simple and unadorned) but it was transformed into a Sambhogakaya (adorned) sculpture by the many offerings made on behalf of the living or the deceased.

 iv. The temple was built using a combination of local Tibetan, Nepalese, Chinese, and Indian styles. The exterior is decorated with early non-figural symbols of the Buddha.

 v. Smaller shrines contain sculptures of other revered figures.

 vi. Pilgrims can circumambulate using a specially built path around the temple or may spin prayer wheels while in the main shrine.

 vii. The Chinese Government, which now has political control over Tibet, limits access to the shrine.

 viii. In 2008, a replica of the shrine was built in Arlington, Massachusetts, at an American branch of Tibet's Katsel monastery.

 III. ISLAMIC ART

A. Overview

1. Islamic art of Western Asia may be religious or secular and may or may not have been made by or for Muslims.

2. Religious texts and architecture are decorated with non-figural imagery including calligraphy, vegetal designs, and geometric patterns. In secular art figural imagery is prominent in manuscript illumination and the decorative arts, but images of the Prophet Mohammed are never allowed.

3. Geometric tessellation is used to decorate many Islamic buildings and is favored for the mathematical precision and infinite nature of the style.

4. Calligraphy is a highly revered form of art, and sections of the Koran are often used to decorate architectural structures.

5. Pilgrimage is an important religious practice in Islam. The Kaaba in Mecca and the Dome of the Rock in Jerusalem are two of the most important pilgrimage sites.

6. Persian paintings from the Timurid and Safavid Dynasties had a large impact on secular Islamic art. The style of Persian miniatures was emulated by Ottoman and Mughal artists.

7. Islamic metalwork is regarded as the finest of the medieval world.

Test Tip

Remember that, at its start, the Islamic style was highly influenced by the initial regions that were conquered including the Byzantine and Greco-Roman cultures. For example, golden domes and tile decorative elements were derived from Byzantine churches and the use of arches and columns were derived from Greco-Roman temples.

B. Artworks from the image set

Image 183 (three images). The Kaaba. Mecca, Saudi Arabia. Islamic. Pre-Islamic monument; rededicated by Muhammad in 631–632 CE; multiple renovations. Granite masonry, covered with silk curtain and calligraphy in gold and silver-wrapped thread.

i. The Kaaba is the most sacred site in Islam. Mosques all over the world have a qibla wall located on the wall that faces the direction of The Kaaba, which the congregation faces during prayers.

ii. The Kaaba is located within The Great Mosque (Al-Masjid al-Haram) in Mecca, Saudi Arabia. It is the largest mosque in the world and includes both outdoor and indoor places for prayer.

iii. The shrine and mosque have undergone several renovations since they were first built.

iv. The shrine is built on the site where Ishmael's mother, Hajar, found water after being led into the desert by Abraham.

v. The shrine contains a black rock, believed to be the remnants of a meteorite, the only remains of the original structure built on the site.

vi. The area became a Bedouin settlement, during the time of Ishmael and Hajar, and the monotheistic religion (early Judaism) of Abraham was practiced there.

vii. When Ishmael's family perished, the inhabitants reverted to paganism. The Prophet Mohammed conquered the city in 629 CE and converted the people to the new religion of Islam.

viii. Travelling to Mecca to pray at The Great Mosque is one of the five pillars of Islam. The pilgrimage (known as the Hajj or Umrah depending on the time of year it is made) commemorates the near sacrifice of Abraham's son and the subsequent journey to Mecca by mother and son as well as their struggle to survive in the harsh desert environment.

ix. This was the site where it is believed that the Prophet Mohammed was first called to prayer after arriving from the city of Medina.

Image 185 (two images). Dome of the Rock. Jerusalem, Israel. Islamic, Umayyad. 691–692 CE, with multiple renovations. Stone masonry and wooden roof decorated with glazed ceramic tile, mosaics, and gilt aluminum and bronze dome.

i. This shrine was built during the early days of Islam and is considered to be the structure that defined the Islamic style for centuries.

ii. It was built on the site of the Jewish Temple Mount where it is believed that both Jewish temples once stood.

iii. The rock the shrine was built over is sacred to Muslims (it is believed to be the rock where the Prophet Mohammed ascended to heaven) and Jews (it is believed to be the place where Abraham nearly sacrificed Isaac).

iv. The interior and exterior are decorated with calligraphic scriptural passages from the Koran.

v. It is believed to have been the site of a Byzantine Christian church at the time of the Islamic conquest of the area. Byzantine churches in Italy, Syria, and Israel have similar characteristics.

vi. The shrine was first built by the Umayyad caliph Abd al-Malik as a symbol of the superiority of the new faith to Jews, by the location, and to Christians, by the interior calligraphic decoration proclaiming the one true faith.

vii. The original mosaics were done by Byzantine artists from the newly conquered lands and incorporate the new method (at the time) of using Arabic calligraphy as a decorative element.

viii. The dome is of gilded wood, and the current exterior Persian tiles were added during a renovation by Suleiman ("The Magnificent") in 1545.

ix. The structure was built using mathematical symmetry. Each outer wall is 67 feet long, a measurement that also corresponds to the diameter of the dome as well as the height of the building from the drum.

x. The finial on the dome is a full moon that, if looked through, aligns with the city of Mecca.

Image 186 (four images). Great Mosque (Masjid-e Jameh). Isfahan, Iran. Islamic, Persian: Seljuk, Il-Khanid, Timurid and Safavid Dynasties. c. 700 CE; additions and restorations in the 14th, 18th, and 20th centuries CE. Stone, brick, wood, plaster, and glazed ceramic tile.

i. This mosque was built at the center of the old city and shares walls with several other buildings of the neighborhood.

ii. In the 11th century, the Seljuk Turks made Isfahan their new capital. The core of the mosque's structure was built during that time.

iii. Additions were made during several other periods continuing into the 20th century.

iv. At the center is a large courtyard with prayer halls extending from each side.

v. A series of hypostyle columns holds up the roof that contains small domes over each column.

vi. While the exterior is plain, the interior is richly decorated with geometric designs, tile work, and brickwork.

vii. Originally the many entrances allowed people to use the courtyard as a passage to different parts of the city. Only one entrance is open today.

viii. The qibla wall is on the south side of the courtyard and is flanked by two minarets. It serves as the entrance to the main mihrab contained in domed chambers beyond it that are used only by rulers.

Image 188. Basin (Baptistère de St. Louis). Muhammad ibn al-Zain. c. 1320–1340 CE. Brass inlaid with gold and silver.

i. The French Kings beginning with King Louis XII had cordial relations with both the Mamluk and the later Ottoman rulers. Several fine works made by Islamic craftsmen became part of the French Royal collection.

ii. This basin is decorated with scenes from Mamluk court life, animals, coats of arms, and scenes of hunting and battles.

iii. It was made by Islamic craftsmen for a wealthy patron to use during banquets or for ritual hand-washing.

iv. The basin is signed by Muhamma ibn al-Zain in six places, but does not contain the name of the original patron or any religious inscriptions.

v. It was probably given to the French royal family by an Ottoman ruler. It was used to baptize several royal children beginning with Louis XIII. In 1856, it was used to baptize the son of Napoleon III and may have captured the imagination of artists like Ingres who did several paintings containing Turkish themes.

Image 187. Folio from a Qur'an. Arab, North Africa, or Near East. Abbasid. c. 8th to 9th century CE. Ink, color, and gold on parchment.

i. The Koran is the sacred text of Islam and was written down from the earlier oral tradition. It contains the writings of the Prophet Mohammed.

ii. This page is part of a full text that was made for a wealthy patron. Pieces of it are found in several museums around the world.

iii. The design of each page was carefully planned and was executed by a team of Koranic scribes who carefully considered the positive and negative spaces on the page.

iv. The style of the calligraphy is known as kufic script, created using a wide reed pen and ink. Although many of the words are composed of several strokes they are integrated into one continuous line.

Image 189. Bahram Gur Fights the Karg, folio from the Great Il-Khanid Shahnama. Islamic; Persian, Il'Khanid. c. 1330–1340 CE. Ink and opaque watercolor, gold, and silver on paper.

i. This page is from a well-known copy of *The Book of Kings* (the *Shahnameh*) written by the Persian poet Ferdawsi between 977 and 1010.

ii. The book contains 60,000 verses and tells the story of the heroes and rulers of Persia from the mythical past to the Islamic conquest in the 7th century.

iii. This copy was probably commissioned by a high-ranking officer of the Ilkhanid court.

iv. It was produced by a royal scriptorium and the style of the painting was heavily influenced by European art (the realistic figures) as well as by Chinese art (the style of the landscape).

v. The style of Persian manuscripts and decorative elements had far reaching influence in the Islamic world as well as Hindu India and even Christian Europe.

vi. This page shows Bahram Gur, a Sassanian King of Persia, fighting the mythical horned wolf (karg).

Image 190. The Court of Gayumars, folio from Shah Tahmasp's Shahnama. Sultan Muhammad. c. 1522–1525 CE. Ink, opaque watercolor, and gold on paper.

i. This page depicts the first king of Persia, Gayumars, enthroned before his court.

ii. His son is seated to his left and his grandson is standing on his right. The artist implied, through the composition, the concept of succession (the left side is favored). However, the reader would know that the ruler's son was murdered, lending a tragic theme to this illustration.

iii. The entire picture was made to show harmony between nature and humans, which adds to the tragedy of the story.

iv. This copy of the *Shahnameh* was made for Shah Tahmasp of the Safavid Dynasty in Persia (Iran) and was well known by contemporaries. It was presented by the patron to the Ottoman Sultan Salim II.

v. The artist, Suktan Mohammed, combined elements from the classical Persian style with the Turkmen-inspired Tabriz style. Later the two styles would be blended by many other artists.

Image 191. The Ardabil Carpet. Maqsud of Kashan. 1539–1540 CE. Silk and wool.

i. This carpet was made by a royal weaving factory during Shah Tahmasp's rule when the weaving industry reached great heights in Persia (modern-day Iran).

ii. Carpets and prayer rugs are important to Islamic culture, particularly in Persia, due to the rituals of daily prayer conducted a minimum of five times per day.

iii. Carpets like this set the standard for design and workmanship. Persian carpets from this period are considered to be the best in the world.

iv. The carpet contains a total of approximately 25,000,000 knots, about 340 per square inch.

v. Since the work was created for a mosque, there are no figural design elements. The design is meant to represent a heavenly dome reflected in a pool of water filled with floating blossoms.

Test Tip

The Islamic style of architectural decoration as well as miniature painting had far-reaching impact across Europe and Asia. You should be able to explain these influences.

SOUTH, EAST, AND SOUTHEAST ASIA 300 BCE–1980 CE

Note: The image set for this chapter can be found on pages 142–155 of the College Board's *AP Art History Course and Exam Description.*

I. OVERVIEW AND COMMONALITIES

A. Artistic traditions from this area of the world reach back into prehistoric times. The oldest known works are from the Yuchanyan Cave in China (18,300–17,500 BCE) and from the Jomon culture of Japan (10,500 BCE). The ancient Indus Valley civilization of India and Pakistan also produced numerous artifacts.

B. Some of the world's most developed and philosophic traditions developed in South Asia.

1. Hinduism and later Buddhism, Jainism, and Sikhism differentiated between the earthly and cosmic realms.
2. These traditions understood time, especially the lifetime, as cyclic.
3. Certain sites and/or beings were considered to be sacred to worshippers.

C. East Asian religions are some of the most philosophical of the world.

1. Daoism, Confucianism, and indigenous Chinese religions dominated China, and to some extent Korea, before the arrival of Buddhism.

2. The animistic Shinto religion dominated Japan before the arrival of Buddhism and remained a strong cultural tradition.

3. All of the East Asian religions place an emphasis on interconnections among humans, nature, and the spirit world.

D. Buddhism travelled from India to China first, then to Korea and lastly to Japan. Often local traditions and religious ideas were blended with the central concepts to create unique forms of Buddhism in each region that eventually replaced the native traditions.

E. Other religions, brought to the region primarily by invaders, are found in South and East Asia as well.

1. Alexander of Macedonia ("Alexander the Great") was the first to bring what is now known as the Greco-Roman religion and culture to the region.

2. Christianity was introduced, to a small degree, by West Asian and European travelers and invaders.

3. Islam had a large influence in northern India, Malaysia, and Indonesia, where Islamic sultanates ruled some of the regions.

F. Trade affected the development of culture and art in Asia and Europe.

1. The Silk Road linked Asia, including India and Central Asia, to Europe.

2. Seasonal monsoon winds allowed traders to move goods and ideas between Asia and North Africa.

3. Ceramics created in China were collected internationally. The blue and white style became so popular that local versions of the style were created, notably in Persia, Turkey, and the Netherlands.

4. Silk and silk weaving originated in China and was traded all over the world.

5. Asian artworks were acquired by collectors through gift or trade.

6. Mongolian imperial conquests allowed for long periods of peace along trade routes, allowing for the spread of Asian culture to Europe.

The Silk Road brought Asian artistic styles to Europe and vice versa. You should be able to give examples of Asian art that was influenced by European style (for example, the Gandharan style of sculpture in India) and European art that was influenced by Asian art (for example, blue and white ceramics of Delft, the Netherlands).

II. INDIA

A. The major religions that developed in this region are Hinduism, Buddhism, Jainism, and Sikhism. They have some commonalities including:

1. Time and life is thought of as a cycle, with reincarnation included as part of that cycle.
2. Certain sites and/or beings held sacred.
3. Time and life considered as a cycle. The belief that reincarnation is part of the life cycle.
4. Religious methodologies and social practices serve to create spiritual development, spiritual release, or divine union.
5. Pre-existing animistic beliefs were grafted onto each religion.

B. Hinduism, Buddhism (after contact with the Greco-Roman world), and Jainism are iconic and have the following commonalities:

1. The number of religious images and sculptures rival those of Christian imagery.
2. Figural imagery may be venerated in temples or shrines.
3. Figural images may be either sculptural or two-dimensional.

C. Regional painting styles developed to illustrate mythical and historical subjects and poetry.

D. Other cultures played a role in the development of local styles of art.

1. The Gandharan style (modern day Pakistan and Afghanistan) was highly influenced by Greco-Roman traditions, especially by the introduction of naturalism in art.

2. In the 12ᵗʰ and 13ᵗʰ centuries much of western India was controlled by Islamic sultanates. The use of paper for manuscripts and paintings and the extensive use of patterns and bright colors, were influenced by Persian miniatures.

E. Artworks from the image set

Image 192 (four images). Great Stupa at Sanchi. Madhya Pradesh, India. Buddhist; Maurya, late Sunga Dynasty. c. 300 BCE–100 CE. Stone masonry, sandstone on dome.

i. A stupa (the Sanskrit word for "topknot") is a mound shaped structure containing Buddhist relics.

ii. Stupas originated as pre-Buddhist burial mounds for kings. What began as a way to honor the dead became a place to contemplate the interconnectedness of all life.

iii. This is one of the oldest and best preserved of all of the stupas. It was built during the reign of Ashoka, a Buddhist convert and proponent, who chose an ideal place on a hill so that it could be seen from all around in an attempt to unify his empire under a common religion.

iv. It was later enlarged and decorated during the Sunga dynasty.

v. Unlike most stupas, this one is not connected to the Original Buddha's life.

vi. The figural sculptures, which were added later, were done in the regional Mathuran style using sandstone and depicting figures as broad shouldered with soft bellies and wearing closely fitted drapery. The style is related to the earlier depictions of yakshas (male nature deities) of the region.

vii. The older decorations reflect the early years of the religion when the Buddha was represented only in symbolic form (the wheel, footprint, empty throne, and lotus flower are the most common symbols used).

viii. The architecture of the stupa represents the central tenets of Buddhism, with the overall shape representing the crowned and seated Buddha in meditation pose.

ix. All of the parts of the stupa represent the elements that make up the universe. The square represents the earth,

the dome represents water, the spire represents fire, the upper spire represents air, and the topmost shape represents space.

x. The entire structure was used as a meditation aid and as a place of pilgrimage. Worshippers engaged in clockwise circumambulation, with the right side of the body closest to the stupa.

xi. The four gates (toranas) mark the cardinal directions. They are decorated with scenes from the life of the Buddha.

xii. Like medieval churches, the decorations on stupas were meant to impart important stories to worshippers, many of whom were illiterate.

Test Tip

Like many Christian churches, Buddhist stupas contain architectural elements that are symbolic of the central ideas of the religion. You should be able to explain this concept and offer examples for discussion.

Image 200 (four images). Lakshmana Temple. Khajuraho, India. Hindu, Chandella Dynasty. c. 930–950 CE. Sandstone.

i. This Hindu temple is dedicated to Vishnu and was built to house a multi-headed Vishnu idol crafted in Tibet.

ii. The main shrine is flanked by four smaller temples and sits on a broad platform, which allows for ritual circumambulation.

iii. The architectural structure of Hindu temples, such as this one, symbolize all elements of the cosmos and are meant to be places of transcendence.

iv. The plan is based on mathematical and symbolic principles featuring symmetry and repetitive designs. The four cardinal directions are important as is the incorporation of perfect squares and circles.

v. The structures deliberately evoke images of mountains, where the gods were believed to dwell.

vi. The temple is known for its extensive number of relief carvings including depictions of more than 600 gods and goddesses of the Hindu religion.

 vii. A large group of the images feature erotic scenes that some believe refer to male/female concepts (known in East Asia as Yin and Yang) or to tantric unity (the unity of energy and form).

Image 202. Shiva as Lord of Dance (Nataraja). Hindu; India (Tamil Nadu), Chola Dynasty. c. 11th century CE. Cast bronze.

 i. This iconographic type was developed during the Chola dynasty.

 ii. All of the gestures are narrative symbols.

 iii. Shiva is depicted dancing at the golden hall at the center of the universe where all of the other gods are in attendance (although not shown). His hair has come undone and projects outward as he moves.

 iv. His dance proves to all that he is the creator, destroyer, as well as the preserver of the universe.

 v. His right hand holds the drum that makes the sound of creation (related to the heartbeat) while the lower right hand points to the raised left leg and makes the gesture of protection (meant to allay fear).

 vi. The upper-left hand holds fire, representing destruction, while the ring of fire around him represents the cosmos.

 vii. The right foot tramples a dwarf-like creature representing the triumph over ignorance and temptation.

 viii. Worshippers believe that veneration of Shiva Nataraja can help the soul to achieve eternal serenity and salvation.

Image 208. Jahangir Preferring a Sufi Shaikh to Kings. Bichitr. c. 1620 CE. Watercolor, gold, and ink on paper.

 i. The vertical format of this work was influenced by the Persian miniatures brought to India by the Mughal emperors.

 ii. The style of the painting combines Indian (pose and throne) with the Islamic Persian (bright colors, vegetal patterns, symmetry, use of calligraphy) and European (naturalism) traditions.

 iii. Unlike in Persia, Indian miniatures were usually made by individual painters rather than in workshops.

 iv. Paintings like this were often bound into albums and given as gifts.

v. The subject matter is symbolic of the spiritual world surpassing the earthly realm.

vi. Jahangir, son of Akbar, hands a book, the most respected of all objects, to a religious scholar.

vii. Akbar was a revered Islamic ruler who sought to maintain peace between Mughal rulers and the Hindu majority.

viii. Below him are people deemed less important than the scholar, including an Ottoman sultan, King James I of England (copied from a gift given to the court), and a self-portrait of the artist in the lower left.

ix. As a symbol of humility, the artist has signed the work on the step to the throne.

x. The halo combines the sun and crescent moon, both of which are symbols of Islam.

xi. The throne is hourglass shaped to symbolize time.

Image 209 (two images). Taj Mahal. Agra, Uttar Pradesh, India. Masons, marble workers, mosaicists, and decorators working under the supervision of Ustad Ahmad Lahori, architect to the emperor. 1632–1653 CE. Stone masonry and marble with inlay of precious and semiprecious stones; gardens.

i. This grand mausoleum was built by Shah Jahan I, Jahangir's successor, as a tomb for his favorite wife Mumtaz Mahal, who died in 1631, while giving birth to their fourteenth child. The body of Shah Jahan I, who died in 1666, is interred next to hers.

ii. The tomb took 22 years to complete and represents the queen's house in Paradise, complete with a palace garden and reflecting pool.

iii. The period of Shah Jahan I's rule is considered to be a golden period of Mughal architecture.

iv. The color was designed to contrast highly with the red sandstone and to create a sense that the structure is floating among the clouds.

v. Like most Islamic architecture, the structure is decorated with elaborate symmetrical geometric and vegetal patterns as well as calligraphic inscriptions from the Koran.

 CHINA

A. Daoism and Confucianism along with native folk religions dominated China before the arrival of Buddhism.

 1. The central tenets of Daoism involve living in harmony with nature and the Dao.
 2. Confucianism is an ethical system of behaviors rather than a religion.
 3. Both developed in the 5th century BCE.

B. The Buddhism that developed in China combined the indigenous religions with aspects of Daoism and Confucianism in order to make conversion to Buddhism more acceptable to common people. Courtly patronage helped spread Buddhism.

C. Like India, China was home to foreign cultures as well. Foreign invaders such as the Mongol (Yuan) and Manchu dynasties considered Chinese culture to be supreme and preferred to adopt it rather than to destroy it.

D. The practice of monochromatic ink painting on silk and paper was developed in China. These include illustrated manuscripts of Buddhist sutras done with gold or silver ink on mulberry-dyed paper.

E. The pagoda, based originally on a Chinese watchtower, incorporated symbols in a manner similar to stupas.

F. Chinese ceramics, especially porcelain, were prized all over Europe and Asia for their durable, yet fragile appearance.

G. Calligraphy was considered to be the highest art form.

H. Professional and non-professional artists were revered in China. Literati landscape paintings done by non-professional artists were highly influential in Korea and Japan. Often these works were paired with poetry.

I. Artworks from the image set

Image 193 (two images). Terra cotta warriors from mausoleum of the first Qin emperor of China. Qin Dynasty. c. 221–209 BCE. Painted terra cotta.

 i. Emperor Qin is considered to be the first emperor of China.

 ii. These images are from his vast necropolis, a portion of which has not yet been excavated.

 iii. Archeologists have unearthed sculptures of 8,000 soldiers, 130 chariots, 520 horses, and 150 elite cavalry horses along with stone armor, crossbows, and other weapons.

 iv. The sculptures of figures also include officials, acrobats, and entertainers.

 v. The necropolis was begun when the emperor ascended the throne at age 13 and was built by at least 700,000 workers over many years.

 vi. The life-sized figures are made of terra cotta using a combination of molds and the coil method. It is not known if some are portraits, but each figure has unique facial features.

 vii. Originally all of the objects were brightly painted with realistic colors.

 viii. Every object is signed by every worker who touched it, the result of which was absolute perfection in every detail, probably on pain of death.

 ix. This is believed to be the largest necropolis made for a single individual. Qin's burial mound has not been excavated, but contemporary accounts describe a large scale map of China complete with rivers of Mercury and a roof containing a map of the cosmos.

 x. The purpose was to protect the strict ruler in death from the many enemies he had made while alive.

 xi. This is an early example of the imperial practice of using peasant labor to glorify state power.

Image 194. Funeral banner of Lady Dai (Xin Zhui). Han Dynasty, China. c. 180 BCE. Painted silk.

i. This banner comes from one of the best-preserved tombs in China. It included over 1,400 objects including silk tapestries, bamboo objects, pottery vessels, musical instruments, wooden figures, lacquerware, clothing, and food.

ii. The tomb contained the remains of the Marquis of Dai and his family, of the Western Han dynasty. This banner was made for Lady Dai (Xin Zhui).

iii. Banners like this one were displayed during the funeral procession and ceremony.

iv. The painted scene may show the conducting of the deceased's soul to the land of the immortals.

v. The upper part depicts heaven, the bottom depicts the underworld, and the middle depicts the earthly realm. All use a combination of Chinese native and daoist symbols.

vi. The search for immortality was an important theme in the Western Han dynasty.

Image 195 (three images). Longmen caves. Luoyang, China. Late Northern Wei to Tang Dynasty. 493–1127 CE. Limestone.

i. The 2,300 caves and niches that were carved into the limestone cliffs were created during the height of Chinese Buddhism.

ii. The caves are located on both sides of the Yi River and were begun when the emperor of the Northern Wei dynasty made the area his capital. The site served as a gateway to his palace.

iii. The complex contains 110,000 Buddhist stone statues, 60 stupas, 2,800 inscriptions, and 140 prescriptions for curing various illnesses.

iv. Workers on the site and patrons gained merit from their actions, often intended to better the afterlife for deceased ancestors. The site was continuously added to for over 400 years.

v. The sculptures were done in two distinct styles. The earlier ones were done in the central China style/ Northern Wei style (slim figures influenced by Indian statuary) while the later ones were done in the Great Tang style featuring graceful lines and naturalistic forms.

vi. The Fengxiansi Cave contains nine giant sculptures including the Buddha (Grand Losana), two disciples, two bodhisattvas, two kings, and two warriors. This cave, which once had a temple above it for honoring ancestors, was originally shielded from view by a roof and later by a façade.

vii. The Fengxiansi Cave, completed in 675 CE, embodied the strength and spirituality of the Tang dynasty.

Image 201. Travelers among Mountains and Streams. Fan Kuan. c. 1000 CE. Ink on silk.

i. This is one of the most famous of the literati style of painting, a style favored by the educated elite of the Northern Song dynasty court. It is a monumental landscape painting that is almost seven feet tall.

ii. The style featured six essentials codified by the master that Fan Kuan studied under including spirit or vitality (chi), harmony and rhythm (yun), mental concentration (ssu), scenery (ching), brushwork (pi), and ink/tone (ching hao).

iii. Kuan developed his own style based on his observation of nature and rooted in Daoism as well as Confucian ideas about truth and beauty.

iv. He became one of the many recluse artists who became disenchanted with men and war. Most of them lived solitary lives while travelling, painting, and writing poetry.

v. This painting depicts mountains, considered to be sacred, using a uniquely Asian form of atmospheric perspective and featuring two very small figures overpowered by the vastness of the landscape.

vi. Many East Asian artists used only black (and gray when water is added) ink on white because the black ink contains all of the colors of the visible light spectrum.

Image 204. The David Vases. Yuan Dynasty, China. 1351 CE. White porcelain with cobalt-blue underglaze.

i. These vases were named for the man who collected them and brought them to England.

ii. They were made as an offering to a Daoist temple and originally were given along with an incense burner (now missing). A specific name and date are painted onto the works.

iii. This style of fine porcelain, known as blue/white, was first produced in China in 600 CE and influenced styles in diverse regions such as Persia, Turkey, and the Netherlands. Many of the pieces made in this style were created for export to Europe and Islamic territories.

iv. The Yuan dynasty of China, during which these were produced, was part of the Mongol Empire, and the cobalt used to make the blue glaze was imported from modern day Iran, which was part of the Mongol empire at the time.

v. The decoration depicts dragons, considered to be one of the four supernatural spirits, and the mounts of the gods. The decoration also features phoenixes (believed to embody the five virtues of benevolence, righteousness, propriety, wisdom, and sincerity) along with vegetal patterns. All of the decoration is symbolic of good luck and are metaphors for gentlemen and sages, Confucianism (phoenix) and Daoism (dragon).

vi. The form of the vases is based on older styles of bronzeware commonly found in temples.

Image 206 (five images). Forbidden City. Beijing, China. Ming Dynasty. 15th century CE and later. Stonemasonry, marble, brick, wood, and ceramic tile.

i. This palace complex took 14 years to build and was used during both the Ming and Qing dynasties, until 1924. It is considered to be the world's largest palace complex.

ii. It was constructed during the Ming dynasty after the expulsion of the Mongols in an attempt to return to the former glory of the Han dynasty.

iii. The city was meant to separate the emperor from the public in order to renew imperial power.

iv. It was forbidden to enter the complex without the permission of the emperor.

v. The only gate in use today is the front gate (Wumen Gate).

vi. Originally, the central doorway was for the exclusive use of the emperor. The empress used it only once, on her wedding day, and once a year certain scholars were granted permission to use it. The other doors through the gate were for specific ranks of people.

vii. Within the complex a series of bells and drums announced the movements of the emperor.

viii. The complex is surrounded by a high wall and a moat, with lookout towers at each corner.

ix. The Wumen gate allowed access to the outer court in the southern section of the complex, where the emperor conducted business and received guests. The Hall of Supreme Harmony was a reception room, a coronation room, and a room where generals were dispatched to war.

x. The Shenwu gate led to the northern section or inner court, where the emperor lived with his family. This area was private and included the Palace of Tranquility and Longevity, which was a bedroom and marriage chamber.

xi. The decoration of the complex features yellow as the dominant color, the symbolic color of the royal family.

Image 212. Chairman Mao en Route to Anyuan. Artist unknown; based on an oil painting by Liu Chunhua. c. 1969 CE. Color lithograph.

i. This work was part of the Cultural Revolution of 1966, during which traditional artists were humiliated, tortured, and/or denounced.

ii. It depicts Chairman Mao during the 1920s walking to the Anyuan Coal Mine, where he helped organize a successful strike. He and other Communist leaders regarded this event as their first successful venture.

iii. It is an idealized portrait and one of many works created using the state-sanctioned realist style that was influenced by earlier European propaganda art created under Stalin, Hitler, and Mussolini.

iv. The glowing tones and heroic stance made it very popular. Although the original artist is unknown, this image was published widely in newspapers and journals and on posters. The image was printed on utensils, and statues were made of Mao in this heroic stance.

IV. KOREA

A. Most Korean traditions were heavily influenced by China due to the conquest of the region by the Tang Dynasty.

B. During several periods Neo-Confucian ideas were embraced and had a great influence on artistic style, especially ceramics.

C. Artworks from the image set

Image 196. Gold and jade crown. Three Kingdoms Period, Silla Kingdom, Korea. 5ᵗʰ to 6ᵗʰ century CE. Metalwork.

 i. The Silla kingdom was well known for the numerous gold objects created locally and used in burials.

 ii. This crown is from an above ground tomb designed for elite and royal people.

 iii. It was once worn by a Silla queen who was buried with many essentials and luxuries intended for use in the afterlife.

Image 205. Portrait of Sin Sukju (1417–1475). Imperial Bureau of Painting. c. 15ᵗʰ century CE. Hanging scroll (ink and color on silk).

 i. This painting is an ancestor portrait, a popular form of ancestor veneration in Korea, China, and Japan.

 ii. It is meant to honor the deceased by recording his likeness, important deeds, and rank. Paintings like this were created by court painters.

 iii. Sin Sukju is depicted as a Neo-Confucian scholar and politician wearing the official green uniform of his rank. The symbols painted on his chest were probably added after his death.

 iv. This painting was created during the Joseon dynasty, which lasted until 1910. It is primarily remembered for the unique form of Confucianism called Neo-Confucianism, which was instituted during that time period.

V. JAPAN

A. The major religions of the region include the ancient, animistic, nature-based Shinto religion and Buddhism, which was introduced from China and Korea in the 7ᵗʰ and 8ᵗʰ centuries.

B. Courtly patronage as well as similarity to local traditions helped Buddhism spread throughout Japan.

C. Japanese architecture often uses natural materials. As in China, many architectural works use wooden structures with tile roofs.

D. Rock gardens, Zen ink painting, and teahouses are artistic forms unique to Japan.

E. The Yamato style of painting was an important artistic contribution. This unique approach to narratives employs outlines, flat color, stylized figures with simplified faces, and elevated perspective.

F. Artworks from the image set

Image 197 (five images). Todai-ji (Great Eastern Temple) Nara, Japan. Various artists, including sculptors Unkei and Keikei, as well as the Kei School. 743 CE; rebuilt c. 1700. Bronze and wood (sculpture); wood with ceramic-tile roofing (architecture).

 i. This Buddhist temple complex was originally modeled after Chinese Tang style architecture.

 ii. Originally built in 752 CE, the temple complex was destroyed by fire, earthquakes, and civil war and restored several times. The most notable restoration took place from 1181–1206 under the direction of Shunjobo Chogen, a Japanese monk who had travelled to China.

 iii. The Daibutsuden (Great Buddha Hall) is one of Japan's most famous temples. It was the head Buddhist temple in Japan and is believed to be the best of imperial Buddhist architecture.

 iv. It was built for the Kegon sect of Buddhism, the earliest form of Japanese Buddhism.

 v. The Great Buddha sculpture depicts the Vairocana Buddha, the central cosmic Buddha and the one that embodies emptiness. The Great Buddha seen today dates from 1692, when the original was replaced, and is in the style of Indian sculptures of the Vairocana Buddha.

 vi. The two Nio guardian statues, done by famous sculptors Unkei and Keikei, date from the Kamakura period when the Shogunate held the power in Japan.

 vii. They depict Hindu gods adopted into Japanese Buddhist tradition who, like the shoguns, are aggressive guardian deities meant to protect against evil.

viii. The style of the Nio figures is one of exaggerated realism, with the hair styled in the warrior-style topknot.

ix. They were once covered in black lacquer, making them appear to be even more intimidating.

x. The Great South Gate was reconstructed in the 12th century CE in the Chinese Song Dynasty style.

Image 203 (two images). Night Attack on the Sanjô Palace. Kamakura Period, Japan. c. 1250–1300 CE. Handscroll (ink and color on paper).

i. This emaki (illustrated handscroll) piece is a fragment of the original Heiji scrolls, once much larger but now existing in fragments.

ii. This panel is considered to be one of the masterpieces of the Yamato painting style, meant to break from the Kara style (Chinese style). It features stylized figures with simple faces and bright pigments seen from an elevated perspective, with clouds used to divide the space.

iii. Scrolls like this one are read from right to left in small (approximately two feet wide) segments and depict tales from history, fiction, the four seasons and other subjects.

iv. This depicts a brief but deadly armed conflict of 1159, part of the Heiji disturbance, during which a coup was staged against the sovereign. In this panel the palace is surrounded and torched and the sovereign is captured.

v. Like the Bayeux Tapestry, this painting offers a rare depiction of the Japanese Samurai armor of the Kamakura period.

Image 207 (three images). Ryoan-ji (Peaceful Dragon). Kyoto, Japan. Muromachi Period, Japan. c. 1480 CE; current design most likely dates to the 18th century. Rock garden.

i. This Zen temple stands on what was originally a Fujiwara clan estate during the Heian period.

ii. It was constructed for the Rinzai branch of Buddhism that was brought to Japan from China in 1191.

iii. The dry garden (rock garden) is a uniquely Zen Japanese art form that depicts the beauty of oceans, rivers, islands and/or mountains using only rocks, sand and gravel.

iv. This one was carefully designed by an unknown artist to seem random.

 v. Only 14 of the 15 carefully placed rocks are visible from any angle of the garden. The number 15 denotes completeness in Zen Buddhism. The garden serves as a reminder that completeness in this world is not possible.

 vi. The wet garden is a pond that attracts many water birds and has two small islands, one of which features a shrine to the Shinto goddess of luck and a bridge connected to it from the main grounds.

Image 210 (two images). White and Red Plum Blossoms. Ogata Korin. c. 1710–1716 CE. Ink, watercolor, and gold leaf on paper.

 i. This screen was made for a feudal lord and features the Rinpa style of painting.

 ii. The style is known for the technique of using wet color on wet ink, seen in the branches and trunks. The water is depicted as stylized loops to evoke the rhythmic flow of water.

 iii. Ogata Korin originated the style of depicting plum blossoms without outlines.

 iv. The unique style of this work is part of the Yamato style of painting.

Image 211. Under the Wave off Kanagawa (Kanagawa oki nami ura), also known as the Great Wave, from the series Thirty-six Views of Mount Fuji. Katsushika Hokusai. 1830–1833 CE. Polychrome woodblock print; ink and color on paper.

 i. This is one of the most famous of the Edo period woodblock prints.

 ii. The minimalism, strong shapes, and outlines as well as bright colors are typical of the Ukiyo-e (floating world) prints made at the time. This one was intended for tourists visiting Mount Fuji, the highest and most sacred mountain in Japan. Prints like this sold for about the same price as a bowl of noodles.

 iii. The artist designed the image, but the woodblock prints were made by a master printer.

 iv. Most Ukiyo-e prints depict the world of courtesans and actors, but Hokusai, known for his clever ideas, decided to revisit the popular theme of the many views of Mount Fuji.

 v. In this depiction the great wave dwarfs the highest mountain in Japan as well as the fishermen returning home.

 vi. Hokusai was influenced by Dutch prints, brought by the only European nationality allowed to trade with Japan.

 vii. The linear perspective, low horizon line, and strong blue color (at the time a new and excellent pigment originating from China) are all hallmarks of those influential prints.

 viii. Hokusai originated a uniquely Japanese approach to perspective with these works, which had a large effect on modern European art during the late 19th century.

VI. SOUTHEAST ASIA

A. Much of Southeast Asia is linked culturally to India due to waves of importation and attempts at colonization.

B. During the second millennium CE many areas of the region came under control of Islamic sultanates. Today, Islam is a dominant religion in Southeast Asia.

C. Artworks from the image set

 Image 198 (three images). Borobudur Temple. Central Java, Indonesia. Sailendra Dynasty. c. 750–842 CE. Volcanic-stone masonry.

 i. This is the largest stupa complex in the world. It took 75 years to build, using an interlocking system of masonry.

 ii. Buddhist pilgrims came from all over Asia to pay homage and, like many pilgrimage temples, the decorations are meant to impart Buddhist stories and values to worshippers.

 iii. The complex contains 2,672 sculpted reliefs depicting the life journey and teachings of the Buddha as well as Javanese history. They are revealed to worshippers slowly during ritual circumambulation.

 iv. The lowest level depicts the world of desire and greed.

 v. The images on the five upper levels instruct worshippers on conquering attachment.

 vi. At the top level, sculptures of a meditating Buddha and saints as well as five mountain-like sculptures (representing the five volcanoes) represent supreme bliss.

 vii. At the top level, in the center, is a stupa pointing to the highest realm of nirvana.

Image 199 (six images). Angkor, the temple of Angkor Wat, and the city of Angkor Thom, Cambodia. Hindu, Angkor Dynasty. c. 800–1400 CE. Stonemasonry, sandstone.

 i. This temple complex was originally built by the Khmer civilization who ruled over a huge kingdom.

 ii. It now contains 100 stone temples but originally contained palaces, public buildings, and smaller homes.

 iii. The complex was built on land that was located in a strategic military position and had fertile farmland.

 iv. Built to honor the Hindu god Vishnu, it was designed to be a symbolic representation of Hindu cosmology. Some scholars believe that it was built to line up with certain constellations.

 v. The short dimensions lie on the North/South axis, and the 108 towers represent a sacred number to Hindus and Buddhists.

 vi. The relief that depicts the Churning of the Ocean of Milk shows an episode from the Puranas in which Devas (angels) and Asuras (demons) battle for the world. When the Asuras won, Indra, commander of the Devas, asked Vishnu for help. He instructed them to churn the ocean of milk to become immortal.

 vii. Buddhism arrived in Cambodia during Ashoka's reign in India and was embraced by Jayavarman II who proclaimed himself to be a god-king. He was the first of the Angkor dynasty, and he identified with both Hinduism and Buddhism.

 viii. The relief of Jayavarman VII as Buddha depicts a ruler who ascended to the throne during crisis and then blamed the Hindu gods for abandoning his empire. He embraced Buddhism and added Buddhist reliefs to the complex.

 ix. In this depiction Jayavarman VII appears as an ascetic in a meditative pose.

THE PACIFIC/OCEANIA
700–1980 CE

Note: The image set for this chapter can be found on pages 159–162 of the College Board's *AP Art History Course and Exam Description.*

I. OVERVIEW

A. The region consists of over 25,000 islands, 1,500 of which are inhabited. By 800 CE, the area was described as three sub-regions. Relative isolation from colonization for several thousand years allowed for unique styles to develop that were shaped by tribal customs and ecological surroundings.

B. Although each sub-region has unique stylistic tendencies, there are overall connections throughout the region.

C. Objects created by specialized craftsmen are an integral part of the religious and social life of the islands. Most objects are created for ancestor or spirit worship. Some are focused on fertility.

D. The belief in the coexistence of life and death requires Pacific people to show respect to the deceased in order to protect themselves. Masks, statues, and other objects used in a prescribed way help ensure this protection.

E. Chiefs are linked by genealogy to the deities. They serve as the bridge between this world and the supernatural one.

Chiefs distribute wealth to their people through prescribed rituals of exchange.

F. Individual positions are not as important as the welfare of the community.

G. Artists are accorded high status. Manual skill and inventiveness are associated with magic and are highly respected. While works of art are being created, the patron(s) make sure that the artist is supplied with all of the necessities of life and even some luxuries.

H. Art is a language with prescribed visual vocabulary. The head is considered to be the most important part of the body and is often depicted as larger in proportion to the rest of the body.

I. The arts of the region, including visual arts, songs, dances, dramas, and storytelling, are made for use in daily life, as expressions of social status and genealogy, as symbols of spiritual beliefs, or as items made for exchange.

J. The combination of identity, power, and spiritual strength is known as mana. Each culture of the region developed a means for protecting this force through the use of shielding or wrapping, called tapu.

K. Most works of art are meant to be used in some way; therefore, the creation, performance, ritual use, and sometimes destruction of the object are more important than the object itself.

L. The colonization of the region and the mass conversion to Christianity during the 19th century had a significant effect on the arts of the region, especially Polynesia. The creation of figurines representing ancestors and deities declined significantly, and many existing examples were destroyed after being condemned as pagan idols.

M. A large number of objects from pre-colonial times were collected by missionaries, colonists, and explorers and sent back to Europe and the United States where they ended up in museums and private collections.

II. MICRONESIA

A. Overview

1. This sub-region is composed of approximately 2,000 islands scattered over a huge area of sea.

2. In the 16th century, Spanish galleons began to visit the sub-region, especially the island of Guam. In the 1800s, other European and American whalers, traders, and missionaries regularly visited the area. From 1919 until 1945, Japan occupied the region. Most of the region is now independent of any outside nation, although the U.S. has a military presence there.

3. Some of the most important objects that come from this region include Palauan storyboards for the decoration of the bai (men's houses), carved figures, and fiber crafts such as fans, baskets, etc.

Test Tip

Be prepared to discuss the pros and cons of European colonization on the arts of the Pacific Islands.

B. Artworks from the image set

Image 213 (two images). Nan Madol. Pohnpei, Micronesia. Saudeleur Dynasty. c. 700–1600 CE. Basalt boulders and prismatic columns.

i. The ruins of this abandoned city, which are about 900 years old, consist of 92 artificial islets that are in total 1 mile long and one-half mile wide.

ii. One part of the city was constructed for the use of priests and rulers, and the other half contained vaults, meeting houses, public baths, temples, and agricultural pools.

iii. Scholars are unsure how the heavy basalt was moved into place to build this site or what the original use was. The basalt was cut and stacked without the use of mortar. Some speculate that the city was built over a period of several centuries by thousands of workers.

iv. The site was abandoned in the mid-19th century.

v. The site may have been used to make the ceremonial and medicinal drink with sedative and anesthetic properties called Sakau (it is known by other names in other sub-regions of the area).

Image 217. Female deity. Nukuoro, Micronesia. c. 18th to 19th century CE. Wood.

i. This region of Micronesia has only 300 residents, who live on a ring of tiny islands.

ii. Dinonga Aitu (deity figures) like this one are rare and exhibit a unique style of streamlined simplicity.

iii. Micronesian figural sculptures like this one have heads that are mostly in proportion to the body. This aesthetic is unique to the region.

iv. Figures like this one were probably kept in culthouses, unique forms of art in which art and architecture are closely connected, and used for specific rituals.

Image 221. Navigation chart. Marshall Islands, Micronesia. 19th to early 20th century CE. Wood and fiber.

i. Micronesians navigated long distances between small islands.

ii. Stick charts like these were associated with long voyages, along with weather charms (called hos).

iii. Charts like this illustrated currents, sandbars, wave swells, and the location of islands.

iv. The horizontal and vertical sticks are used as a support grid. The diagonal and curved sticks represent wave swells and currents. The small shells represent islands.

v. Some charts, like this one, illustrated a large area, while others illustrated only a few islands.

vi. Prior to a voyage, the travelers would perform a ceremony using weather charms while chanting to guard against storms and evil spirits. Navigators would memorize a stick chart like this one before leaving, unlike European sailors who brought maps along on a voyage.

III. MELANESIA

A. Overview

1. In 1660, the Dutch claimed New Guinea as part of the Dutch East Indies (now called Indonesia). From the mid-17th century

until the mid-19ᵗʰ century Britain, Australia, Germany, and Japan also colonized the region.

2. In the late 19ᵗʰ century, missionaries converted the majority of residents to Christianity, although some areas, like the interior highlands of New Guinea, resisted westernization until the 1950s.

3. Residential separation of men and women was common, with women and children occupying domestic dwellings and men residing in culthouses, used for rituals and defense.

B. Artworks from the image set

Image 222 (two images). Malagan display and mask. New Ireland Province, Papua New Guinea. c. 20ᵗʰ century CE. Wood, pigment, fiber, and shell.

i. Malagan masks and displays were created to honor the dead and were used in elaborate feasts and ceremonies.

ii. Artworks associated with these ceremonies are collectively called malagan.

iii. Preparation for malagan ceremonies can last for a few months to a few years after a death. Performances are organized, food is prepared, and masks and sculptures are created for use and display during the ceremony, after which most items are destroyed.

iv. Ceremonies are paid for with pigs and shell money. Often more than one family will pool resources to pay for a ceremony to honor several deceased family members at once.

v. Sculptural displays are custom made to honor specific people. Each sculpture displays information about the deceased's family lineage and is meant to represent the soul of the deceased.

vi. It is believed that the deceased inhabit their sculpture until the ceremony ends, at which time they travel to the realm of the dead but still have the ability to interact with the living. Once used, the sculptures are burned or allowed to rot.

vii. Masks are used in elaborate performances to tell stories and perform rituals meant to help send the soul of the deceased to the realm of the dead. Unlike the sculptures, masks are kept for use in future malagan ceremonies.

Image 218. Buk (mask). Torres Strait. Mid- to late 19th century CE. Turtle shell, wood, fiber, feathers, and shell.

 i. Masks like this one were used during funerary ceremonies, harvest festivals, and initiation ceremonies.

 ii. The imagery is a combination of human and animal.

 iii. Senior men wore masks with elaborate grass costumes to re-enact epic stories from oral traditions.

 iv. This mask was worn over the head like a helmet.

IV. POLYNESIA

A. Overview

1. The Marquesas Islands were visited in 1595 by a Spanish navigator who found little to exploit there. The English Captain James Cook was the first European to extensively explore the area. By the early 20th century, most of the area had been colonized by Chile, France, Germany, the United Kingdom, and the United States.

2. When the more traditional sculptural art forms were in decline due to their perception as pagan, secular artistic traditions continued, including the creation and decoration of bark cloth.

3. The practice of tattooing in Oceania is unique to Polynesia. Tattoos among the Maori people were used as status symbols as well as a means of beautification and protection.

4. The French Post-Impressionist painter Paul Gauguin was highly influenced by his time in Tahiti, which was colonized by the French. Many of his best paintings were done on the island.

B. Artworks from the image set

Image 214. Moai on platform (ahu). Rapa Nui (Easter Island). c. 1100–1600 CE. Volcanic tuff figures on basalt base.

 i. The island of Rapa Nui (Easter Island) has 887 of these large-scale figural monoliths, all made between 1250 and 1500 CE.

ii. Some are deliberately placed near beaches, possibly as guardian figures, and others are in quarries.

iii. Scholars are unsure of their original significance although many believe they represent chiefs who were believed to be direct descendants of the local deities.

iv. The heads are disproportionately larger than the bodies and some, like this group, wear a pukao (topknot) made of red volcanic rock. The red rock is not as resilient as the volcanic rock used for the rest of the sculpture, therefore scholars are uncertain if most of the figures originally had pukaos.

v. Although they are all similar in style, each one has unique features. Some have white and black inlaid eyes. For this reason, some scholars believe they are ancestor figures that represent specific people.

vi. Many of the figures appear to have been in transit to a specific site by the beach but were abandoned.

vii. Some of the groups were placed on stone bases, called ahu, in a straight line. Burial sites are located near some of the groups.

viii. Many of the figures were toppled by the time Europeans arrived on the island. This was due to tribal warfare, weather, and deterioration.

ix. The decline of the island's population was brought about by a combination of deforestation, rat infestation, cultural change, Peruvian slave traders, and the introduction of European diseases like smallpox.

Image 215. 'Ahu 'ula (feather cape). Hawaiian. Late 18th century CE. Feathers and fiber.

i. Feathered capes and cloaks like this one were worn by Hawaiians of the highest social status.

ii. The length of the cloak reflected the status of the owner. A person of lower status owned this one.

iii. These feathered cloaks and capes were worn during ceremonies and battles for physical and spiritual protection.

iv. Red feathers were associated with gods and chiefs. Yellow feathers were highly valued because of their scarcity on the island.

v. These capes were created using a unique method of bundled feathers attached to a mesh base.

vi. The style of this 'ahu 'ula may have been in imitation of European officers' jackets. This cape was presented to a Russian explorer in 1817 by a queen.

Image 216 (three images). Staff god. Rarotonga, Cook Islands, central Polynesia. Late 18ᵗʰ to early 19ᵗʰ century CE. Wood, tapa, fiber, and feathers.

i. Wooden figures like this one represented gods and possibly ancestors and/or totemic animals. This is the only surviving wrapped staff god.

ii. The lower portion of the staff was ritually wrapped in bark cloth, coconut fiber, and feathers in order to contain the deity's powers (mana), which were both revered and considered to be potentially dangerous.

iii. The lower end of the figure would have been attached to a large phallus, which is now missing.

iv. Early explorers of the Cook Islands reported seeing these large sculptures being carried on litters during rituals.

v. Because all staff gods that remained on the island were destroyed by missionaries during the 19ᵗʰ century, the original meaning of these sculptures is now lost.

vi. On other islands, similar figures are used to show the line of descent from a deity of male ancestors.

Image 219. Hiapo (tapa). Niue. c. 1850–1900 CE. Tapa or bark cloth, freehand painting.

i. Decorated cloths like this one were used for ceremonies or rituals.

ii. Many depict specific events in abstract form.

iii. The designs used are unique to the island of Niue, and some may take inspiration from local plants.

iv. The cloth and designs are made exclusively by women.

v. The designs are painted freehand using a highly animated visual system that may represent mana (spiritual power).

Image 220. Tamati Waka Nene. Gottfried Lindauer. 1890 CE. Oil on canvas.

i. This is a portrait painted posthumously of a well-known Maori chief who took the baptismal name of Thomas Walker.

ii. He encouraged and protected trade with Europeans in New Zealand.

iii. He led his tribe in battles with other Maori tribes, both on their own and sometimes alongside of the British. He believed that the only chance for Maori survival and for the continuation of their culture was to join forces with the British.

iv. He is dressed in a traditional fiber cloak holding a tewhatewa (weapon staff).

v. The artist travelled extensively in New Zealand and painted many portraits of Maori.

vi. The traditional method for creating a tattoo (ta moko) is a long and painful process that starts with incised cuts into which dark ink is imbedded using a bone chisel. Medicinal leaves are placed over them to speed healing and protect the recipient.

vii. All Maori men of rank had facial tattoos done at puberty during special rituals.

viii. Men's tattoos were done mostly on the face because of the importance of the head as the seat of spiritual power. Women's tattoos were not as extensive.

ix. The tattoo artist created a unique design for each person that reflected their genealogy and highlighted their facial features.

x. Various symbols on different parts of the face indicated rank and genealogy.

Image 223. Presentation of Fijian mats and tapa cloths to Queen Elizabeth II. Fiji, Polynesia. 1953 CE. Multimedia performance (costume; cosmetics, including scent; chant; movement; and pandanus fiber/hibiscus fiber mats), photographic documentation.

i. In 1953, Queen Elizabeth II of England paid a visit to the Kingdom of Tonga, the only Pacific nation to retain its own monarchy. Queen Salote had attended the coronation ceremony for Queen Elizabeth II earlier that year.

ii. At the time, Tonga was protected by the British government under arrangements made by Queen Salote prior to her death (this treaty ended in 1970).

iii. In this photo, an elaborate welcoming ceremony was underway which was the largest ever seen on the island.

iv. A group of women are presenting the Queen of England with a very large Ngatu launima, which is a large decorated bark cloth.

v. This one was made especially for this visit and, like all decorated bark cloths, was made by women.

vi. Ngatu are gifts that are meant to be recirculated at important events such as weddings, funerals, and other special occasions.

vii. The cloth in the picture was used in 1965 as part of the funeral ceremony of Queen Salote.

Test Tip

Pre-colonial native craftsmen of Oceania, Africa, and the Americas placed great value on natural materials. You should be able to discuss the reasons for this tendency.

GLOBAL CONTEMPORARY 1980 CE–PRESENT

Note: The image set for this chapter can be found on pages 165–173 of the College Board's *AP Art History Course and Exam Description.*

I. OVERVIEW

A. Technological advances and global awareness have had a significant impact on how art is made and on where and how it is displayed.

B. Beginning in the 1990s, curators actively sought to show the work of artists previously ignored by the traditional art establishment. As a result, artists from diverse nationalities, ethnicities, genders, and sexual preferences have been embraced by museums, galleries, and other exhibition venues.

C. Artworks that use appropriation, uncommon materials, and interactivity have redefined traditional notions about art subjects and media.

II. NEW MEDIA AND INSTALLATIONS

A. Overview

1. New media artworks are primarily made using computers. They may incorporate film and video, three-dimensional printing, and traditional materials.

2. The term is constantly being redefined as new technologies emerge.

3. Installation artworks are a form of conceptual art that incorporate two- and three-dimensional materials to transform a space. The artworks may or may not be site specific.

4. Some new media artworks and installations incorporate performance and/or interactivity.

B. Artworks from the image set

Image 224 (two images). The Gates. New York City, U.S. Christo and Jeanne-Claude. 1979–2005 CE. Mixed-media installation.

i. The artists developed the concept for this large-scale installation in 1979, although it was not actually produced until 2005.

ii. The work was temporary and is linked to the environmental art of the 1970s.

iii. Other artworks by these artists have used fabric, curtains, and umbrellas to wrap and change large structures or natural environments.

iv. This piece incorporated 7,500 constructed gates across 23 miles of footpaths in New York City's Central Park. Each 16 foot tall gate had a large piece of saffron colored fabric hanging to seven feet above ground level.

v. The artists' intention was to create an aerial view of a golden river that appeared and disappeared among the trees in the park. At ground level the fabric evoked organic forms as it moved in the air, transforming the footpaths completely.

vi. The installation was financed by the artists and most of the saffron material was intended for recycling. The artists sold merchandise related to the exhibition.

Image 225 (two images). Vietnam Veterans Memorial. Washington, D.C., U.S. Maya Lin. 1982 CE. Granite.

i. This site-based artwork was designed in 1981 by Lin while she was a student at Yale University's School of Architecture.

ii. Her design was one of over 1,400 submitted to a call for entries by the United States Government for a national Vietnam Veterans Monument to be placed in Washington, D.C.

iii. Her work is influenced by diverse sources including Japanese gardens, Native American Earth mounds, and earthworks such as Spiral Jetty.

iv. For this monument she designed a highly reflective black granite v-shaped wall that is sunk into the land rather than set on top of it. The names, placed in chronological order, of the 57,661 American soldiers who died in the conflict are inscribed on the wall, allowing viewers to see the names as well as their own reflections simultaneously.

v. The sunken placement of the wall was important to the concept because the artist wanted viewers to be on a spiritual journey that would make them reflect upon the death of the soldiers while being cognizant of the fact that they were still alive.

vi. Due to pressure from war veterans who were critics of the design, a more traditional and realistic sculpture and American flag were added, but were placed off to the side of Lin's design.

Image 229. A Book from the Sky. Xu Bing. 1987–1991 CE. Mixed-media installation.

i. This mixed-media installation is made from hand-printed books as well as ceiling and wall scrolls printed using wood letterpress type.

ii. The wooden type was hand-carved and then printed by the artist to mimic the form of traditional Chinese publications.

iii. The type is not actual Chinese lettering. The artist designed imaginary words that make no sense in any language.

iv. The printed matter, which took years to create, was intended to look legible but was made not to be.

v. The work was first installed in a Chinese gallery in 1988–1989 and has since been shown in several museums and exhibition spaces around the world.

vi. During the time when the work was created, the Cultural Revolution in China had officially ended, leading Chinese artists to question both the past and the future of the Chinese culture.

vii. Xu Bing quickly became a leading member of the Chinese avant-garde.

viii. The artist intended to immerse the viewer in a sea of imaginary words while addressing the loss of meaning and culture in his native country.

Image 236. En la Barberia no se Llora (No Crying Allowed in the Barber Shop). Pepon Osorio. 1994 CE. Mixed-media installation.

i. This artwork was originally installed in an exhibition space in Hartford, Connecticut. At the opening reception, the artist recruited real barbers to offer haircuts to viewers.

ii. The work was meant to be entered and experienced by the viewer. It was originally installed in a vacant store.

iii. This artwork re-creates the artist's memory of his first haircut at age five. What was seen as a celebratory rite of passage by others became a scary scenario that he mostly cried through.

iv. Pepon Osorio worked for several years as a social worker in the Bronx, New York City. His work draws on Puerto Rican cultural norms, inner-city life as well as childhood memories.

v. The installation "shop" contained images of Latinos, men crying, powders meant to develop male prowess, and other items associated with masculinity.

vi. The work was meant to show the contradictions found among cultural ideas of masculinity.

Image 238. Electronic Superhighway. Nam June Paik. 1995 CE. Mixed-media installation (49-channel closed-circuit video installation, neon, steel, wood, and custom electronic components).

i. This work was inspired by Paik's arrival in the United States in the 1960s. At that time, superhighways were new and were heavily advertised as a way for Americans to see the country on a limited budget.

ii. The huge scale of the work was intended to show how large Paik found the United States to be compared to his native Korea.

 iii. The numerous flashing images are meant to evoke landscapes seen from the window of a moving car. Inserted into these images are scenes from pop culture and movies that helped define the way that Americans saw themselves.

 iv. The neon outlines recall signs viewed on the road such as motels, diners, etc. They also outline the states to remind the viewer of the distinct identity of each state in the country.

 v. Paik coined the phrase "electronic superhighway." This artwork was meant to contrast the actual road trips of the past with the virtual travels of the internet, which was fairly new yet growing exponentially at the time when this artwork was created.

Image 239. The Crossing. Bill Viola. 1996 CE. Video/sound installation.

 i. This work, like most works by Viola, uses new media to create an immersive sound and video environment.

 ii. The artwork uses a double-sided video projection on a freestanding piece of clear acrylic.

 iii. On one side of the image a man walks up to the viewer and a trickle of water overhead becomes a deluge in which the man disappears.

 iv. On the opposite side of the acrylic sheet the same man disappears after being engulfed in flames.

 v. The artist draws on universal truths about life and death found in both Eastern and Western religious traditions.

Image 243. Darkytown Rebellion. Kara Walker. 2001 CE. Cut paper and projection on wall.

 i. Walker is well known for her installations that explore the history of race relations and slavery in the United States.

 ii. The use of cut paper silhouettes is deliberately reminiscent of the Victorian era, when the medium was used as an inexpensive alternative to painted or photographic portraits.

 iii. This work, like most of Walker's installations, makes use of life-size silhouettes placed on the walls of the space with overlays of colored projections. The subject is a mix of fact and fantasy meant to evoke an emotional response in the viewer.

iv. The shapes depict stereotypes of antebellum African American slaves engaged in rebellion of various sorts. The silhouettes both reveal and conceal details about the figures.

v. The viewer is forced to become part of the scene, making it impossible to ignore the history and the brutality of slavery in the United States.

vi. Walker also creates an alternate view of African Americans that is very different from the representations found historically in American visual and pop culture.

Image 244. The Swing (after Fragonard). Yinka Shonibare. 2001 CE. Mixed-media installation.

i. This installation is composed of a life-sized headless female mannequin dressed in bright African printed fabric. The pose was appropriated from the Fragonard painting of the same name.

ii. The resulting sculpture is both familiar and strange. The viewer can place him- or herself in the position of either of the male figures present in the original painting.

iii. The fabrics are a contrast to the pink frilly costume depicted in the original painting and allude to the hybrid of Dutch and African traditions embedded in the fabric.

iv. The headless mannequin may be a visual reminder of the downfall of the aristocracy that commissioned Rococo paintings. Twenty-five years after the Fragonard work was completed, the French Revolution ended the aristocratic way of life captured in the work.

Image 248. Shibboleth. Doris Salcedo. 2007–2008 CE. Installation.

i. Salcedo created a temporary 548-foot-long series of fissures of various widths (up to one foot across in some parts) in the floor of the exhibition space.

ii. The work is deliberately reminiscent of cracks made in the ground by earthquakes and droughts.

iii. The title refers to a word or custom used to differentiate members of ingroups from those of outgroups.

iv. Salcedo's intent was to call attention to divisions in ethnicity, political association, class, and culture that are embedded in modern society.

v. For this work, Salcedo drew on her experience as a Colombian visiting the United States and Europe.

vi. The artwork was part of a series created for the Turbine Hall, the main entrance lobby of the Tate Modern museum in London. Following the exhibition in 2007–2008 the crack was filled in, but still remains visible.

Image 250. Kui Hua Zi (Sunflower Seeds). Ai Weiwei. 2010–2011 CE. Sculpted and painted porcelain.

i. This installation was originally made for display at the Tate Modern's Turbine Hall. When the exhibit ended in 2011 the artist re-created the installation, in different formats, in other museums and venues around the world. Some of the seeds were sold in glass jars as well.

ii. The installation was composed of 100 million realistic looking porcelain sunflower seeds spread over the floor. Originally viewers could walk through the seeds, but within 10 days of the exhibit opening, the dust created by the foot traffic across the work resulted in a change in the installation. The museum and the artist decided that the public could view the work from above or from the sides, but they could no longer interact with it.

iii. Each seed was individually sculpted and hand painted by craftsmen working in Jingdezhen, China, where porcelain goods have been produced for 1,200 years.

iv. The artwork was inspired by memories of the artist's childhood when Chairman Mao referred to himself as the sun and to his followers as his loyal sunflowers.

v. Sunflower seeds are a popular snack in modern day China, despite their association with Mao.

vi. In 2011, the artist, who is an outspoken critic of the Chinese government, was arrested in his native China and held in captivity for three months. He was released due to pressure from representatives of the art world.

III. ARCHITECTURE

A. Overview

1. Many late 20th and early 21st century architectural works are a response to the modernist style that dominated the 20th century.

2. Often referred to as Post-Modernism, many works appropriated modernist and classical works in order to add a new layer of meaning to the style.

3. The use of organic, rounded forms and asymmetrical designs are a hallmark of 21st century architecture. Other characteristics include the use of design elements inspired by the natural world, disjointed elements, and random angles.

B. Artworks from the image set

Image 240 (three images). Guggenheim Museum Bilbao. Spain. Frank Gehry (architect). 1997 CE. Titanium, glass, and limestone.

 i. This building was constructed to serve as a museum of modern and contemporary art.

 ii. The design uses freeform sculptural elements that are asymmetrical.

 iii. The building is located in the old industrial heart of the city of Bilbao, Spain, along the Nervion River.

 iv. The design both blends with and stands out from the industrial buildings around it.

 v. The shiny titanium tiles that sheathe most of the building may have been inspired by fish and the fishing industry that, along with the shipbuilding industry, was once a major part of Bilbao's economy.

 vi. This style is sometimes called deconstructivist, meaning bending and twisting traditional styles to create a new aesthetic.

Image 249 (two images). MAXXI National Museum of XXI Century Arts. Rome, Italy. Zaha Hadid (architect). 2010 CE. Glass, steel, and cement.

 i. Located in Rome, Italy, this contemporary art museum exemplifies the neofuturistic style, characterized by curving forms and elongated structures.

 ii. The building is composed of bending oblong tubes that overlap and intersect with each other.

 iii. Hadid was inspired by flowing rivers, and she sought to integrate the building into the urban fabric of the city.

IV. ARTISTIC APPROPRIATION

A. Overview

1. The intentional borrowing, copying, and/or alteration of pre-existing images or objects were a major component of the Pop Art movement of the mid-20ᵗʰ century.

2. In the 21ˢᵗ century, appropriation is used to challenge traditional notions about authorship and creativity as well as to add a new layer of meaning to the work. This style is often referred to as Post-Modernism.

> **Test Tip**
>
> *It is important to understand the many reasons why Post-Modernist artists use appropriation.*

B. Artworks from the image set

Image 230. Pink Panther. Jeff Koons. 1988 CE. Glazed porcelain.

i. This piece is from a series titled "Banality."

ii. Koons deliberately drew from pop culture images to create a sculptural design intended to comment on art and beauty as commodities.

iii. The Pink Panther is a cartoon character from a film and TV series from the 1960s and 1970s. For this sculpture Koons placed him in a semi-erotic pose with a platinum blonde woman who is reminiscent of Hollywood celebrities like Marilyn Monroe and Jayne Mansfield.

iv. The artworks from the Banality series were fabricated by workshops in Germany and Italy that had long-standing traditions of working with porcelain and wood. Each piece was made in editions of three for simultaneous exhibition around the world.

v. Koons was one of the first artists to engage in self-promotion by taking out ads in major art magazines and employing an image consultant in order to create celebrity status for himself.

vi. The use of deliberately gaudy colors and appropriated images were inspired by kitschy, inexpensive knickknacks.

Image 231. Untitled (#228), from the History Portraits series. Cindy Sherman. 1990 CE. Photograph.

 i. All of Cindy Sherman's artworks are self-portraits.

 ii. For this series of photographs, Sherman employed theatrical makeup, costumes, and props to make it appear as though she had been painted with oil paints.

 iii. Each of the works in this series draws from painted masterpieces.

 iv. This work portrays Judith holding the head of Holofernes. The story about a Jewish heroine who saves her people from foreign domination is one of the few feminist stories from the Bible.

 v. In creating this work, Sherman is portraying a feminist hero while also blending aspects of painting with photography.

 vi. In creating a photograph that is modeled after Old Master paintings, Sherman is challenging the viewer to re-examine the artistic merit of each of the two mediums.

V. CULTURAL INVESTIGATIONS/EXAMINING HISTORY IN RELATION TO THE MODERN WORLD

A. Overview

 1. Many late 20th-century and 21st-century artists have used their cultural heritage as the central theme of their artwork.

 2. Often the artwork puts the viewer in the position of having to re-examine cultural and historical biases.

 3. In many cases non-European artistic traditions are combined with traditional European techniques and media to create a whole new aesthetic vocabulary.

 4. The theme of the individual in the modern world is recurrent in many of these works.

B. Artworks from the image set

Image 226. Horn Players. Jean-Michel Basquiat. 1983 CE. Acrylic and oil paintstick on three canvas panels.

 i. Basquiat emerged from the New York City graffiti scene of the 1980s.

ii. Basquiat's artwork was labeled Neo-Expressionism, and was commercially exploited despite his personal problems including a drug addiction that led to his early death.

iii. Much of Basquiat's artwork drew inspiration from so-called primitive approaches to imagery and to street art, especially graffiti.

iv. The themes of racism, cultural identity, and social tensions were prevalent in Basquiat's work.

v. This painting is a kind of triptych featuring jazz musicians Charlie Parker and Dizzy Gillespie in the outer wings. The painting also features words that Basquiat associated with these musicians and geometric shapes made of lines.

vi. The traditional approach to creating the illusion of three-dimensional space is absent in this work. In this work, Basquiat pays tribute to these African-American artists by rejecting traditional European painting techniques in favor of a flat, Expressionist style.

Image 227. Summer Trees. Song Su-Nam. 1983 CE. Ink on paper.

i. Song Su-Nam was the leader of the Sumukhwa (oriental ink) movement of the 1980s while he was a professor at Hongik University in Seoul, South Korea.

ii. The goal of the movement was to recover a national identity rooted in Korea's past.

iii. In this work the artist combined techniques made famous by Post-Painterly Abstractionists with the subtle tonal variation used in Chinese and Korean literati-style ink paintings.

iv. The use of a traditionally East Asian medium combined with abstraction resulted in a new and unique approach to a European/American artistic style.

Image 228. Androgyn III. Magdalena Abakanowicz. 1985 CE. Burlap, resin, wood, nails, string.

i. This is one of many artworks by the Polish artist Abakanowicz that ask the viewer to examine the relationship between the individual and society.

ii. The idea of self versus group is loosely based on the history of Poland in the 20th century, particularly the Nazi German occupation and the postwar Soviet domination.

iii. In the early 1970s, the artist began to make freestanding sculptures from her fiber works.

iv. Abakanowicz used a mold process to make the form out of burlap combined with resin. The result is a three dimensional object that has a hollow interior that can be viewed when the piece is seen from the front.

v. This is one of a series of sculptures that Abakanowicz elevated from the floor by creating a wooden structure as a base.

vi. Abakanowicz was inspired by existential ideas about modern spiritual and physical existence.

Image 232. Dancing at the Louvre, from the series The French Collection, Part I; #1. Faith Ringgold. 1991 CE. Acrylic on canvas, tie-dyed, pieced fabric border.

i. This piece is part of a series that tells the story of a fictional African-American young woman who travels to Paris in the 1920s and befriends many famous artists. In this panel, she and her family are more interested in having fun than viewing masterpieces of European art history.

ii. In writing and illustrating this story, Ringgold revised history, allowing her character to interact with people who were considered to be artistic heroes of the time period. Some of the story was inspired by the life story of Josephine Baker.

iii. Ringgold's mother was a fashion designer and seamstress. After her mother died in 1981, Ringgold started making the story quilts for which she became famous.

iv. Ringgold's approach combines traditional European techniques with African-American folk art.

v. The central image is painted on canvas while the border, which contains the text, is made of various pieces of fabric. The entire artwork is then finished using traditional quilting techniques.

vi. The hybrid technique combined with the subject matter pays homage to feminist history, especially African-American women's history, and to the women who made the quilts that guided escaped slaves along the Underground Railroad.

Image 233. Trade (Gifts for Trading Land with White People). Jaune Quick-to-See Smith. 1992 CE. Oil and mixed media on canvas.

i. This artwork was made as a response to the 500th anniversary of Columbus's landing in the New World and was part of a series called The Quincentenary Non-Celebration.

ii. The artist is Native American, and she uses her cultural heritage combined with her traditional art training to make artworks that address the history of her people.

iii. The central theme of this artwork is the history of Native Americans being poorly compensated for their tribal lands and the different ways that each side saw the same world, which led to the uneven exchange.

iv. The large canvas is covered with tribal newspaper articles about native life combined with images of stereotypical Native Americans from product designs and advertisements.

v. Smith was inspired by Abstract Expressionist painters in her energetic application of brushstrokes over the collage.

vi. On the topmost layer of the painting, she painted the outline of a canoe, which is a traditional native form of transportation and a reference to movement.

vii. Above the painting, Smith hung a string lined with inexpensive toys and souvenirs. Some of the objects imitate traditional Native clothing and tools, while others feature images of Natives used as mascots.

viii. By pairing the painted and collaged image of the canoe with the inexpensive trinkets, hats, and costumes, the artist is envisioning a world where the Native tribes can offer modern day cheap goods that they consider to be offensive in exchange for the return of tribal lands.

Image 234. Earth's Creation. Emily Kame Kngwarreye. 1994 CE. Synthetic polymer paint on canvas.

i. The artist who created this artwork was an Aboriginal Australian who was completely untrained in art and who did not begin to paint until she was 80 years old.

ii. All of her artworks use the dotwork patterns derived from the traditional Aboriginal Australian style to depict the dreaming stories of her cultural heritage.

iii. Her work has often been compared to Impressionist and Abstract Expressionist artworks, although she knew nothing about art history.

iv. All of her color schemes were influenced by the landscape. This one refers to the "green time" after the rainy season.

v. She was the first Aboriginal artist whose work broke the million-dollar mark at auction.

Image 235. Rebellious Silence, from the "Women of Allah" series. Shirin Neshat (artist); photo by Cynthia Preston. 1994 CE. Ink on photograph.

i. This artwork is one of a series of works that portray female warriors of the Iranian Islamic Revolution of 1979.

ii. This self-portrait depicts the artist with her face covered partially by Farsi text.

iii. The text, which covers the part of her face usually covered by a niqab (traditional Muslim face scarf), is poetry written by Iranian women that contemplates martyrdom and the role of women in the revolution. The long tradition of Persian poetry is referenced in this portion of the artwork.

iv. The rifle that divides her face symbolizes the deliberate arming of Muslim women during the revolution.

v. In this artwork, the traditionally submissive gaze of religious Muslim women takes on new meaning. The viewer is reminded that the niqab may conceal more than a woman's face.

Image 237. Pisupo Lua Afe (Corned Beef 2000). Michel Tuffery. 1994 CE. Mixed media.

i. This artwork, made by a New Zealander, is made from flattened corned-beef tins joined by rivets.

ii. Drawing on his Samoan heritage, Tuffery named the work for the local Samoan term for canned goods. The term derived from a Samoan rendition of the words "pea soup," which was the first canned food to be introduced to the island.

iii. Canned foods quickly became prestigious items used as ceremonial gifts in Samoa.

iv. This artwork is a visual comment about an imported item that displaced native foods, a direct result of the effects of European colonization on Pacific peoples.

v. The artwork challenges the viewer to consider whether or not the colonization of the Pacific islands created a dependence on European goods.

Image 241. Pure Land. Mariko Mori. 1998 CE. Color photograph on glass.

i. This artwork is part of the "Esoteric Cosmos" series created in 1996–1997.

ii. The series, created using digital imagery, draws inspiration from the style of ukiyo-e ("floating world") prints from the Edo period in Japan.

iii. The artist depicted herself as Kichijoten, the Japanese goddess of happiness, fertility, and beauty, floating over the Dead Sea at dawn.

iv. Cartoon characters float in the empty landscape with her. The empty landscape embodies the Buddhist idea of emptiness called sunyata.

v. The landscape is reminiscent of Western landscape paintings as well as video games. The figures are references to Manga (Japanese graphic novels) and Anime (Manga-inspired films and television shows).

vi. The artwork is both a reference to Japanese Pop culture and an updated version of traditional Japanese Buddhist imagery.

Image 247. Preying Mantra. Wangechi Mutu. 2006 CE. Mixed media on Mylar.

i. This artwork is one of many Mutu has produced that deals with the subject of European colonization in Africa.

ii. Mutu's collages include imagery from fashion magazines, popular magazines, pornographic images and medical illustrations. The result is a re-imagined African female body with indirect or direct references to exploitation, sexism, and racism.

iii. In this artwork the traditional Western female reclining nude is re-imagined as a woman placed on a blanket that resembles a Kuba cloth.

iv. The crowned woman stares boldly at the viewer, and she holds a green snake in her left hand.

v. Her body, which is the same color as the leaves of the tree, along with the tree itself visually symbolize the many global creation myths, including one from her native Kenya, that feature trees as central to the story.

vi. The snake is a reference to the biblical creation story of Adam and Eve.

vii. By combining Western and African images and symbols the artist invites the viewer to examine the concept of hybridization.

Image 242. Lying with the Wolf. Kiki Smith. 2001 CE. Ink and pencil on paper.

i. This is one of a series of works in which Smith combines myths, folk tales, biblical narratives, and Victorian literature to create new concepts about feminine identity.

ii. In this large scale drawing, the female reclining nude bonds with a wolf.

iii. The drawing references both the folk tale of Little Red Riding Hood and the biblical story of Saint Genevieve, who had the ability to domesticate wolves.

iv. By visually referencing the two stories, Smith re-interprets them in a feminist light.

Image 245. Old Man's Cloth. El Anatsui. 2003 CE. Aluminum and copper wire.

i. This artwork is part of a series called Gawu, the Ewe (language of Ghana) word for metal cloth.

ii. The objects used are recycled and cut metals fastened together with wire.

iii. This artwork was made from a thousand drink tops that the artist found in the bush.

iv. European bottled liquors were a major trade item used in the transatlantic slave trade. The use of the tops symbolizes a major contact point between the artist's native Africa and the European colonial powers that exploited the continent.

v. The fact that the tops came from liquor bottles that had been consumed by native people lent the material a history that embodied ideas about trade and dependence.

vi. The patterns and colors of his metal cloth works are deliberately reminiscent of richly patterned Ghanaian kente cloth. The liberal use of gold colored metal refers to the former British name for Ghana (The Gold Coast).

vii. The artist creates the work as a flat piece of fabric but manipulates it in various ways during installation to best catch the light in the space.

Image 246. Stadia II. Julie Mehretu. 2004 CE. Ink and acrylic on canvas.

i. The Ethiopian born Mehretu portrays the chaos of the modern world in her large-scale paintings.

ii. Mehretu often overlaps architectural plans, diagrams, photos, graffiti, and maps combined with abstract shapes and designs to create paintings that have an illusion of depth and movement.

iii. The surface of this painting was built up in layers to add to the illusion of depth and motion.

iv. Mehretu was inspired by the many abstract movements of the 20th century.

v. The title of the work, one of a triptych, refers to arenas where national identity, power struggle, commercialism, entertainment, and heated conflict merge into a whole experience.

Test Tip

You should be able to compare and contrast contemporary non-European art with traditional art of the artist's country.

PART III

TEST-TAKING TIPS

STRATEGIES FOR SUCCESS ON THE MULTIPLE-CHOICE QUESTIONS

On the AP Art History exam, there will be 80 multiple-choice questions that will need to be completed in 60 minutes. This section of the exam will test your comprehension of the 250 art images associated with the AP Art History exam.

In Part A of this section, you will encounter eight sets of multiple-choice questions (with three to six questions in each set) associated with one or more color images. These questions are meant to test your ability to recognize specific artists and styles, place the work(s) in a specific period of art, and understand the context of the work(s). These tasks may seem less difficult because the image(s) will be right in front of you, printed in the test booklet. Be vigilant and read the questions carefully. Moving through them too quickly may cause you to miss the answer.

In Part B of this section, you will be answering 35 discrete multiple-choice questions, which may or may not be accompanied by images. Take your time. Read each question and the answer choices carefully before deciding which answer is correct.

I. TIPS FOR PREPARING FOR THE MULTIPLE-CHOICE QUESTIONS

 A. Create a set of flashcards. You can download your own images from trusted websites on the Internet. (Ask your teacher to recommend a good website.) No matter what textbook you might be using, a good website will be valuable in providing familiar images found in the texts. It might also offer other views of sculpture and architecture that might not be so familiar, but may be on the exam.

 1. Flashcards can be used in a number of ways.

i. Print or paste the picture on the front and the identifying information on the back. This information should include the artist, title, date, and culture or style. Add any contextual information such as patron, political or social references, purpose, and a story about the artwork.

ii. As you create your flashcards keep reviewing the past images and start comparing or contrasting them with "newer" images. This is extremely helpful when comparing early Gothic churches with late Gothic churches or Greek Classical temple structures with the Neo-Classical structures found in the late eighteenth and early nineteenth centuries. Many students find that if they have not studied all the images in comparison, they make incorrect identifications.

iii. Study a single group or art period. What are the characteristics that place those images into that time period? Is there a particular medium, figurative style, subject matter, or purpose that is significant throughout that group?

iv. Mix them up; try shuffling them like a deck of cards. Now, sort them in chronological order; or go through and fit them into themes, such as "sacred spaces," "power and authority," "violence and death," "gender representations," "propaganda," and so on. Keep in mind that there might be overlap between these themes, so don't feel your assortments must be concrete. Come up with your own themes, as an individual or as a class.

B. Create concept definition maps.

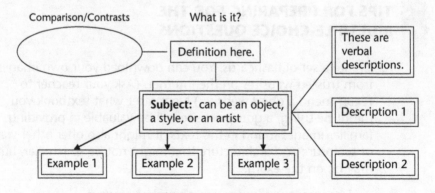

An Example of a Concept Definition Map

1. Concept mapping is a visual way to define a topic. Definitions, descriptions, and examples all are part of the process. This technique is especially suited for studying styles that seem to be similar but are in fact distinct. Example: Create a separate concept definition map for each of the eight content areas that are found on the exam: Global Prehistory, Later Europe and the Americas, Africa, etc. Using this method you can address style, religion, politics, and subjects, and have a broader interpretation of the content. Multiple-choice questions often ask about very specific issues, and this is an excellent way of understanding the unique aspects of a topic along with the whole of that topic.

II. TEST-DAY STRATEGIES FOR THE MULTIPLE-CHOICE QUESTIONS

A. Read the question and think of your answer before you read the answer choices given. This can help you select the best choice, rather than falling into distracting traps.

B. Eliminate as many answer choices as possible. All multiple-choice questions have the same answer format: one right answer, one foil (seems like it could be right but it is not), and two more obviously wrong answers. As you review the answer choices for each question, try to eliminate the two more obviously wrong answers and cross them out (you can write in the exam booklet); this will narrow your answer choices to two, giving you a 50 percent chance of answering the question correctly.

C. Circle key words in a question such as EXCEPT, ALL, NOT, or BEST. Students often miss questions that use negative logic, such as "All of the following EXCEPT," because they get confused. Be sure to focus your mind on the logic of the question.

D. Answer all of the questions. Your score on the multiple-choice section of the AP Art History exam will be based only on the number of questions you answer correctly. There is no "guessing penalty." Be sure to answer all of the questions, even if you have to guess.

STRATEGIES FOR SUCCESS ON THE FREE-RESPONSE QUESTIONS

The free-response section of the AP Art History exam is divided into two parts: Part A is comprised of two 30-minute essays, and Part B consists of four 15-minute essays. The two longer free-response essays will be timed and students will have 30 minutes to complete each one. One hour is allowed for the four shorter free-response questions, and it is suggested that students spend 15 minutes on each question.

I. STRATEGIES FOR WRITING AN EFFECTIVE ESSAY

1. DO read the question thoroughly, and underline or highlight exactly what the question is asking.

2. DO NOT write an introduction or a conclusion. This may waste precious time when you need to be *answering* the question.

3. DO NOT add unnecessary information simply because you know it. Answer only the question that is asked. Including facts or details that do not specifically address the question will not help your score and may waste time.

4. DO write quickly and neatly; the essay readers must be able to read and understand what you have written.

5. DO NOT repeat yourself. Do not rewrite or state in a new way an answer you have already given; it does not raise your score.

6. DO identify the artworks in your essay as fully as possible. Include the title or designation of the work (and place of location for architectural works), artist or originating culture (if artist is not known), time period of creation, and the material(s)

from which the work was created. If you do not know the title, include a very detailed description of the artwork. If the description is detailed enough you will probably receive some points.

7. DO watch carefully for key words such as "BOTH." In such a case, be sure that your answer addresses both artworks. If a part of your answer applies only to one of the artworks, do not use it.

8. DO refer to the given image or text when the question asks you to do so. If a free-response question includes a primary source (text), you must refer to that source when answering the question in order to get full credit for that question.

9. DO write something for each question, even if you are not sure of the answer. You have a better chance of earning points if you can make at least a modest attempt to answer. This may help you to pass the exam.

10. DO re-read the question to be sure that you answered completely and accurately before moving on.

11. DO NOT expect the essay readers to take your margin notes and outlines into account. The essay readers are not allowed to read this extraneous information; you will be graded only on what is included in your final essay.

12. DO keep track of your time. Wear a watch: You cannot take a cell phone into the testing room, and not all exam rooms have wall clocks.

Remember: You have one hour of writing for Part A and one hour of writing for Part B. You will likely feel tired toward the end of the two hours, but if you give it one last burst of energy and answer *all* the questions, your chances of passing the exam will be much greater.

GENERAL TIPS FOR THE FREE-RESPONSE SECTION

1. Use flashcards to prepare. Chapter 14 discusses how to make and use flashcards effectively. Duplicate those activities when preparing for the free-response section.

2. Practice writing both 30-minute and 15-minute responses in the time allotted. This will help you become familiar with the process of writing an essay within a limited timeframe.

3. Do not panic if you read a question and you think you do not know the answer. Take a moment to collect your thoughts and recall what you *do* know. Once you begin writing, other ideas will surface. Some students just give up and leave the question blank. DO NOT DO THAT!

 If you practice essays enough … you will not panic on test day!

ONE FINAL THOUGHT

On exam day, make sure to eat before the test. The AP Art History exam is administered in the afternoon, so avoid heavy food at lunchtime and opt for something light, such as a sandwich, salad, or fruit. Also, drink water. (You may be able to take a water bottle into the exam room.) A comfortably full and hydrated test-taker is an alert and happy test-taker.

Notes

Notes

Notes

Notes

Notes